Various Small Books

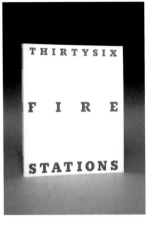

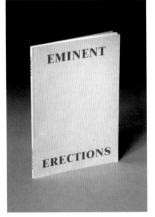

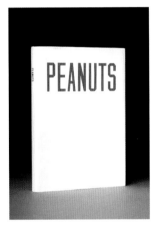

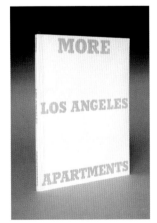

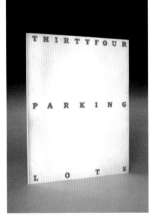

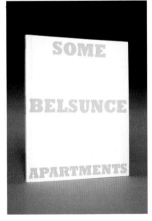

VARIOUS SMALL BOOKS

Referencing Various Small Books
by Ed Ruscha

edited and compiled by
Jeff Brouws, Wendy Burton,
and Hermann Zschiegner

text by Phil Taylor
with an essay by
Mark Rawlinson

The MIT Press
Cambridge, Massachusetts
London, England

For information about special quantity discounts, please email
special_sales@mitpress.mit.edu or write to Special Sales Department,
The MIT Press, 55 Hayward Street, Cambridge, MA 02142.

This book was set in Garamond, Rockwell and Trade Gothic, utilizing
QuarkXpress. Printed and bound in China.

Library of Congress Cataloging-in-Publication Data

Taylor, Phil, art historian.
Various small books : referencing various small books by Ed Ruscha /
text by Phil Taylor with an essay by Mark Rawlinson ; edited and compiled
by Jeff Brouws, Wendy Burton, and Hermann Zschiegner.
 p. cm
Includes bibliographical references.
ISBN 978-0-262-01877-7 (hardcover : alk. paper)
1. Artists' books. 2. Ruscha, Edward—Influence. 3. Ruscha, Edward—
Themes, motives. I. Rawlinson, Mark (Mark S.) II. Ruscha, Edward. Works.
Selections. 2013. III. Title.
N7433.3.T38 2013
709.04′082—dc23

2012022466

10 9 8 7 6 5 4 3 2 1

Design and Production: Jeff Brouws
Project Director: Wendy Burton
Production / Photoshop assistance:
Wendy Burton, Hermann Zschiegner
Copy Editor: Alexandra McKee

CONTENTS

"I am interested in what is interesting" (Ed Ruscha, 1971)

Essay

"Like Trading Dust for Oranges":
Ed Ruscha and Things of Interest

Mark Rawlinson

Fifty years ago, in 1962, Edward Ruscha published *Twentysix Gasoline Stations*, the first of a series of photobooks the artist made through the 1960s and 1970s.[1] Consisting of black and white photographs of twenty-six filling stations situated along Route 66 between Los Angeles and Oklahoma, this deceptively simple book, much like Marcel Duchamp's *Fountain* (1917), irrevocably altered our understanding of art. From contemporaneous reviews of *Twentysix Gasoline Stations* to ongoing critical arguments about the artist's aesthetic legacies, Ruscha's photobooks have continually attracted artistic as well as critical attention. Collected here in *Various Small Books* are works inspired by Ruscha's experiments with the medium of photography, language, and the form and content of the photobook. Whether as straight homage or as a self-conscious borrowing of Ruscha-as-artistic-material to be reshaped, refined or even rejected, *Various Small Books* provides evidence of a visual history running in parallel with, and asking similar questions as, the textual history of Ruscha criticism.[2] But what is it about Ruscha's photobooks that makes them so attractive to write about and, in this instance, engage with as an artist some fifty years after the publication of *Twentysix Gasoline Stations*? To be clear, there is no sense in asking Ruscha for the answer. Despite myriad interviews Ruscha has failed to make good and explain, and his photobooks each remain a conundrum, antagonistically refusing to acquiesce to easy categorization or to be reconciled with traditional histories of photography and art. They seem to exist in the gaps between media, genre, and practices; in short, as Kevin Hatch argues, "they do not fit anywhere very comfortably."[3]

For Charles Desmarais, Ruscha's recollection of a "daydream," in which the factual fate of his photobooks are revealed to him by "The Information Man," "may be the artist's clearest statement yet concerning his series of enigmatic books, as well as the best critical clue to their meaning."[4] Ruscha's recollection is lengthy and, crucially, factual: "[o]f the approximately 5000 books of Ed Ruscha that have been purchased, only thirty-two have been used in a directly functional manner. [...] two were used as a device to nudge open a door, six have been used to transport foods like peanuts to a coffee table..."[5] Significantly, Ruscha does not craft for his books a future history of aesthetic or art historical significance; nor is there an account of their influence on a future generation of artists. Instead, Ruscha gives us what he calls the facts: an act that only serves to sustain the enigmatic, contrary, and irresolvable quality of his photobooks.

But facts alone cannot account for the historical arc of the photobooks' continuing irresolvability; an arc that might well begin, somewhat arbitrarily, with Philip Leider's 1963 review of Ruscha's *Twentysix Gasoline Stations* and end with Margaret Iverson's 2009 commentary on Ruscha's impact on photography after conceptual art. According to Leider, "we are irritated and annoyed by [*Twentysix Gasoline Stations*], but feel compelled to resolve the questions it raises";[6] and, writing almost fifty years later, Iverson can still say with some justification: "Ed Ruscha's books are puzzling."[7] As the work gathered in *Various Small Fires* confirms, the compulsion identified by Leider and the puzzling nature of the photobooks is ongoing and, essentially, *productive*. It also shows that Ruscha's "Information Man" omitted one crucial fact: namely, that Ruscha's photobooks would continue to inspire, and perhaps infuriate, but crucially engage the *interest* of contemporary artists and photographers.

Various Small Books shows the many ways in which this interest manifests itself, where the most common strategy is that of appropriation. Many books riff on Ruscha's use of language and the titles of his photobooks, some through literal replication or through inversion of the original title, others adopt the title as a sort of template, ignoring specific phrases or words and borrowing instead the metric rhythm of the title. Many

photobooks mimic the colors and typography of the original covers; some adopt Ruscha's strategic use of the photobook but more often than not with a twist. In most cases, too, Ruscha's typological explorations of mundane subject matter — the gas station, the street, or the swimming pool — are revisited or extended to include shopping trolleys (Tom Sowden, *Fiftytwo Shopping Trolleys*, 2004) and the lids of coffee cups (Hermann Zschiegner, *Every coffee I drank in January 2010*, 2010). Kai-Olaf Hesse's *Vingt-Six Stations Service* (2007) appropriates the title, cover and, to a large extent, the content of Ruscha's *Twentysix Gasoline Stations,* whilst also throwing in the concertina-form of *Every Building on the Sunset Strip*; similarly *Twentysix Abandoned Gasoline Stations* (1992) by Jeff Brouws and Stan Douglas's *Every Building on 100 West Hastings* (2003) play ironically with Ruscha's ironic titles and format, whilst supplementing the "neutrality" of the original works with a more obvious political consciousness. And works such as Joachim Koester's *Occupied Plots, Abandoned Futures: 12 (former) Real Estate Opportunities* (2007) and Travis Shaffer's *Thirtyfour Parking Lots* (2008), to name two, revisit the original sites of Ruscha's work but in very different ways; whilst the work of Jean-Frédéric Schnyder's *Zugerstrasse* (2000), Dominik Hruza's *73 Häuser Von Sinemoretz* (2004) and Hesse above, adapt Ruscha's idiom for places outside the United States of America. Some books do nothing of the sort (*None of the Buildings on Sunset Strip* (Jonathan Monk, 2002). Whatever the approach, one cannot help but wonder what it is about Ruscha's photobooks that attracted and attract the attention of artists/photographers from across the globe? And whilst I shy away from suggesting a definitive answer, in what follows I argue that Ruscha's proto-photoconceptualism, for all the artist's protestations and the criticisms laid against (photo-) Conceptual art practice, opened the way for the work contained in *Various Small Books* because, quite simply, it is *interesting.*

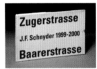

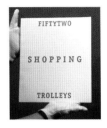

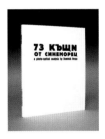

On Not Being A Photographer

After the appearance of *Twentysix Gasoline Stations,* Ruscha persistently denied a genuine interest in the medium of

photography. In "I'm Not Really a Photographer," a conversation with A.D. Coleman, Ruscha was clear: "I never take pictures just for the taking of pictures; I'm not interested in that at all. I'm not intrigued *that* much with the medium.... I want the end product; that's what I'm really interested in. It's strictly a medium to use or not to use, and I use it only when I have to."[8] The end product is not a fine photographic print but the book, a mass-produced object whose coming-into-being Ruscha describes as "contrived."[9] "The first book came out of a play on words," says Ruscha; "The title came before I even thought about the pictures. I like the word 'gasoline' and I like the specific quantity of 'twenty-six.'"[10] Ruscha then, as is logical, set about "finding" the photographs to fit.

> I had a vision that I was being a great reporter when I did the gas stations. I drove back to Oklahoma all the time, five or six times a year. And I felt there was so much wasteland between LA and Oklahoma City that somebody had to bring in the news to the city. It was just a simple, straightforward way of getting the news and bringing it back. I think it's one of the best ways of just laying down facts of what is out there. I didn't want to be allegorical or mystical or anything like that.[11]

The emphatic and deliberate avoidance of the mystical or the allegorical (one might assume Ruscha is referencing two defining texts of the 1950s: Jack Kerouac's Beat novel *On the Road* (1957) and Robert Frank's *The Americans* (1959), to which Kerouac also provided the introduction) is part of a deliberate decision-making that marks out Ruscha's photobooks as proto-photoconceptualism.[12]

Everything about the photographic medium is placed second behind the idea; photography just happens to be the medium best suited to giving substance to the idea because, as Nancy Foote says, the "first function" of the photograph "is, of course, documentation."[13] Here the camera becomes a purely practical tool, the means to an end — "I just pick it up like an axe when I've got to chop down a tree, I pick up a camera and go out and shoot the pictures that I have to shoot," says Ruscha — and the final photograph is valued for its evidential rather than aesthetic qualities.[14] Ruscha's straightforward relegation of photography to the realm of the practical at the expense of

aesthetic and medium-specific sensitivity places him within a category of artists Foote named "the anti-photographers."[15] As Foote notes, "conceptual art exhibits little *photographic* self-consciousness, setting itself apart from so-called serious photography by a snapshot-like amateurism and nonchalance that would raise the hackles of any earnest professional."[16]

One "earnest professional" whose hackles have most certainly been raised by photoconceptualism, and especially Ed Ruscha, is photographer Jeff Wall. In "Marks of Indifference" (1995) Wall offers an outspoken reflection on the historical trajectory of photography from avantgarde modernism to the contemporary via Conceptual art. Here photoconceptualism distinguishes itself as a terrible necessity, the teleological endpoint of modernist self-reflexivity, where the continual self-questioning of the grounds of the medium served only to propel it toward oblivion. But rather than tipping over into the abyss, Conceptual art stopped short, instead shoring itself to a systematic "reductivism" and "amateurization" of the photographic medium, positing an anti-aesthetic.[17] Only at this lowest ebb did "photography" realize its true task: to "turn away from Conceptual art, away from its reductivism and its aggressions."[18]

Wall's critique is deadly serious and in many ways, his arguments echo those made by Benjamin Buchloh in his essay, "Conceptual Art 1962-1969: From the Aesthetic of Administration to the Critique of Institutions" (1990). Buchloh argues that *Twentysix Gasoline Stations* provides the earliest indication of "the key strategies of future Conceptual Art": these being "to choose the vernacular (e.g. architecture) as referent; to deploy photography systematically as the representational medium; and to develop a new form of distribution (e.g. the commercially produced book as opposed to the traditional crafted *livre d'artiste*)."[19] What irks Wall about Ruscha in particular relates specifically to Buchloh's observations on Conceptual art practice — which he defines in its earliest phases as an "aesthetics of administration." This argument is worth considering at length because it helps illuminate the connection between Ruscha's photobooks and the many diverse responses to them contained in *Various Small Books*, whilst also revealing the influence of philosopher, Theodor Adorno on both Buchloh and Wall.

Conceptual art's negation of fine art photography's core principles, which as Foote hinted often favor their opposite (amateurism over professionalism; lack of competence over technical skill, etc.), is only part of the problem for Wall.

> "Great art" established the idea (or ideal) of unbounded competence, the wizardry of continually evolving talent. This ideal became negative, or at least seriously uninteresting in the context of reductivism, and the notion of limits to competence, imposed by oppressive social relationships, became charged with exciting implications.[20]

An infatuation with playfulness and irony, and, of course, all the tangible temptations of so-called low culture turns art away from seriousness. Making serious art, as Wall points out, is considered a lot less interesting than the "exciting implications" Conceptual art practice offered. One can easily see Wall's point. Take Ruscha's regular eschewal of the photographic medium ("I have no interest in photography as a medium."[21]), or the relentless claims he makes to the facticity of his work, to its neutral bearing on its subject matter, and the neutral nature of the subject matter also. "My pictures are not that interesting, nor the subject matter. They are simply a collection of 'facts'";[22] or, "I don't have any message about the subject matter at all. They're just natural facts, that's all they are."[23] And yet, Ruscha says, "I am dead serious about everything I make."[24] Wall's attack is complex but arguably misses the more nuanced ideas at the heart of Ruscha's practice. For one, we must treat Ruscha's denial of interest in the medium as questionable; after all, his deliberate inversions of the medium *are* an engagement with it, but just not of the type Wall considers productive for the medium. More importantly, for Ruscha, "The book is the look, not the photograph";[25] a crucial distinction whose complexities Wall overlooks. Somewhat bluntly, Wall says Ruscha's books "ruin the genre of the 'book of photographs,' that classical form in which art-photography declares its independence" because in the moment of their conscious collaboration with the aesthetics of administration, Ruscha's photobooks apparently surrender photographic independence; that is, their ability to critique the prevailing social order, the determinate negation of the idea of "great art."[26]

The negation of the idea of "great art" leads inevitably to the sacking of its figurehead — the great artist — and it is here that we find a way to rethink Wall's criticisms. The French literary theorist Roland Barthes famously argued for the "death of the author" but this was in 1967, some five years after Ruscha shook off the role of the artist/author in favor of a persona, that of a "great reporter" for *Twentysix Gasoline Stations*.[27] Barthes' point was simple: "[t]o give a text an Author," he said, "is to impose a limit on that text;" in other words, criticism had long entertained itself with the notion that to understand a work of art, the task critic must understand the intention of author/artist/maker.[28] In essence, the critic must identify the author's intention for the work of art. However, freed of the "author" the meaning of the work becomes less the work of the critic and more that of the reader. More telling is perhaps Barthes assertion that

> As soon as a fact is *narrated* no longer with a view to acting directly on reality but intransitively, that is to say, finally outside of any function other than that of the very practice of the symbol itself, this discon-nection occurs, the voice loses its origin, the author enters into his own death, writing begins. The sense of this phenomenon, however, has varied; in ethnographic societies the responsibility for a narrative is never assumed by a person but by a mediator, shaman or relator whose "performance" — the mastery of the narrative code — may possibly be admired but never his "genius."[29]

Barthes work offers one way of reading the deliberate "facticity" of the photobooks, but also Ruscha's subversion of the role of artist genius to mediator or conduit; two acts which almost *demand* the mass-produced product Ruscha strived to make.

As such, Ruscha's working methodology arguably predates Barthes theorization of a similar impulse, especially through the artist's efforts to minimize his "presence" in *Twentysix Gasoline Stations*; so much so that Sylvia Wolf can rightly claim, "there is not much to look at."[30] "Titled with the threadbare economy of fact," consisting of forty-eight pages, 7x5 inches in size, with a series of black and white photographs of gas stations, each with a one-line caption on the page opposite, *Twentysix Gasoline Stations* is a quite a stark object to behold.[31]

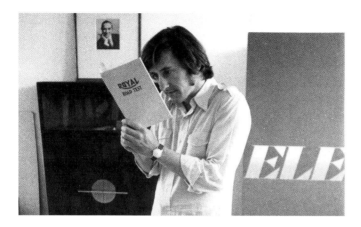

Twentysix Gasoline Stations is, according to Herman Barendse, "somewhat desolate"; to which Ruscha responds: "There's a dryness I went for, actually. I liked that, having it dry and simple and, in a way, unartistic."[32] Again, the specter of factuality appears and not just in *Twentysix Gasoline Stations* but across the range of Ruscha's photobooks. As Bernadse notes, the "terrific irony" of the photographs contained in *Real Estate Opportunities* is that "they look right. They don't look out of place at all; they look exactly like the images used to advertise Real Estate." According to Ruscha, "there was no conscious effort to imitate that style, but at the same time it is really functioning in the same way as a real estate photographer who goes out to shoot a picture to show somebody what some land looks like. That's all I was doing, showing the land."[33]

The act of "showing," or as Barthes calls it, "narrating," whether it be the desolate strip of highway between Los Angeles and Oklahoma, or "what some land looks like," or, for that matter, the patterns made by tire-rubber and oil-leaks left by cars in parking lots or the rich variations of the color blue of swimming pools across Los Angeles, gives the factual a peculiar kind of openness quite in contradiction to our sense perception of a document containing "only the facts." But Ruscha's attraction to the "unartistic," to the "unconscious" replication of commercial or industrial imagery of the type able to comfortably exist in the window of the office of a realtor, are exactly the type of "exciting implications" of conceptual

practice about which Wall is highly circumspect, to say the very least. By way of explanation, here is Wall's critique of Ruscha's *Some Los Angeles Apartments* (1965):

> The photographs in *Some Los Angeles Apartments* (1965), for example, synthesize the brutalism of Pop art with the low-contrast monochromaticism of the most utilitarian and perfunctory photography (which could be imputed to have been taken by the owners, managers, or residents of the buildings in question). Although one or two pictures suggest some recognition of the criteria of art-photography (e.g. "2014 S. Beverly Glen Blvd"), the majority seem to take pleasure in a rigorous display of generic lapses: improper relation of lenses to subject distances, insensitivity to time of day and quality of light, excessively functional cropping, with abrupt excisions of peripheral objects, lack of attention to the specific character of the moment being depicted — all in all a hilarious performance, an almost sinister mimicry of the way "people" make images of the dwellings in which they are involved.[34]

Ruscha is flatly accused of being a bad photographer, ignorant of the craft, and, along with the wider community of Conceptualists, a hypocrite. For Wall, Conceptual art's celebration of amateurism and lack of technical competence as core or defining (anti)-aesthetic attributes are pure façade rather than truly revolutionary or democratic principles. Ruscha's "everyman" approach is nothing less than a form of "sinister mimicry" and certainly not an affectionate adoption of amateur photography. Ultimately, Wall argues that, "The pictures are, as reductivist works, models of our actual relations with their subjects, rather than dramatized representations that transfigure those relations by making it impossible for us to have such relations with them."[35] In other words, Ruscha's photographs fail to reveal the structures of oppression and antagonism, the ideologies which trap us within the "iron cage" of contemporary capitalism, because his work, like that of his Conceptual contemporaries, "mimes the operating logic of late capitalism," choosing to replicate rather than transfigure those self-same systems of power.[36] In effect, neutering the power of art/photography.

The influence of Theodor Adorno on Buchloh and Wall is explicit here; especially Adorno's concerns expressed in the opening *Aesthetic Theory* that it "is self-evident that nothing concerning art is self-evident anymore, not its inner life, nor its

SOME

LOS ANGELES

APARTMENTS

relation to the world, not even its right to exist."[37] Adorno's lengthy contemplation on the possibility of art at the end of twentieth century allows Buchloh and Wall to easily puncture claims made for Conceptual art; and it is not difficult to insert Ruscha's photoconceptualism into the following lines from Adorno and find Buchloh and Wall's argument writ large: "Compositions fail as background music or as the mere presentation of material, just as those paintings fail in which the geometrical patterns to which they are reducible remain factually what they are…The striven-for shudder comes to nothing. It does not occur."[38] Ruscha's admitted attraction to the factual presentation of neutral material in a mass-produced medium would suggest that the series of photobooks initiated by *Twentysix Gasoline Stations* are running on empty; that the deliberate and premeditated anti-aesthetic of photoconceptualism can never be anything more than a book of photographic facts and poorly photographed ones at that. That which would confer upon them the status of art object, what Adorno calls the "shudder" — an aesthetic experience that leaves the viewer irrevocably altered — is foreclosed by Ruscha's emergent photo-conceptualist principles.[39] More so, when one considers that, rather than Adorno's notion of the shudder, Ruscha was rather more interested in a different kind of response from the viewer: "I realized for the first time this book [*Twentysix Gasoline Stations*] had an inexplicable thing I was looking for, and that was a kind of a 'Huh?'"[40]

Interesting Facts

Ruscha's photobooks, then, present us with a particular set of problems relating to the conception, production and distribution of art. It is a problem that leads Wall to conclude: "Only an idiot would take pictures of nothing but the filling stations, and the existence of a book of just those pictures is a kind of proof of the existence of such a person."[41] A neat tautology, yes, and one that impresses on us once again the fact that Ruscha's photobooks can be read as nothing other than the replication of a system rather than an attempt to transcend or transfigure it. They serve no purpose other than to exist

(although they are useful for nudging open doors and carrying peanuts to coffee tables). To close this essay, I will argue that Ruscha's photobooks are, in fact, much closer to the kind of artwork Wall and Buchloh valorize and cherish; and, more than this, that Ruscha's (anti) aesthetic explorations helped initiate the rich and diverse post-photoconceptual work collected here in *Various Small Books*.

So, let us return briefly to the idiotic idea of photographing (badly) twenty-six gasoline stations along *Route 66*. Ruscha says:

> [I]n the early 1950s I was awakened by the photographs of Walker Evans and the movies of John Ford, especially *Grapes of Wrath* where the poor "Okies" (mostly farmers whose land dried up) go to California with mattresses on their cars rather than stay in Oklahoma and starve. I faced a sort of black-and-white cinematic emotional identity crisis myself in this respect — sort of a showdown with myself — a little like trading dust for oranges. On the way to California I discovered the importance of gas stations. They are like trees because they are *there*. They were not chosen because they were pop-like but because they have angles, colours and shapes, like trees. They were just *there*, so they were not in my visual focus because they were supposed to be social nerve-endings.[42]

In plain sight but overlooked, the gas station excites an *interest* in Ruscha; there is also something of an alchemical epiphany (dust for oranges), a sort of shock or shudder that jolts a critical and perceptual realization in Ruscha. To understand what this might mean, let us consider the category of the "interesting" because I believe it best explains the continuing critical and artistic engagement with Ruscha's photobooks found exactly in the work collected here in *Various Small Books*.

In her essay, "Merely Interesting," Sianne Ngai presents a history of "interesting from Kant, through the German romantics Schlegel and Schiller to the present day, even mentioning Ruscha, though her reading of Ruscha is not the focus here."[43] Ngai writes that "there is…one measure that continues to circulate in a promiscuously — if often, in a telling way, unconsciously — in virtually all contemporary analyses of cultural artifacts: interesting."[44] For brevity, I leave aside the more detailed aspects of Ngai's excellent analyses, and instead highlight relevant issues she raises pertinent to this reading of

Ruscha. For Ngai, it is the "very indefiniteness of interesting, and its capacity to toggle between nonaesthetic and aesthetic judgements," that makes it such a pliable and engaging category.[45] To express interest in something — a movie, a book, architecture — is a means of either avoiding or suspending judgment. What is particularly striking is Ngai's commentary on the work of psychologist Silvan Tomkins, whose contemporaneous work on affect in the 1960s resonates wonderfully with Ruscha's "trading dust for oranges" epiphany. For Tomkins, being interested in something is "a necessary condition for the formation of the perceptual world"; so it is hardly surprising that Ruscha's interest was piqued by a familiar but overlooked object: the gas station. Tomkin's calls this, "'interest excitement' and the experience of the unexpected [...]," an experience he classifies "with fear and startle/surprise in his system of affects." Importantly though, a distinction is made between "the feeling of being startled... which dissipates as quickly as it flares up" and interest, which "has the capacity for duration and recursion."[46] As Ngai concludes, "In contrast to the once-and-for-allness of our experience of, say, the sublime, the object we found interesting is one we tend to come back to, as if to verify it is *still* interesting."[47]

But what does this all mean for Ruscha? And, more importantly, following this, what does it mean for the artists and their work gathered here in *Various Small Books*? Ruscha's prescient "death" as "author/artist" and his appropriation of the dry, factual register of a highly administered society and culture — the very things used to diminish his work — find new, critical focus when viewed through the category of the interesting. Ruscha's interviews themselves are littered with the word, often alongside its opposite, "uninteresting," but it is his overpowering "interest in the interesting" that should give us pause, simply because Ruscha's work is not what it seems; or, more to the point, it is so much more than Ruscha — or his alter-ego, the "Information Man" — tells us it is or might be. *Twentysix Gasoline Stations* may well revel in the obviousness of the connection between title and content, in the industrial quality and polish of its production values, it may also display a certain gleeful — satisfaction in using photography to fulfill a premeditated brief rather than testing the limits of the medium for the sake of it.

All these elements form the material for subsequent interpretations of Ruscha; whether taking on without change Ruscha's production values or producing their opposite; whether choosing neutral subject matter or reinvesting the seemingly neutral with a political charge.

 Ruscha constantly reminds us of these facts in interview after interview. However, Ruscha's interest in the gas station, the acknowledgment and then interest in gas stations passed-by or stopped-at en-route between Los Angeles and Oklahoma, and back again, reveal the power of perceptual experience, one that provoked Ruscha to take along a camera to photograph, print and then edit, collate and order, and then publish as *Twentysix Gasoline Stations*. This is not an act of idiocy but a complex and driven effort to make sense of the world; and the production of the artwork in the form of a mass-produced, prosaic photobook cannot be conceptualized neatly as an aesthetic of administration. Moreover, the photobook becomes in and of itself a new field of perception, able to produce in the viewer a particular perceptual experience; for the artists in *Various Small Books* Ruscha's works expanded the field of permissible subjects, approaches and methods available to them. Just like Ruscha's recognition of the gas station as possible subject, so Ruscha's books themselves gain a sort of "visual focus," they become in themselves artistic material for

the artist, becoming a focus for productive engagement.

What this means makes sense when set against a consideration of *Every Building on the Sunset Strip* (1966). Jaleh Mansoor asks: "How does the medium of photography account for the books such as *Every Building on the Sunset Strip* and *Twentysix Gasoline Stations*? What of their status as books? As objects?"[48] These questions do not apply to works simply aping the language and forms of administration. As Mansoor rightly says, "Ruscha's books reward close visual attention" because it is here that what interests Ruscha starts to interest us; the books become as Adorno himself said, "the splinter in the eye"; an intrusion into our perceptual field, one that demands our attention and engages our interest. Taking his own advice, Mansoor's close visual analysis of *Every Building on the Sunset Strip* reveals that the smooth, flattened-out Strip, with its endless procession of commercial store-fronts, residential buildings, parked and passing vehicles is not at all what it seems:

> [T]he tiny ruptures between the photographic units...insist on absolute flatness. Any coherent perspectival rendering of space — as when a side street draws away in a diagonal line to signify recession — buckles in on itself through a fault line, where two snapshots are grafted side by side to continue the horizontal extension. [. . .] The lines between the snapshots refuse to conjoin properly in many instances, leaving the trace of Ruscha's own process of connecting photos together.[49]

The easy and literal, even clichéd evocation, of Los Angeles as pure surface, a place lacking depth that *Every Building on the Sunset Strip* apparently announces and confirms simultaneously is somewhat disturbed by the discontinuities, failed connections. Moreover, its extreme flatness helps cast off clichéd thought to reveal a series of perceptual complexities that questions photographic vision and the medium of photography as deployed in mass-culture.

As such it confounds the notion of Ruscha's photobooks as a naïve and simplistic copying of the products of mass-culture and it registers exactly why the artists in this book have found in Ruscha a starting point or point of departure or diversification. What this means in simple terms is that the literal homages to the photographic style and mass-produced qualities of Ruscha,

like Eric Doeringer's *Some Los Angeles Apartments* (2009) and *Real Estate Opportunities* (2009), John O'Brian's *More Los Angeles Apartments* (1998) and Yann Sérandour's *Thirtysix Fire Stations* (2004), co-exist with elaborately produced collections, such as Edgar Arceneaux's *107th Street Watts* (2003) or Keith Wilson's *All the Buildings on Burnet (burn it) Road* (2011), Kai-Olaf Hesse's *Vingt-Six Stations Service* (2007), Tom Sowden's *Fiftytwo Shopping Trolleys* (2004), Derek Sullivan's *Persistent Huts* (2008) and Daniel Mellis's *Several Split Fountains and a Jack* (2007). Whether as homage to, or critique of Ruscha's mass-production (anti) aesthetic, each of these works engages with an interest in Ruscha — the return to and recalibration of an aesthetic of interest — as well as arousing an interest in us, as viewers, which demands and repays close visual analysis.

Although I disagree with Wall and Buchloh's charge that Ruscha's work lacks a political or social content, the blank presentation of "facts" can be seen as a key frame or support in the work of several artists' books. Most obviously, Mishka Henner's *Fifty-One US Military Outposts* (2010) and Jeff Brouws's *Various Minuteman Missile Silos* (2011), mime Ruscha's titling strategy but flip the emotional distance of his photographic style and pursuit of "neutral" subject matter through the highly-charged and emotive subject of nuclear deterrent buried in silos hidden in the American landscape. Similarly, Travis Shaffer (*Real Estate Opportunities,* 2010; *Eleven Mega Churches,* 2010), Louisa Van Leer (*Fifteen Pornography Companies,* 2006) and Stan Douglas (*Every Building on 100 West Hastings,* 2003) reinvent, or reinvest, Ruscha's neutral engagement with the political landscape of America by directly invoking the various economies of corporate and religious power and exploitation that shape culture and society. In essence, the photobook is revelatory, and, as I have argued in relation to Ruscha, not simply a straightforward copying of an aesthetic of administration, a tautological and purposeless act. Ruscha's photobooks broke the ground so that the *Various Small Books* gathered here might exist: appropriating, questioning, deconstructing, following or mimicking, the works here and those that paved the way are connected by their "capacity for duration and recursion." All of which makes them very interesting, indeed.

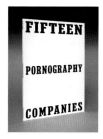

Eric Doeringer,
Some Los Angeles Apartments, 2009

Louisa Van Leer,
Fifteen Pornography Companies, 2006

An array of Ed Ruscha's books from the 1960s and 1970s.

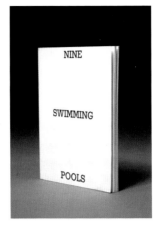

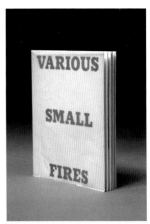

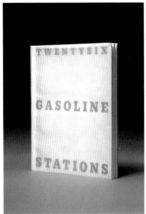

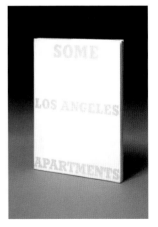

1954-1987

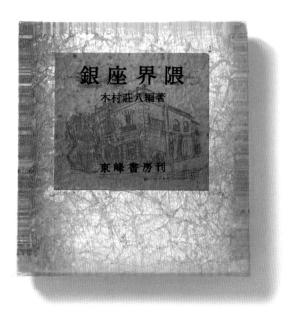

Ginza Kaiwai and Ginza Haccho

Shohachi Kimura and Yoshikazu Suzuki, 1954

Published in 1954, *Ginza Kaiwai and Ginza Haccho* is an outstanding achievement of the book arts. The boxed set consists of two volumes; the first, *Ginza Kaiwai,* is an extensive history of the neighborhood of Ginza with text by Shohachi Kimura and illustrated with woodblock reproductions by Hiroshige, photographs, drawings, and maps. Alongside this conventional book is a concertina volume, *Ginza Haccho,* with two parallel photographic panoramas of every building on the avenue Ginza 8-chome between Shinbashi and Kurobashi bridges. Photographer Yoshikazu Suzuki pieced together over 200 images taken between November 1953 and spring 1954, taking care to maintain continuity of lighting and weather conditions. The result is astonishing. Suzuki collaged figures and cars to add to the dramatic portrayal; at least one area looks as though it was hand-drawn or retouched. Except for two joints where sections of the paper are sutured together, the visual field is almost seamless.

The neighborhood depicted is an upscale retail-shopping district. Since the Meiji Era it had been known for its department stores, bars and restaurants with a western influence. During World War II firebombing inflicted substantial damage on

SPECIFICATIONS:
7.36 x 6.92 inches (closed), 7.16 x 17.40 inches, hardcover, accordion-fold, 364 pages, two volume box-set

EDITION:
unknown

PUBLISHER:
Toho Shuppan

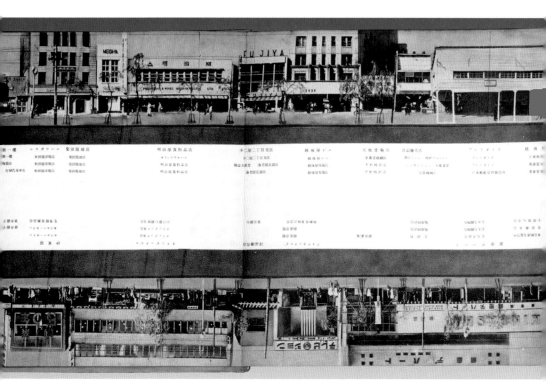

Ginza. Both of these histories are evident to some extent in the panoramic depictions. Businesses with names like Lion, Apollo, and Tea & Lunch U.S. advertise "Fine Arts, Curios, High Class Furnitures." Younger, less developed trees line stretches of the avenue. It is difficult to tell how much of the human staffage was photographed in situ or populated later by photomontage, but the sidewalks are bustling and prosperous; one side of the street is noticeably busier than the other. Though the main road is empty of traffic, Suzuki has made sure that the intersecting streets are congested with automobiles. A sketch on the inside of the backboard shows a capped man smoking with his hands in his pocket: a postwar surveyor of street life.

Ginza Haccho appeared 13 years before Ruscha's *Every Building on the Sunset Strip*. Given the significant congruencies between the two publications, it is natural to speculate as to whether Ruscha was aware of, or could have been aware of, this remarkable predecessor. The conceptual structure of the continuous tracking

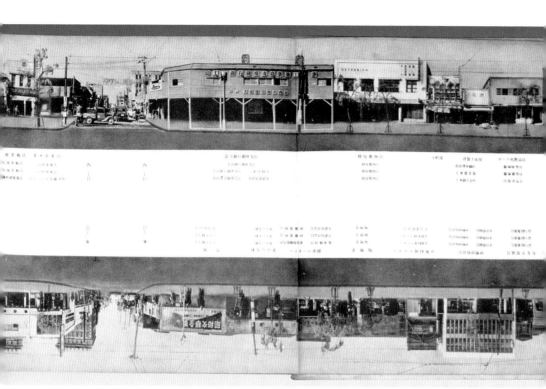

images, the accordion-fold format, and the texts below the
images coincide in both works. Pictorially, Suzuki's iteration is
a more meticulous construction; the images are carefully
integrated, and generally avoid the visual stutters and tonal
distinctions that mark the individual exposures in Ruscha's
book. Linking *Ginza Haccho* to Ruscha risks either anachronism
or attributing influence where perhaps none existed. Nevertheless,
a consideration of the relationship between Ruscha's publication
and Suzuki's is an appropriate way to begin examining how the
projects that follow in this volume function both autonomously
and with reference to Ruscha.

Burning Small Fires

Bruce Nauman, 1968

SPECIFICATIONS:

12.6 x 9.6 inches (closed)
49.2 x 36.81 inches,
poster, folded with
card cover

fifteen black and white
photographs recto only
on one large sheet

EDITION:

unnumbered

PUBLISHER:

self-published

The tradition of artists engaging Ed Ruscha's photobooks begins antagonistically. Bruce Nauman's *Burning Small Fires* is a single folded sheet illustrated with photographs that document the incineration of a copy of *Various Small Fires and Milk*. Each of the fifteen photographs, arrayed in a grid, presents one of the plates from Ruscha's book going up in flames. In each of the exposures except for one, the bound book can be seen lying open on the wood floor of the studio: the next victim awaiting its conflagration. In the last exposure we see the sixteenth and final plate of Ruscha's book, that of a glass of milk. This picture Nauman has spared. Bracketing the survival of *"Milk,"* the premise of Nauman's project is the catalytic conversion of representation into action: every picture of fire begets a burning. An inert glass of milk has no comparable verb to act as a linguistic instruction — one cannot drink a picture — so it becomes the period upon which Nauman's pictorial-performative parroting must arrest. Similarly, the blank pages of *Various Small Fires*, so important to Ruscha's books, make no appearance here. The intervals have been elided.

Even as he opens a sequence of objects initiated by Ruscha's books, Nauman's interpretation of representation as mandate is

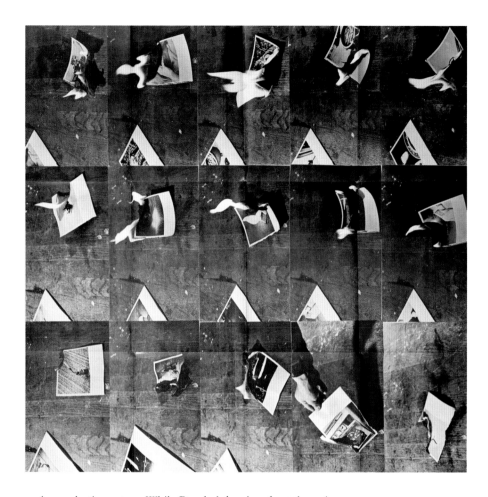

an iconoclastic gesture. While Ruscha's books adopt the guise of non-creative art-making, Nauman pushes further, to the point of art-making by destruction. Engaging the work of his contemporary in such a manner, Nauman seemed to anticipate his work's affect. Folded up, the front cover reads, "urning all ires." This clever word play (the homophone of the verb *earn* and the noun *urn*, with its association of burning), signals the provocation of directly addressing another artist's work, realizing that such engagement is potentially nonreciprocal and nonconsensual. Although this piece is emphatically humorous, not all references are affirmations, and the wry gesture is always predicated on a perversion.

LEARNING
FROM
LAS VEGAS

Robert Venturi Denise Scott Brown Steven Izenour

Learning from Las Vegas

Robert Venturi, Denise Scott Brown, Steven Izenour, 1972

The seminal book *Learning from Las Vegas* exhorts architects to take pop-culture building forms seriously, specifically advocating a design paradigm of the "decorated shed." In the work of Ed Ruscha, Robert Venturi, Denise Scott Brown, and Steven Izenour identified a sympathetic admirer of the visual forms specific to the commercial strips proliferating across the country. The authors confess, "The image of the commercial strip is chaos." And yet they continued, "There *is* an order along the sides of the highway." The highway, they argued, was the independent variable that organized the system. In the text, Ruscha was listed among architectural historians and theorists such as Reyner Banham and J.B. Jackson as inspirations for the precepts of *Learning from Las Vegas* because of their explication of "related images" of architecture. What such writers accomplish with words, Ruscha realizes with graphic images: artworks like *Every Building on the Sunset Strip* visually articulate theories about architecture and the organization of urban visual experience. Furthermore, the ideas promulgated in *Learning from Las Vegas* accord with Ruscha's practice of highlighting common, overlooked elements of the built landscape such as gas stations, parking lots, swimming pools, and ubiquitous, non-native palm trees – not to mention the apartments and office buildings where most people actually live and work. Venturi, Scott Brown, and Izenour went so far as to include "[a]n 'Edward Ruscha' elevation of the [Las Vegas] strip" using the format of *Every Building on the Sunset Strip*. Their version is distinct from Ruscha's in that, besides spanning across a single unfolded page layout in several rows, the border of the panorama is not uniform, but rather contains irregular edges that emphasize individual photographic exposures. The panoramic elevation view was only one of many visual strategies used to illustrate *Learning from Las Vegas*. Street views of filling stations appear alongside sequences of cinema stills and matrix-like "schedules" of plan and elevation design elements for each casino. Within this eclectic approach to establishing an emerging order of the Las Vegas Strip, the authors were sure to emphasize that "[b]uildings are also signs."

SPECIFICATIONS: 14.50 x 10.50 inches, hardcover, printed wrappers, with glassine, 188 pages
EDITION: 2000 **PUBLISHER:** MIT Press

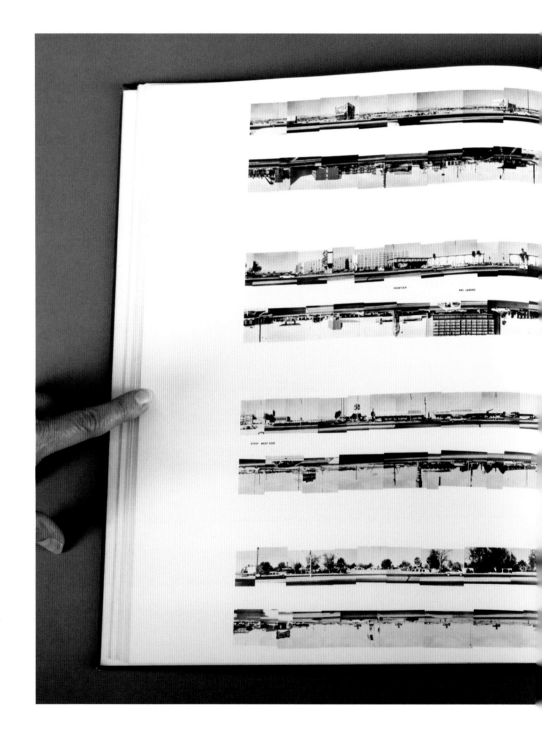

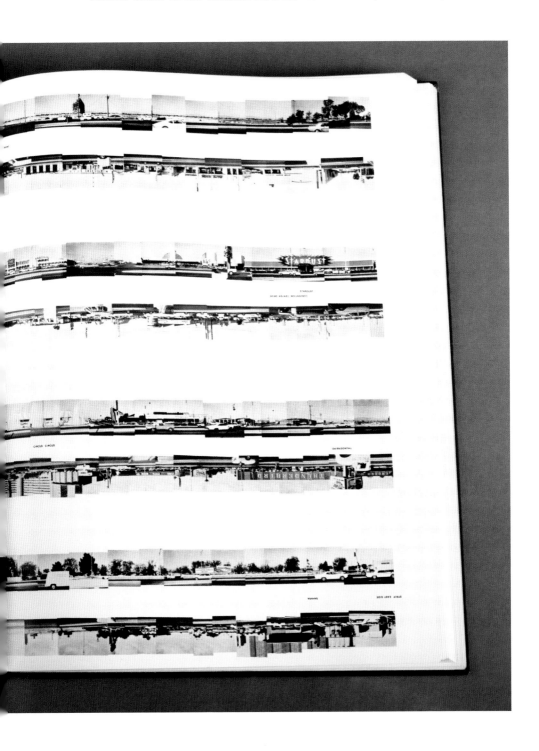

Eminent Erections
David John Russ, 1985

SPECIFICATIONS:
8.26 x 5.82 inches,
softcover, 46 pages

EDITION:
400

PUBLISHER:
Solid Productions

Confronted with this early Ruscha-inspired book, a reviewer pondered why "Australians emulate Ruscha or Rauschenberg, when they have so much going for them from their own culture?" Even the alliterative quality of the artists' names seemed irksome. Certainly David John Russ, working down under in Queensland at that time, adapted the cover design of Ruscha's photo-novel *Crackers,* based on a story by Mason Williams. Feeling mislead by the hijinks of Russ's title, the reviewer complained, "Alas, this bookwork has nothing to do with sex, but in fact more with a sequence of telephone poles!" Tightly composed at sharp angles that emphasize the graphic character of the poles, the 30 photographs on the inside look as though they could be drawn from the oeuvre of Paul Strand. Nevertheless, the title *Eminent Erections* underscores the phallic quality of this subject. Whether the poles are themselves the "erections" or rather index the "eminent" construction of buildings to which they conduct utility services, Russ subtly infuses the built landscape with a psychosexual dimension. What unconscious desires are manifested in industrial design and architecture? What fetishes are fulfilled through the libidinal economies of rampant real estate development? With Russ as a model, it is certainly possible to reconsider Ruscha's cutout palm trees and "colored" cacti; why not also the evidence of pyromania and a compulsion to collect stains (such as sperm, urine, milk and Vaseline)? In *Crackers,* debauchery is self-evident in the "maximum enjoyment" derived from salad, many gallons of dressing, and a naked woman tossed altogether in a cheaply rented bed. Perhaps Russ's innuendo is predicated on the pleasantly deferred gratification experienced while one drives to buy a package of saltines.

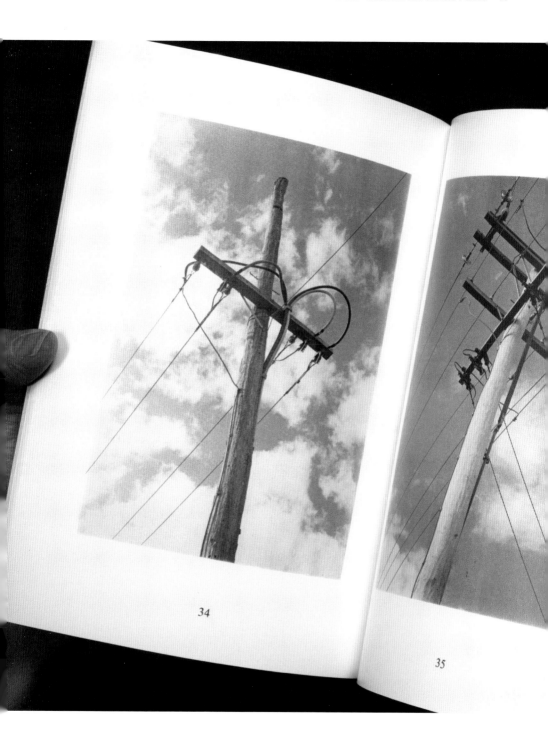

L.H. Lives Here

Maurizio Nannucci, 1987

SPECIFICATIONS:
8.25 x 5.8 inches,
softcover, 104 pages

EDITION:
900

PUBLISHER:
Art Metropole,
Ottenhausen Verlag

"The art community is distinguished by continuous movement, by a sort of visceral nomadism," Maurizio Nannucci writes in his book, *L.H. (Lives Here).* Having been involved in the publication of his own and others' artist's books throughout his career, with this work Nannucci conflates artistic community and creative production by documenting the exteriors of artists' homes. The title functions as a predicate applicable to the artist-subject named in each caption, so that "(Artist X) *Lives Here*" is the implicitly repeated statement running through the book. Arranged alphabetically from (Laurie) Anderson to (Gilberto) Zorio, and stretching from Cologne to Toronto, the photographs map Nannucci's own peripatetic lifestyle over a period of 15 years. Like John Tremblay's collection of business cards, Nannucci's project functions as a pictorial address book of friendships and associations, connections which are personal as well as artistic.

La Bohème this is not: most of the artists' residences are respectable looking dwellings. Even poet John Giorno's address on the Bowery across from the New Museum has become respectable 25 years later. Many of the artists are well-known, even canonical, today, recognizable on the circuit of biennials

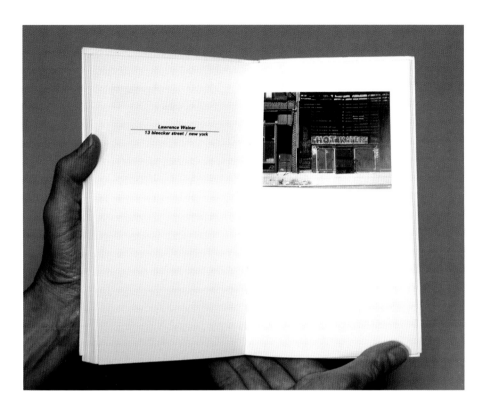

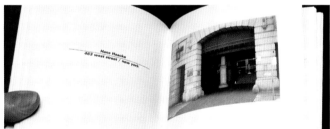

and museum retrospectives, art fairs and auctions. Ruscha's
onetime home at 1024 ¾ North Western Avenue in Los Angeles
is included, and he is singled out for special thanks in the
acknowledgments. Otherwise the book's debt to Ruscha is less
explicit than in other projects collected in this volume. Never-
theless, the deadpan style of depiction, the motifs of real estate
and artist migration, and the parameter-defining function of the
title all resonate with Ruscha's work.

1991-2000

Twentynine Palms
Jeff Brouws, 1991

SPECIFICATIONS:
7 x 5 inches,
softcover, 62 pages

EDITION:
1

PUBLISHER:
Gas-N-Go Publications /
Hand-Job Press

As an early manifestation of his interest in vernacular signage and what Walker Evans termed the "historical contemporary," Jeff Brouws's *Twentynine Palms* draws its titular directive from the California town situated outside Joshua Tree National Park in the Mojave Desert. Brouws has a different form of palm in mind, assembling a typology of signs promoting those roadside mystics who claim access to a higher knowledge writ in the lines of a hand. In an accompanying essay, Brouws writes that it is "still 1956 on Highway 41," evoking Robert Frank's cross-country road trip of that year that resulted in *The Americans.* The pictures here point to a related concern with collective spiritual and emotional anomie, of anchorless travelers in search of elusive truths. Icon and symbol, the outstretched hand is simultaneously supplication and offering. Like many of the signs he photographs, Brouws's book is itself hand-wrought, with saturated c-prints pasted onto individual pages. A note warns, "This book has been assembled with wax and spray glue and should be kept away from heat. In the event of nuclear war this book will vaporize." Ruscha has said that "Words have temperatures for me… Usually I catch them before they get too hot." Brouws is on to something similar. Combining tongue-in-cheek nuclear paranoia with an eye for the polysemy of the open road, he maps an alternate, mystical topography of the American cultural landscape.

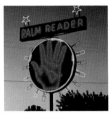

 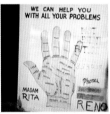

 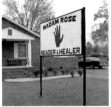

 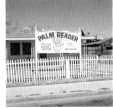 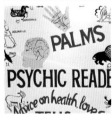 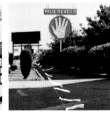

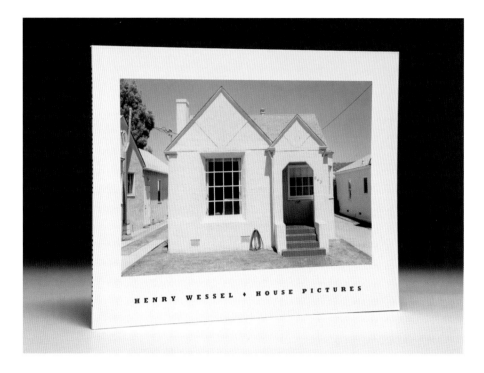

House Pictures
Henry Wessel, 1992

SPECIFICATIONS:
8.5 x 11 inches,
softcover, 32 pages

EDITION:
500

PUBLISHER:
Fraenkel Gallery

An oft-repeated anecdote of artistic origins: in 1956, when Henry Wessel was fourteen years old, he reportedly had his first consequential encounter with photography in the unlikely but apt setting of his mother's real estate office in New Jersey. The enduring influence of that early impression is most explicit in the photographs of houses taken by Wessel near his present residence of Richmond, California and the surrounding area between 1990 and 1991. For his 1992 exhibition *House Pictures* at Fraenkel Gallery in San Francisco, 25 of the pictures were illustrated in the catalogue featured here. The artist subsequently released a limited edition portfolio with the Ruscha-esque title *Forty Real Estate Photographs*. This too was followed by *Real Estate Photographs*, a stand-alone book within *Henry Wessel: Five Books* (Steidl, 2006), this time with 32 images.

Regardless of the covers that bound this series, Wessel's images are alternately humorous and distressing. Many of the modest houses are meticulously well kept. Others have fallen into various states of disrepair, their lawns overgrown or their

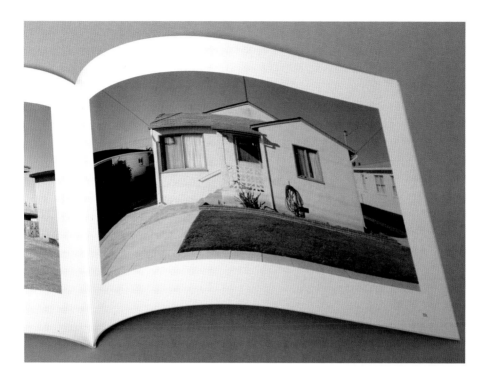

windows boarded up, the texture of faded coats of paint baked by years in the southern California sun. Pattern recognition commences, piecing together a world with sidewalks and buildings set close to the street, in which strange geometries emerge from the common forms of gables, facades, and garages. Simultaneously, salient details emerge. The eye alights upon tchotchkes arranged on a windowsill, the logo of a security alarm system, a cooler parked on the roadside directly before the door, or oil spills in the driveway. Each photograph, Wessel says, "is a platform for hundreds of discrete facts," coalescing into a pictorial history of these individual residences, as well as of this shipbuilding town that reached its economic apogee during World War II.

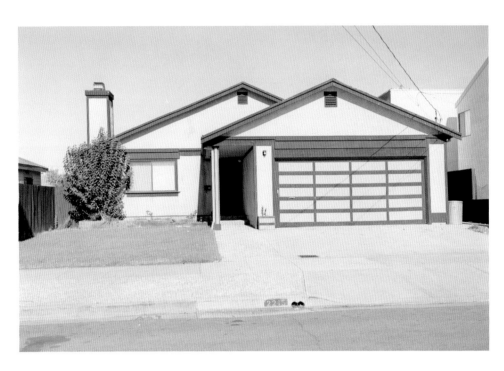

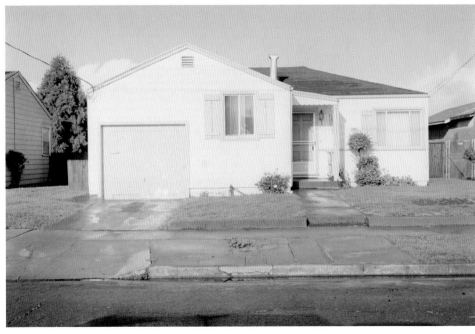

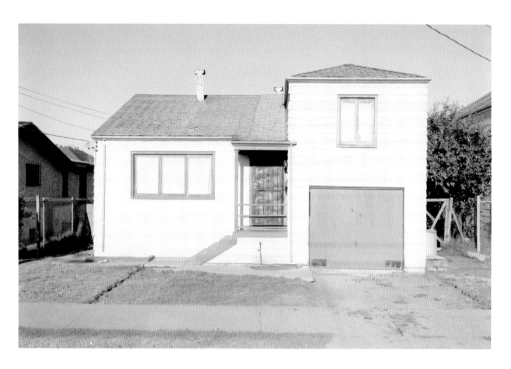

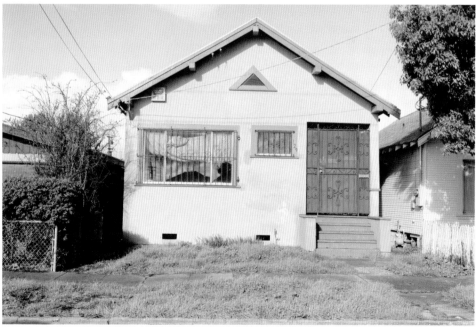

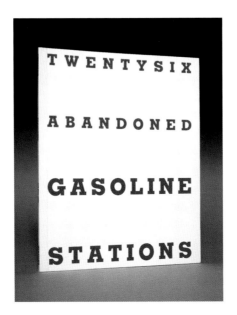

Twentysix Abandoned Gasoline Stations
Jeff Brouws, 1992

SPECIFICATIONS:
7 x 5 inches,
softcover, printed
wrappers with glassine,
48 pages

EDITION:
1000

PUBLISHER:
Gas-N-Go Publications /
Hand-Job Press

In the 1980s new federal regulations handed down by the Environmental Protection Agency required many gas stations to replace aging underground fuel tanks. The capital costs associated with this ordinance exceeded the resources of many small, independent station owners, forcing them to discontinue service. Jeff Brouws had begun photographing abandoned gas stations years earlier, but the project took on a new documentary valence when reporting by the *Los Angeles Times* suggested that large oil companies had colluded with the EPA to enact regulations that put competitors out of business. "I dig gas stations," Brouws has written, and in fact the earliest photograph in this volume, *Fairplay, Colorado*, was taken in 1974, long before he knew of Ruscha or considered himself a photographer. Gas stations were not only way-posts on the road to the wider world, they were places of social converse and the sites that awakened Brouws to graphic design and modern architecture.

The 26 structures collected here, excepting the earliest, were all found in California. The design, concept and structure of the book mimic Ruscha's publication, but it is not a rephotographic project. Shot over almost 20 years, the closed businesses represent a wide range of architectural styles, from

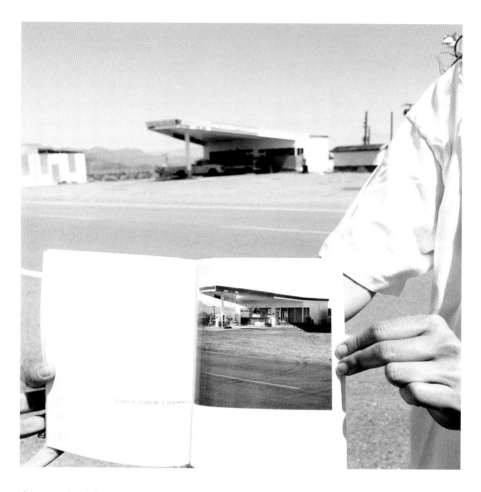

decorated sheds to sweeping modernist wing canopies to ranch-style assemblages of mechanic's garage and convenience store. Each of the distinctive architectural skeletons and their accompanying signage are the ruins of a cultural moment. Blight has not even escaped the titans of the petroleum industry; among the abandoned: Union 76, Exxon, Mobil, and Texaco. Without romanticizing their subject matter, the photographs ask us to consider the forces that have conspired to enact their construction and ultimately their subsequent abandonment. The back cover bears the brand logo of Mobil, accompanied by the searching question, "In our mobile society where does one go?"

A rephotograph of TAGS #19, *Union 76 in situ with same place from book,* Ludlow, California, 1991.

TAGS #19 is a gas station on Route 66 that Ruscha shot but did not include in his own book *Twentysix Gasoline Stations,* 1962.

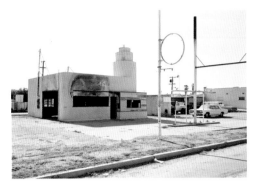
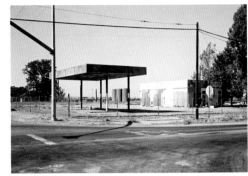
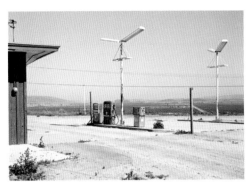

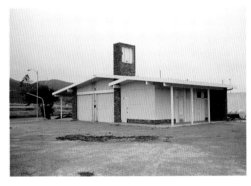
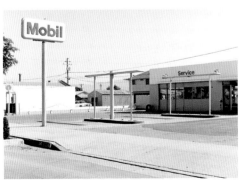
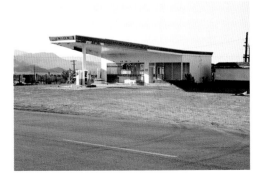

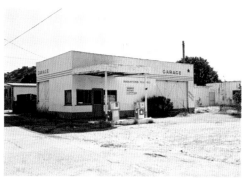

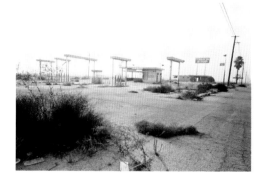

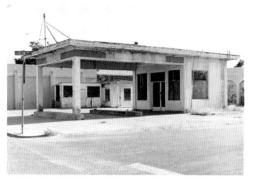

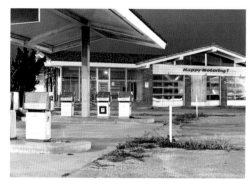

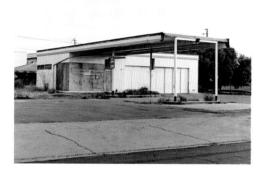

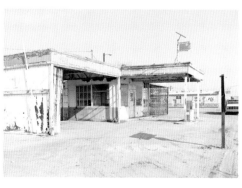

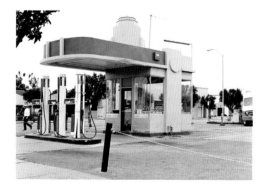

Parade Route

Robbert Flick, 1993

SPECIFICATIONS:

17 x 120 inches,
accordion-fold, in
9.5 x 17.25 x 1.75
inches slipcase

EDITION:

3

PUBLISHER:

self-published

As with *Every Building on the Sunset Strip*, Robbert Flick's *Parade Route* embraces the accordion-fold book format's structural prescription of movement: physically expanding in a manner that mimics its visual form. Using a car-mounted digital video camera for what amounts to a 5.5 mile dolly tracking shot, he captured what Ruscha called "continuous motorized photos" along the annual route for the Rose Parade in Pasadena, California. Flick retrospectively selected video stills that he arranged in dense grids of visual information. Rather than a linear projection of seamless images, the succession of disjointed and repetitive frames creates visual stutters and lacunae in the mapped surface. Such disturbances in the visual field register the subjective, mnemonic nature of Flick's project and draw attention to distinctive elements in the urban landscape. This representational strategy highlights bursts of color and repetitive patterns; flashy signage, peculiar architectural elements, and groups of pedestrians are all occasions for closer looking. At the same time, the capacity to apprehend so much detail comprehensively is impossible for any viewer. Reorienting the object of the spectator's gaze from the absent parade to the bordering sidewalks and architectural facades, Flick yokes the popular festival to the diverse neighborhoods it transverses, making visible the local politics of space. The result is a tabular photographic space, in which looking and reading are intertwined and the city becomes a surface for contemplation.

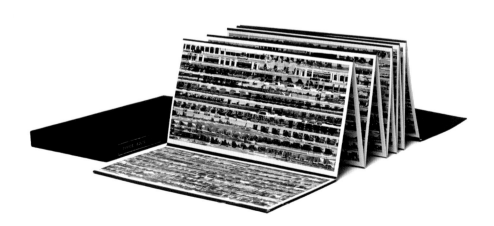

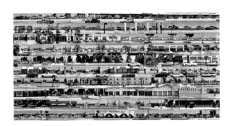

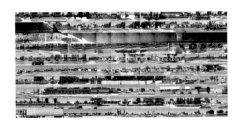

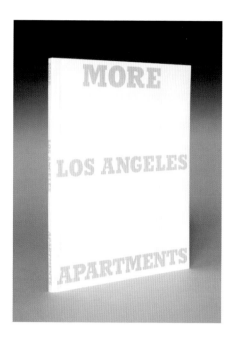

More Los Angeles Apartments
John O'Brian, 1998

SPECIFICATIONS:
7 x 5 inches, softcover, printed wrappers with glassine, 48 pages

EDITION:
1000

PUBLISHER:
VAFS / Collapse Editions

In the late 1990s art historian John O'Brian planned a scholarly work on Ruscha to be entitled *A Small Book About Various Small Books.* Realizing that, in his words, "a feeding frenzy was developing around Ruscha," O'Brian settled on a different tactic, instead producing an homage to engage the artist's work. The resultant book depicts all of the apartment buildings on the 200-block of South Normandie Avenue in Los Angeles, beginning with the odd numbered addresses along the west side of the street moving northward and then reversing course to portray the east side. A note at the end of the book points out that one of the apartments in Ruscha's book was the Capri at 118 North Normandie. For his part, all of the photographs in O'Brian's work were taken while staying at the home of art historian Sally Stein and artist Allan Sekula, just around the corner from the South Normandie 200-block.

More Los Angeles Apartments unfolds as a peripatetic meditation on Ruscha's photobooks, personally placing O'Brian in geographical and conceptual proximity to Ruscha's earlier work. Nevertheless, the differences are critical. Structured as a short walk, O'Brian's iteration functions more as an in-depth

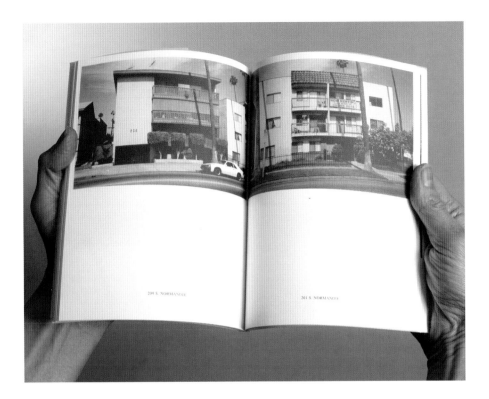

photographic survey of a specific location than a random
assortment of disparate structures. The final images are of a
rapid film developing and printing business with the Ruscha-
esque name Twenty Three Min Photo. Adorned with signage in
Korean and Filipino, this appears to be where the photographs
in the book were developed. (The photo developer seems to
have once been located on the street where Stein and Sekula
live.) Thus O'Brian reveals the conditions of production of
his book while creating a more inclusive representation of the
ethnically diverse population of Los Angeles. Even still, O'Brian
undermines any pretensions to pure documentary. Some images
are printed in color but look strangely unnatural, as though they
are hand tinted or were printed decades earlier and the colors
have shifted. The scale of the subjects and point of view vary
from picture to picture. Several apartment complexes are
depicted from multiple vantage points. Each of these strategies
denaturalizes the transparency of photographic representation.

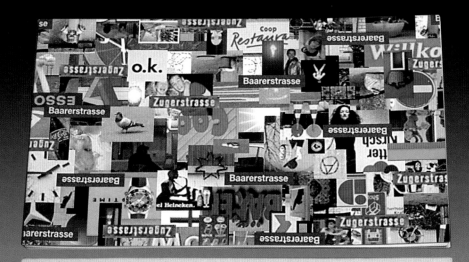

Zugerstrasse

J.F. Schnyder 1999-2000

Baarerstrasse

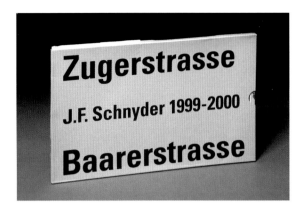

Zugerstrasse Baarerstrasse *Jean-Frédéric Schnyder*, 1999-2000

Two Swiss towns point to one another, the respective names of their main street directing the voyager to its counterpart: "In Zug it is the Baarerstrasse / In Baar it is Zugerstrasse." Jean-Frédéric Schnyder maps this union in his adaptation of *Every Building on the Sunset Strip*. Running north to south, the book tracks a 2.6 km stretch between the two towns, photographed over the course of 16 months. Although the meticulous depiction of the built environment points to the specificity of location, the book terminates in downtown Zug, home to a McDonald's — that icon of globalization and the eradication of cultural difference. Indeed the transition between Zug and Baar does not declare itself, the two villages no longer distinguished by a rural buffer. The artist's grandmother aphoristically declared, "When Zug and Baar have grown together, night falls." Schnyder seems to apply this bit of local wisdom to register the border symbolically, so that darkness abruptly descends on the picture at a major intersection. This is the most conspicuous mark of temporal discontinuity in the book. The headlights and taillights of passing vehicles streak the nocturnal zone, whereas elsewhere great care has been taken to scrub any signs of dynamism. The artist shot westward in the mornings and eastbound in the afternoons to calibrate uniform lighting conditions, declaring the sun his enemy. Having spent "one year with Photoshop in the world of pixels," Schnyder has created an urban surface that appears seamless, adopting impossible perspectives and seasonal anachronisms in a totalizing illusion.

SPECIFICATIONS: 8.66 x 14.17 inches (closed), 8.66 x 283.5 inches, softcover, accordion-fold
EDITION: unknown PUBLISHER: Edition Patrick Frey

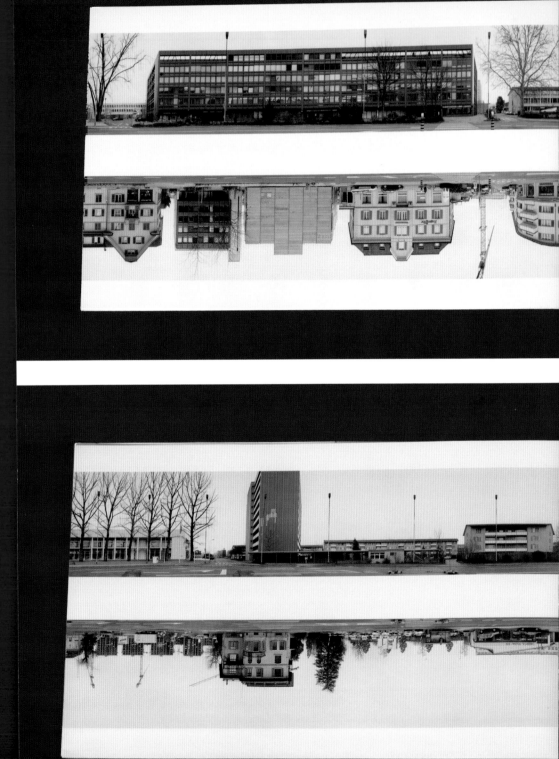

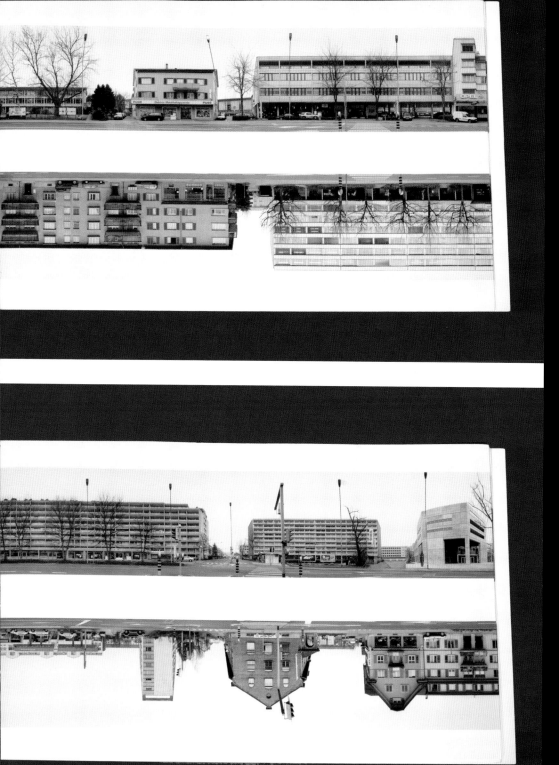

Macintosh Road Test

Corrine Carlson, Karen Henderson, and Marla Hlady, 2000

SPECIFICATIONS:
9.5 x 6.5 inches,
softcover, spiral-bound,
80 pages

EDITION:
100

PUBLISHER:
self-published

"It was too directly bound to its own anguish to be anything other than a cry of negation; carrying within itself the seeds of its own destruction." This quote, which Robert Smithson called "a note of counterfeit Russian nihilism," opens both *Royal Road Test* and *Macintosh Road Test*. The latter is a humorous shot-for-shot knock-off of the former. In this digital age edition the style of a forensic report is preserved, with a number of substitutions to the content. An obsolete Macintosh Plus computer takes the place of the original typewriter as the victim. The scene of the crime has moved north of the border to Canada and the perpetrators' genders have been switched. Each of the artists takes the roles of Ed Ruscha, Mason Williams and Patrick Blackwell as driver, thrower and photographer. Again, the weather was perfect. Sufficiently silly in the original, Corrine Carlson, Karen Henderson and Marla Hlady's do-over strives for absurdity verging on travesty. An odd photograph is captioned skeptically: "Karen Henderson's (left) left hand being examined by Corrine Carlson's (right) right hand over what's left of the computer. Right?" *Macintosh Road Test* suggests that perhaps imitations of counterfeits can indeed engender something entirely un-nihilistic.

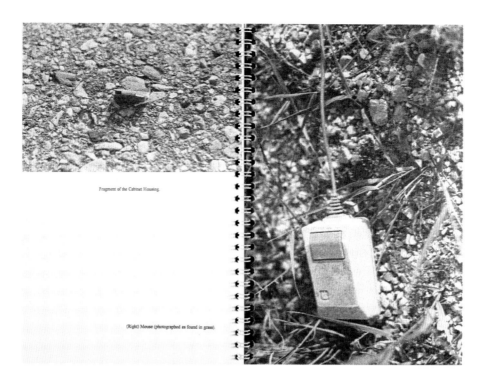

Fragment of the Cabinet Housing.

(Right) Mouse (photographed as found in grass).

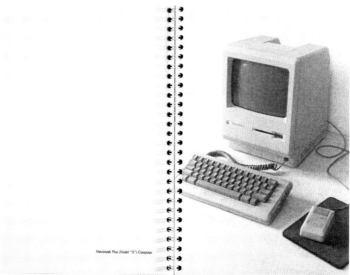

Macintosh Plus (Model "X") Computer

2002-2006

17 Parked Cars In Various Parking Lots Along Pacific Coast Highway Between My House and Ed Ruscha's

Mark Wyse, 2002

SPECIFICATIONS:
8 x 9.5 inches,
softcover, 40 pages

EDITION:
10

PUBLISHER:
self-published

Mark Wyse mixes the conceits of autobiography, conceptual wit, and art historical reverence in this photo essay, the title of which also nods to a canonical early work by John Baldessari. The cumulative effect is of time travel through pictures. The book opens with an aged snapshot of a young boy, perhaps the artist, holding up a small trout with some pride. Although Wyse does not disclose the specific origin and terminus of the journey or when exactly it took place, the cars portrayed are anachronistic in a contemporary context. Many of them seem like automotive dinosaurs, survivors from earlier decades. Cultural icons like the Volkswagen Bug, Ford Mustang, and Chevy Impala are included, most in need of serious bodywork. For his own part, Ruscha excluded cars from among his subjects, explaining that they "are too much like people." In fact, Wyse's photographs are similar to reverential portraits. All of the pictures are taken from extremely low angles — for some the camera was set directly on the ground — that make the cars appear monumental. Visually transporting the viewer back to the era in which Ruscha produced many of his photobooks and developed his signature style, this pictorial and geographical pilgrimage by Wyse (born 1970) charts a genealogical association with an artistic tradition that is roughly contemporaneous with his own birth. Rather than a dispassionate survey, the collection is obliquely but deeply personal.

None of the Buildings on Sunset Strip
Jonathan Monk, 2002

SPECIFICATIONS:
8 x 6 inches. softcover,
wrappers, 80 pages

EDITION:
500

PUBLISHER:
Revolver

As one proceeds through Jonathan Monk's *None of the Buildings on Sunset Strip*, the shadows cast by buildings, cars, street poles, and trees into the pictures grow progressively longer. Dusk has uniformly settled upon the scene by the end of the book. Thus Monk literalizes the temporality proposed by the place name of his geographic subject matter. In depicting the sun setting on the Sunset Strip, the artist underscores the hijinks he constructs in the relay between linguistic and pictorial representation. Such play is also a signature of Ruscha's practice, but the Ruscha original on which this work riffs was deliberately photographed under flat lighting conditions to realize the greatest possible tonal uniformity. This difference points up Monk's antonymic and diacritical mode of working over Ruscha's material; most notable here is the exchange of *None of the* for *Every* building on the Sunset Strip. Taking on an exclusive rather than inclusive approach to the material leads Monk to only photograph intersections on Sunset Boulevard. As a result, the emphasis shifts back on to individual exposures as instances of deliberate framing, and on the relationships constructed between images. A by-product of this tactic is that it surprisingly re-inscribes the iconic status of the Sunset Strip into the pictures; essentially banished by the banality of Ruscha's own photographic strip, here the celebrity of the location is made inescapable by the street signs at each crossroads. Monk's own symbolic encounter with Ruscha within the subject of one of the latter's iconic works is humorously figured as its own form of intersection, as a moment when their artistic practices cross, headed in different directions.

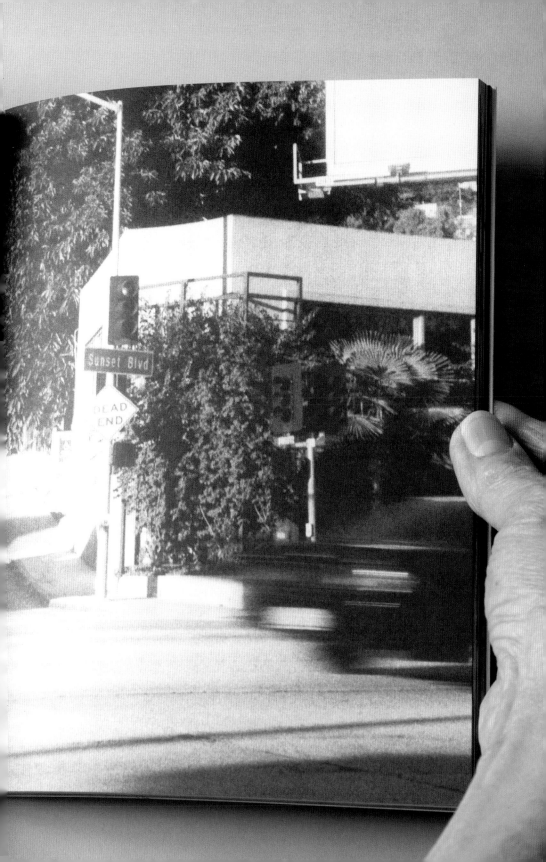

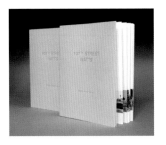

107th Street Watts

Edgar Arceneaux, 2003

SPECIFICATIONS:
7.5 x 6 inches (closed)
7.5 x 110 inches,
softcover, accordion-
fold, 48 pages, two
volumes in hardcover
slip box

EDITION:
1000

PUBLISHER:
Revolver

By offering an anti-sensationalistic, everyday portrayal of a highly mediated site, Edgar Arceneaux's artist book confronts the political valences of representation and visibility within a broader society. Photographed in the evening, the book adapts the continuous tracking shots of *Every Building on the Sunset Strip* to a self-contained block of 107th Street in Watts, California. Rather than two opposing bands of panoramic pictures, Arceneaux uses only one, starting from Simon Rodia's famous Watts Towers at the terminus of the dead-end street and panning down the south side of the block that is lined by single-family homes. At the end of the block the street is cut off by the train tracks of the Metro light rail; here the camera pivots and works back up the opposite side of the street, ending at the Watts Art Center.

A second volume contains essays by Charles Gaines, Lynell George, and Vincent Johnson, which help to contextualize Arceneaux's imagery within historical representations of Watts and the dearth of literature that deals with the area beyond the 1965 riots. Ruminating on the capacity of the photographs to spur personal memories and to challenge negative tropes that plague widespread conceptions of Watts, each of the essays buttresses the photographic content in constructing what Johnson calls "new critical histories of Los Angeles." *107th Street Watts* is only one aspect of Arceneaux's lengthy engagement with the neighborhood through the Watts House Project, a collaborative art endeavor that takes creative approaches to neighborhood redevelopment. With specific visual strategies like those deployed in *107th Street Watts* and a long-term commitment to the location, the artists involved offer positive counter-narratives as the basis for progressive action.

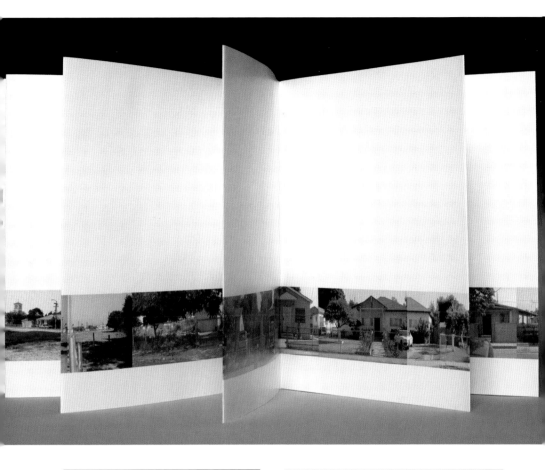

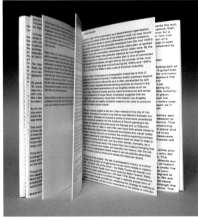

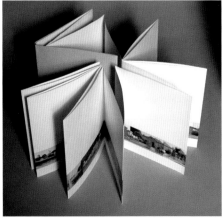

SPECIFICATIONS:

9.5 x 6.25 inches,
softcover, spiral bound,
80 pages

EDITION:

700

PUBLISHER:

Information as Material

Royal Road to the Unconscious

Simon Morris, 2003

In his *The Interpretation of Dreams*, Sigmund Freud wrote that,
"The interpretation of dreams is the royal road (*Via regia*) to a
knowledge of the unconscious activities of the mind." Artist
Simon Morris has (un)cannily assimilated this statement to
Ruscha's *Royal Road Test*. A squadron of students was enlisted
to individually cut out each of the 333,960 words from an
English translation of *The Interpretation of Dreams*. In accordance
with the therapeutic model of the talking cure, each word was
spoken aloud as it was excised. The text was then submitted to
the script of Ruscha's readymade model: the liberated words
were ejected out of the window of a speeding car, 122 miles
southwest of Freud's couch in London. Following this aleatory
event, "Dr. Howard Britton, psychoanalyst, directed the
photographers to any slippages or eruptions of the real that
occurred in the reconfigured text."

'In waking life the suppressed material in the mind is prevented from finding expression and is cut off from internal perception owing to the fact that the contradictions present in it are eliminated – one side being disposed of in favour of the other; but during the night, under the sway of an impetus towards the construction of compromises, this suppressed material finds methods and means of forcing its way into consciousness.

Flectere si nequeo superos, Acheronta movebo.

The interpretation of dreams is the royal road to a knowledge of the unconscious activities of the mind.'

Sigmund Freud, *The Interpretation of Dreams*, (ed.) James Strachey, Penguin Books, 1985

Though such folly would result in language being absolutely divorced from syntactical context, documentation of the trial yielded dubiously meaningful distributions of linguistic elements, such as "be. literature ideas [sic]". Such findings are classified as "road words," "flora words," and "isolated words," depending on where the text alighted. Such scientistic endeavors certainly have their effective limits; unacknowledged but assumed is the project's adherence to Tristan Tzara's 1920 instructions for composing a Dadaist poem. At the end of Morris's book it is reported that a pack of "Royals" cigarettes was found at the scene. A photograph of the artifact shows the litter with its government warning, "Smoking seriously harms you and others around you," face-up, flanked by the free floating words "eulogy" and "moment." Such findings are nothing if not overdetermined.

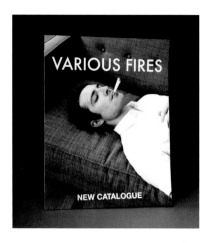

Various Fires

Battan / Sadler, New Catalogue, 2003

SPECIFICATIONS:
10.5 x 8.25 inches, softcover, archival inkjet handmade book, 26 pages

EDITION:
10 signed and numbered

PUBLISHER:
self-published

Various Fires was the first project by New Catalogue, a collaborative enterprise from Luke Batten and Jonathan Sadler. Consistent with their operative model of a stock photo agency, *Various Fires* culls disparate images collected under the subject tag "fire." The ponderous variety of imagery that can be incorporated under such a broad label calls into question the desirability and functionality of such a classificatory system. In contrast to Ruscha's model, these conflagrations are not necessarily all that small. The collection is eclectic: a stylish young woman poking at burning newspaper appears twice in minutely different exposures; the emanating visages of two jack-o-lanterns glow in an otherwise obscure setting; two men and a boy incinerate tree clippings in a rural backyard; a rakish man reclines on a mid-century modern tweed sofa smoking two cigarettes simultaneously. Satirical in nature, the mysterious clouds in several images call to mind the familiar axiom, "where there's smoke, there's fire" — displacing the ostensible subject outside the photographic frame. The connections between pictures are inscrutable, which is the point. As per the purpose of stock photography, these are images waiting to be re-appropriated, given a new context in which they might make sense. But rather than originating from multifarious sources, these photographs are the wily creations of an artistic team who effectively marshal the readymade registers of commercial photographic production.

SPECIFICATIONS:

8 x 6 inches, softcover,
perfect-bound, 120
pages, with postcard
printed of photograph
inserted in pocket in
inside front cover

EDITION:

unknown

PUBLISHER:

Arsenal Pulp Press

Every Building on 100 West Hastings
Stan Douglas, 2003

Although the title of *Every Building On 100 West Hastings* references
Ruscha's survey of the Sunset Strip, in fact Stan Douglas's
photograph and related publication function quite differently
from their namesake. The nearly sixteen-foot-long panoramic
color photo, made in 2001, depicts the entire stretch of one
side of the 100-block of West Hastings Street in Vancouver,
British Columbia, the artist's home. Called "the worst block in
Vancouver" by a reporter for the local *Sun* newspaper, this
stretch of the Downtown Eastside neighborhood is an infamous
skid row, blighted by drugs and skipped over by urban renewal.
Most of the buildings are adorned with signs advertising "For
Sale" and "For Lease." Douglas digitally stitched together 21
images taken over the course of a single night. Illuminated with
the help of specialized cinematic techniques, 100 West Hastings

appears as it never could in real life: devoid of human figures and composed in an artificially unified planar surface. Next to the visually stunning, high production value, limited edition photograph, the accompanying publication functions less as an autonomous wide-distribution work in the spirit of Ruscha than as a textual supplement to unpack the photograph. The 2002 book includes essays and archival photographs elucidating the social history specific to the 100-block and distinguishing it from the surrounding area. Finally, the publication includes a tri-fold poster insert, a miniature facsimile of the original large-scale titular photo that seems like a fragment of Ruscha's accordion-fold work. The implication is that this block contains enough history for a book of its own.

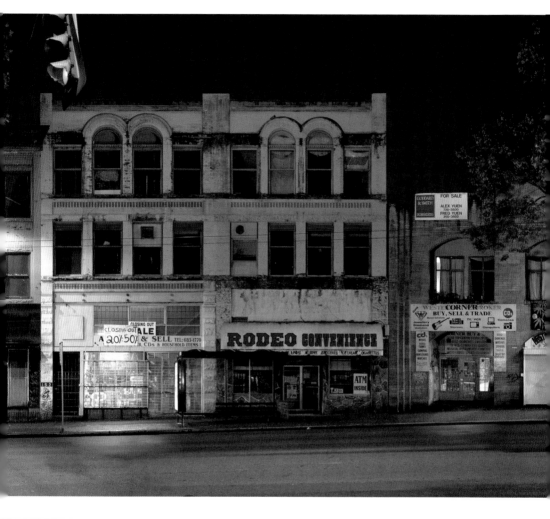

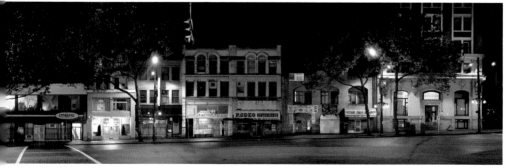

SPECIFICATIONS:

2 x 4 inches,
softcover, flip book,
82 pages

EDITION:

50

PUBLISHER:

self-published

Every Building on the Sunset Strip
Twentysix Gasoline Stations

Jonathan Lewis, 2003

In the annals of proto-cinematic technologies, the flipbook
stands as a transitional form, poised between the dominant
narrative medium of the book on the one hand and new
apparatuses of optical perception on the other. At the beginning
of the 21ˢᵗ century, it stands as an obsolete gimmick, but one
with remarkable endurance — at least in the kitsch registers of
gag-gifts and tourist shops. These two examples, by Jonathan
Lewis, stand as latter day souvenirs to canonical drives under-
taken by Ed Ruscha. *Twentysix Gasoline Stations* consists of
sequential images culled from the website Mapquest in which
the "starred" location moves progressively from Los Angeles

to Oklahoma City, presumably along the route Ruscha may
have taken on the road trip that resulted in his publication.
Satellite images drawn from the Internet also animate *Every
Building on the Sunset Strip*. Unlike Lewis's other flipbook, this
one actually depicts the subject matter of the Ruscha work,
albeit from an angle precisely perpendicular to the original.
Each of these slight diversions deals more with the historical
production than the content of Ruscha's books; they are pithy
records of road trips screened through the mediation of the
Internet age. Still, the choice of the flipbook format points to
an additional valence of commodification, in which the hagio-
graphic keepsake veers suggestively between appreciation
and irony.

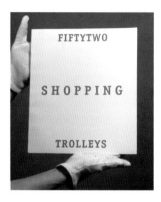

Fiftytwo Shopping Trolleys (in Parking Lots)
Tom Sowden, 2004

SPECIFICATIONS:

11.5 x 10 inches,
softcover, perfect-bound,
laser-printed with
screen-printed cover,
52 pages

EDITION:

15

PUBLISHER:

self-published

If we are truly honest with ourselves, Ed Ruscha would never say "shopping trolley." It comes as no surprise then that when perusing Tom Sowden's *Fiftytwo Shopping Trolleys (in Parking Lots)* one notes the preponderance of shopping "carts" from the UK-based Tesco stores mega-brand. Between zero and four trolleys adorn each page, where they are either centered or distributed in a two by two grid. Sowden has shot each at an oblique angle from above and excised the negative space surrounding each trolley, so that it appears to float on a white background. Despite its being "cut out" of its original photo-graphic context á la *Colored People* or *A Few Palm Trees*, each cart remains anchored to its specific location because of the transparency of their metal grid-frame construction. Painted parking spot lines, the pillar of a massive streetlight, bumpers and the edges of cars are all visible flanking the trolley. As a result, the pictures operate somewhere between pure product shots set against seamless backdrops and in situ documentation of *objets trouvés*. The more one looks at these trolleys, the more absurd they seem. A surprising variety of designs are represented, especially in handle shapes. Each cart is meticulously branded, with bold colors, store name, and of course space for advertising. A less cynical assessment might praise the shopping buggy as the apex of functionalist industrial design. But photographed by Sowden from a variety of orientations that emphasize the cantilevered legs and contorted wheels, the trolleys are endowed with surprising animation, such that they might be dancing across the page.

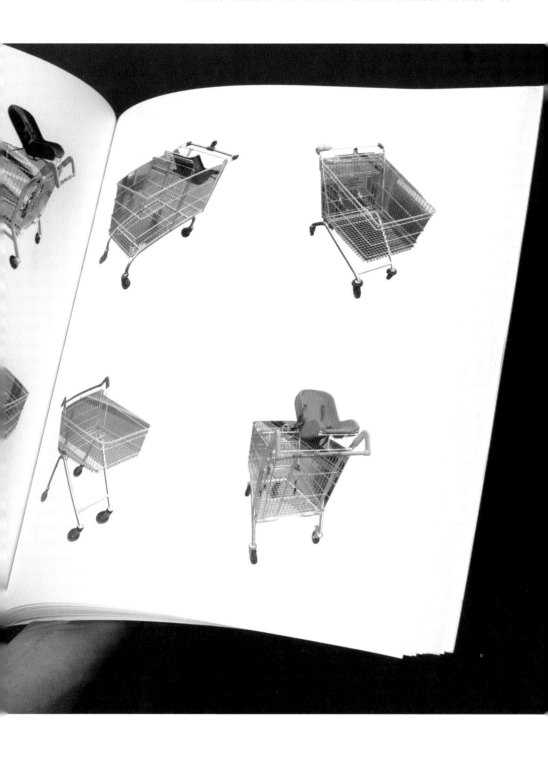

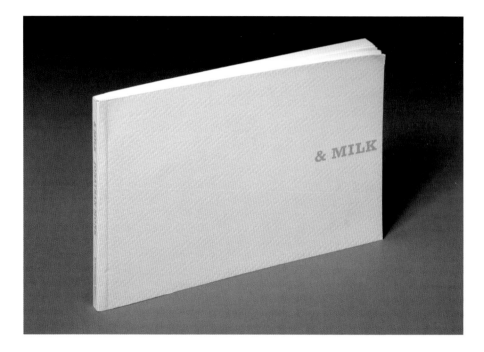

& Milk (Today is just a copy of yesterday)
Jonathan Monk, 2004

SPECIFICATIONS:
6 x 9 inches,
softcover, perfect-
bound, 64 pages

EDITION:
800

PUBLISHER:
Grazer Kunstverein

Following the title page of Jonathan Monk's *& Milk* is a band of text that wraps around the recto and verso of a single sheet, reading "Today is just a copy / of yesterday." By breaking apart the aphorism and necessitating turning the page, the typographical layout and elliptical preface pave the way for a project deeply concerned with issues of replication, generation, and temporality. Quite simply, Monk began with a single photographic exposure of a glass of milk; the 50 illustrations that follow all stem from this one. Adopting a daily routine, the original slide of the glass of milk begat another that was reproduced from it, and then this second slide gave birth to another, and so on. Colors progressively change, details become muddled, and the framing of pictorial space shifts ever so slightly. The perfectly benign, if unexciting, glass of milk at the beginning is transformed into a sickly container of glue. Using the publication as a dumb flipbook can animate this change.

Operating as a supplement to Jonathan Monk's exhibition *small fires burning (after Ed Ruscha after Bruce Nauman after)* at the Grazer Kunstverein, this volume is the pendant *non sequitur* to

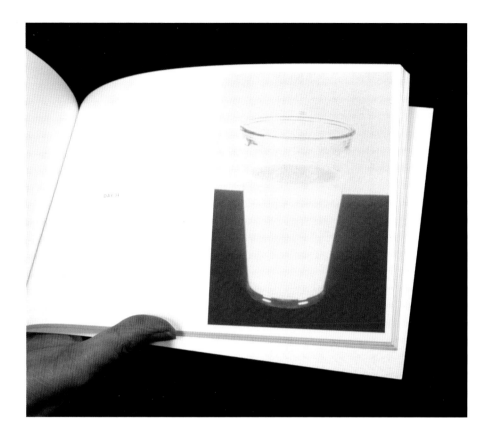

the film that gives the exhibition its name — in which Monk films a copy of *Various Small Fires & Milk* going up in flames, page by page. Monk's two works each approach mediation and degeneration through different means. Together they reproduce (or eclipse) the nominal content of Ruscha's book while also adapting Nauman's contribution to this sequence of objects.

An epigraph of sorts at the end of *& Milk* muses on the nature of copying, of duplications of duplications, and of the two hours required for developing photographic slides. This text is attributed to Fotolabor Kadmon, Wien — presumably the photo lab responsible for processing the slides. "After Ed Ruscha after Bruce Nauman after," indeed. Here, the agent responsible for the labor of production ascribes meaning to the work, so that Fotolabor Kadmon's essay further disperses the authorial and interpretative gestures of *& Milk*.

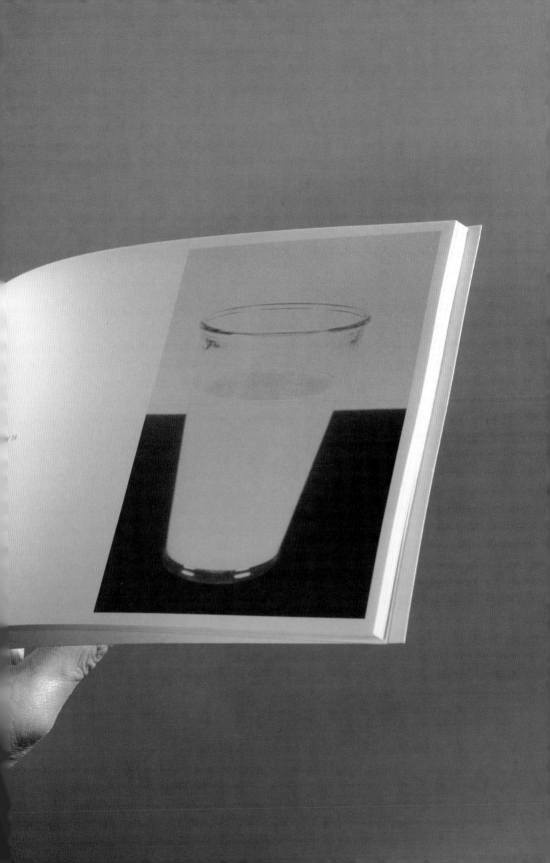

Picturing Ed: Jerry McMillan's Photographs of Ed Ruscha 1958-1972

Jerry McMillan, 2004

This collection of photographs by Jerry McMillan, the same size as many of Ruscha's books at 7 x 5.5 inches, shows another side of the photobook's history: that of the artist himself. Perhaps more accurately, it shows images of the persona that Ruscha was complicit in promoting. In character as sailor, cowboy, Okie, beatnik, rebel without a cause, beefcake, playboy (as well as, quite literally, bunny), and bohemian artist, Ruscha is revealed self-consciously hamming for the camera. Here he is presented as more than the deadpan documenter of the banal built land-scape. McMillan and Ruscha both hail from Oklahoma City. While each attended the Chouinard Art Institute, McMillan became increasingly interested in photography and would ask Ruscha to pose for him: "He was always a willing model." Although some of the photographs were taken at McMillan's instigation, others are clearly the result of Ruscha's own self-conception. There is a droll humor to many of the images, as though their campy staging is knowingly tongue-in-cheek. Several pictures show Ruscha overseeing production of his books or posing with the finished works. Evidently he was just as self-conscious in fashioning his persona as he was meticulous in creating his books.

SPECIFICATIONS:
7 x 5.5 inches, softcover, perfect-bound, 108 pages

EDITION:
1200

CONCEPT & DESIGN:
Craig Krull

PUBLISHER:
Craig Krull Gallery, Smart Art Press

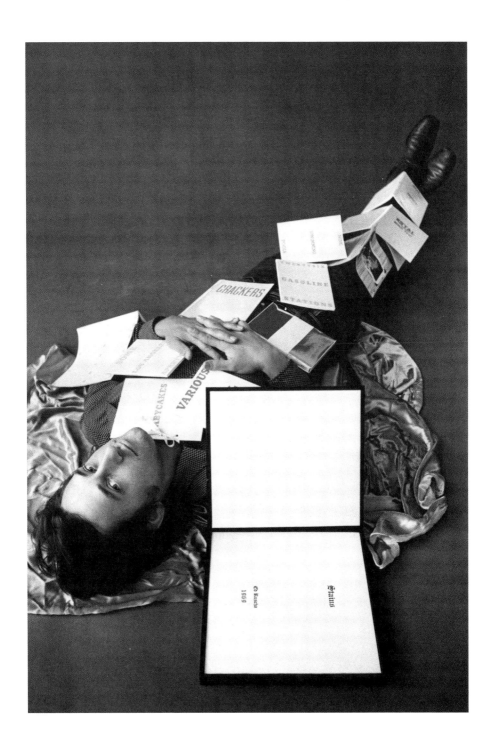

THIRTYSIX

FIRE

STATIONS

Thirtysix Fire Stations

Yann Sérandour, 2004

Conflating the subject matter and format of two Ruscha publications, Yann Sérandour's *Thirtysix Fire Stations* documents all of the municipal buildings in Montreal devoted to firefighting as of December 19, 2001. However, in undertaking his photographic inventory of the subject, the artist used location information gathered for government administration in 1999. Upon finding that during the intervening years three stations on the list had been closed for renovation, relocated, or demolished, Sérandour left the corresponding three pages vacant in the publication. Those fire stations that were in service occupy a wide variety of architectural structures. Having anticipated an occasion to return to the "empty" sites and complete the photographic survey, in 2005 he found that one of the stations had serendipitously become an artists' center with a special emphasis on architecture. Two years later the art center hosted an exhibition of Sérandour's project, with postcards of the three unpublished one-time fire stations serving as invitation cards, thus completing the long-gestating survey. Unintentionally tracing the capricious transformations of real estate and urban redevelopment, the omissions and subsequent additions to the project offer a telling document of historical change in their own right.

SPECIFICATIONS: 7 x 5.5 inches, softcover, printed wrappers with glassine, perfect-bound, 80 pages
EDITION: 600 **PUBLISHER:** self-published

73 КЪЩN
ОТ СИНЕМОРЕЦ
a photo-optical analysis by Dominik Hruza

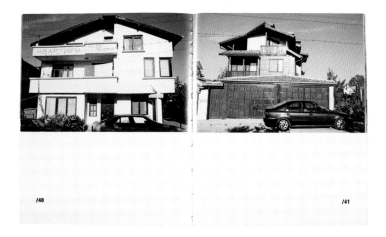

73 Häuser von Sinemoretz, a photo optical analysis
Dominik Hruza, 2004

Bathed in glowing evening light, several multistory structures are sparsely distributed across a rolling landscape of grassy golden plains. In the distance the azure sea peaks out from behind a bluff. A few perfunctory posts connected by wire outline the plot around a house. Little difference can be discerned between the sod driveway that accommodates a small automobile and the untamed fields around it. This scene introduces Dominik Hruza's "photo-optical analysis" of Sinemoretz, a Bulgarian village located on the Black Sea a short distance from the border with Turkey. Prior to 1989, when Bulgaria was within the ambit of Soviet influence, many of the residents of the town belonged to the Roma ethnic minority group, and most people subsisted on fishing and agricultural production. In subsequent years, political and economic upheavals produced an influx of investment capital, as outsiders flocked to the village to construct vacation homes and seaside resorts. The traces of this gradual transformation are evident throughout Hruza's survey of the extant built environment, which deploys frontal street views produced with a uniform focal length and depth of field. The book is organized in two sections of photographs taken in the evening and morning, corresponding to the eastern and western sides of the streets respectively, so that all of the buildings are frontally lit. Hruza considers the photographs sociological raw data that only take on significance when set in relation to one another. The work remains open-ended: the artist plans to repeat the project in 2014. A wide range of architecture is depicted, from pan-European villas to ad hoc shanties. The preponderance of Cyrillic signage suggests that this is far from the world of Ruscha. Yet the marks of the Euro zone are emblazoned in the German name of a bed and breakfast, translatable as "The Flying Dutchman."

SPECIFICATIONS: 6.75 x 5.75 inches, softcover, perfect-bound, 84 pages
EDITION: 150 **PUBLISHER:** self-published

Getting to Know the Neighbors *Jennifer Dalton,* 2004

SPECIFICATIONS:

6 x 7 x 11 x 1200
inches, softcover,
accordion-fold, book /
sculpture

EDITION:

1

PUBLISHER:

self-published,
Collection of
Michael Hoeh

In 2004, the Environmental Protection Agency listed nearly
400 potentially hazardous sites in the 11211 and 11222 zip
codes of Brooklyn's Williamsburg and Greenpoint neighborhoods.
Artist Jennifer Dalton visited each site, taking a photograph to
record the encounter and collecting them all in the handmade
artist's book, *Getting to Know the Neighbors*. Sites range widely,
from explicitly industrial businesses and retail storefronts such
as a dry cleaners, to public schools and high-rise apartments.
Each image is annotated with the address and date of Dalton's
visitation as well as the reason for it being an EPA regulated
facility — often the vague label "hazardous waste." Led by the
frontline colonization of the creative class, these North Brooklyn
neighborhoods were and continue to be transformed by an
influx of real estate development and gentrification. The process
is seemingly unchecked by the potential environmental threats
which might make the area less appealing to new residents
including the extensive oil spill contaminating Greenpoint's soil.
Inspired by *Every Building on the Sunset Strip*, Dalton's concertina
book was unfurled atop a custom table snaking through the
local Plus Ultra Gallery upon first display; extending over 100
feet in length, the format ensures that the viewing experience
simulates a virtual walk through the neighborhood. Despite the
muckraking subject matter, the title casts the artist as informed
resident conforming to proper social etiquette, all the while
doing her environmental due diligence on the neighborhood
she inhabits.

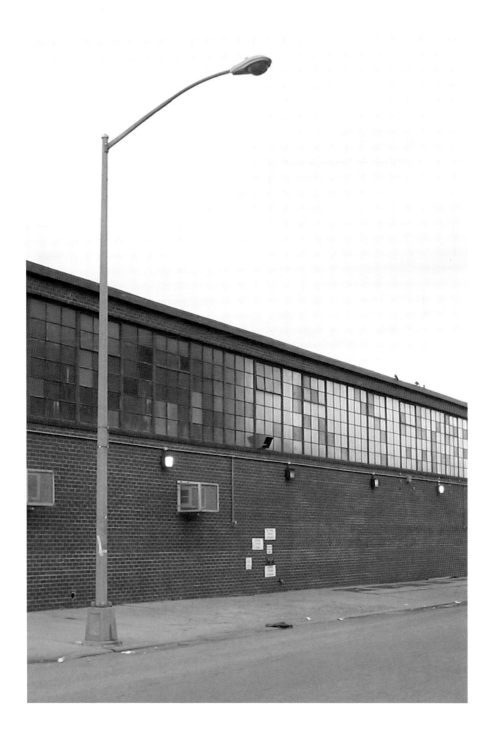

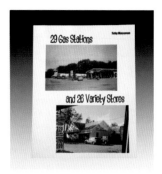

29 Gas Stations and 26 Variety Stores

Toby Mussman, 2005

SPECIFICATIONS:

11 x 8.5 inches,
softcover, perfect-
bound, 54 pages

EDITION:

unknown

PUBLISHER:

self-published

Anyone who has gone on a road trip is well aware of the
symbiotic relationship between filling stations and convenience
stores. As a result, the accounting gets a little fuzzy in Toby
Mussman's *29 Gas Stations and 26 Variety Stores*. The artist has
chosen to photograph variety stores in color and, like Ruscha,
gas stations in black and white, with one of each on every page,
except for the last, which includes two gas station images. But
some of the black and white images also include variety stores,
and some of the color photographs contain gas stations — no
surprise given the conjunction of gas stations and convenience
stores within a single business model. Whereas the gas stations
are almost exclusively multinational corporations like Getty,
Mobil, and Citgo, the variety stores are comprised of many
mom-and-pop operations. These have hand painted signs
advertising "Old Fashioned Ice Cream" or Vietnamese noodle
soup and international calling cards. The facade of an outfit
named Silly's is adorned with Einstein's iconic portrait, his tongue
fully distended. Mussman has an eye for such idiosyncratic
expressions of vernacular signage, staying away from the
interstate freeways in favor of small town highway-side
establishments. In many of the photos, one can see reflections
due to the artist shooting through the windshield of his car, and
unlike in Ruscha's gas station pictures, Mussman has included
human figures as well as other cars both parked and in transit.
Near the end of the book, a 7-Eleven appears in both the top
black and white space as well as the bottom color picture. Due
to differences in lighting and the camera's orientation, they
seem to be different franchises, but one cannot be sure.

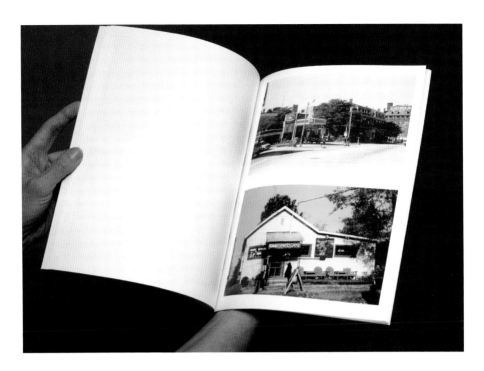

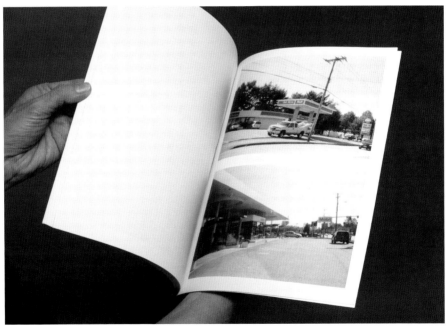

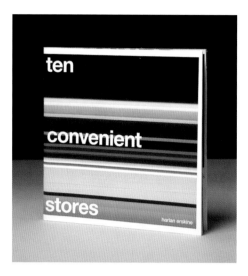

Ten Convenient Stores
Harlan Erskine, 2005

SPECIFICATIONS:
7 x 6.75 inches,
softcover, saddle-
stiched, 40 pages

EDITION:
100

PUBLISHER:
self-published

In the dark of night, a beacon emerges on the roadway: the convenience store. If this is our guide, what an ironic tribute to our cultural moment it is. The ten examples represented in Harlan Erskine's book were found in Miami-Dade County, Florida, but could be anywhere in the United States given the homogeneity of corporate consumerism and the loss of local identity figured in the architecture. Photographed at night, the bright illumination of the storefronts emerges from an obscure space, their windows plastered with beer and cigarette promotions, and in one case, wanted posters and perp sketches. Each photograph is followed by a full-bleed, two-page detail of the window facade in close-up, rendering all of the details of the advertisements and the product displays within. The surfeit of description, wrought with a large-format camera, testifies to the information overload of 24-hour availability. Drawing on Bernd and Hilla Becher's typological approach, Erskine's formal relationship to his subject matter is quite different than that posited by Ruscha's gasoline station snapshots. A fluorescent glow demarcates the threshold between interior and exterior, a haunting distance the photographs ultimately maintain. In contrast to the stasis of the pictures inside, the 7-Eleven awning emblazoned in a dynamic blur on the book's cover offers an altogether different outlook on the convenience store streaking by.

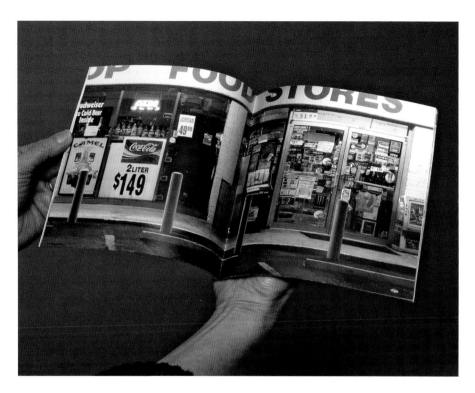

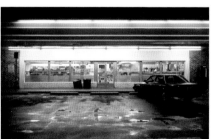

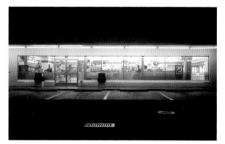

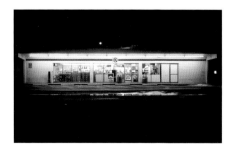

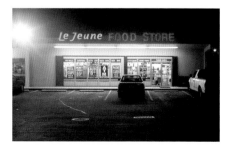

SPECIFICATIONS:
12.25 x 12.25 inches,
hardbound, 56 pages

EDITION:
unknown

PUBLISHER:
Nazraeli Press

The History of Photography Remix
Kota Ezawa, 2006

Kota Ezawa's *The History of Photography Remix* is a conceptual
photography book that does not contain any actual photographs.
Instead, Ezawa has rendered iconic photographs as drawings
using a simple style adapted from cartoon animation. The result-
ing project has been presented as a 35mm slide show, in Duratrans
transparency lightboxes of individual works, and in this book
published by Nazraeli Press. In a creative practice that is similar
to the writing of history, Ezawa uses archival sources as his
material. Photography, because of its ostensibly privileged
access to evidence of the past, provides the raw historical data
for this interpretative process, in which crafting an image functions
as a way of knowing. A wide range of applications of photog-
raphy is sampled, including both self-consciously aesthetic works
and photographs never intended as art.

At the heart of this method are questions about the nature
of communication and its applicability to different media.
Ezawa's reproductions precipitate considerable reductions of
the information carried by the picture. The images lose their
evidentiary status in the translation from photographic to

handcrafted media, but at the same time accumulate symbolic potential. The effect is particularly eerie with Ezawa's rendering of one of Ruscha's parking lots, *Church of Christ, 14655 Sherman Way, Van Nuys*. Leafy tree branches and their cast shadows, the darkest areas of the original photo, seem like ominous black clouds or a toxic spill spreading across the landscape. One recalls Ruscha's comment that the oil droppings on the ground were the most interesting aspect of the parking lots pictures.

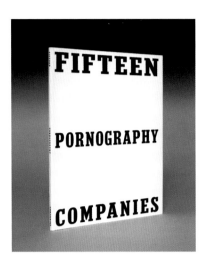

Fifteen Pornography Companies
Louisa Van Leer, 2006

SPECIFICATIONS:
7 x 5.5 inches, softcover,
perfect-bound, 40 pages,
in hardcover slipbox

EDITION:
500

PUBLISHER:
self-published with
grant funding from
CalArts

The pornography industry is one of the largest economies in the Los Angeles area, but it remains nearly invisible within the topography of the city. Louisa Van Leer set out to document this shadow industry by photographing the registered business addresses of fifteen companies involved in the production, distribution, and promotion of adult content in the San Fernando Valley. The banality of the locations marks a striking contrast with the sensationalized discourse around pornography. While some buildings have conspicuous signage identifying the proprietor, in many instances only the captions of the photograph hint at the nature of the business conducted within. The closest thing to a "money shot" comes from a lascivious bus station bench advertisement for the television show "Desperate Housewives" in front of VCA Entertainment. In another location, all of the visible addresses are clearly occupied, and by obvious retail businesses: a Popeye's restaurant, Sushi Dan, and a Pack-n-Mail. The mysterious placement of Pamela Peaks Productions is only clarified once one notices the sign for "Mailbox Rental — 24 Hour Access" at the Pack-n-Mail; presumably this service merely supplies the mailing address for the production company, while the locus of activity lies elsewhere. The cumulative effect of the photographs is to locate the literal *place* of pornography within the urban landscape of Los Angeles. Even pornographers, it would seem, go to work in a business park or commercial strip.

MARINA *PACIFIC*, VAN NUYS, CALIFORNIA

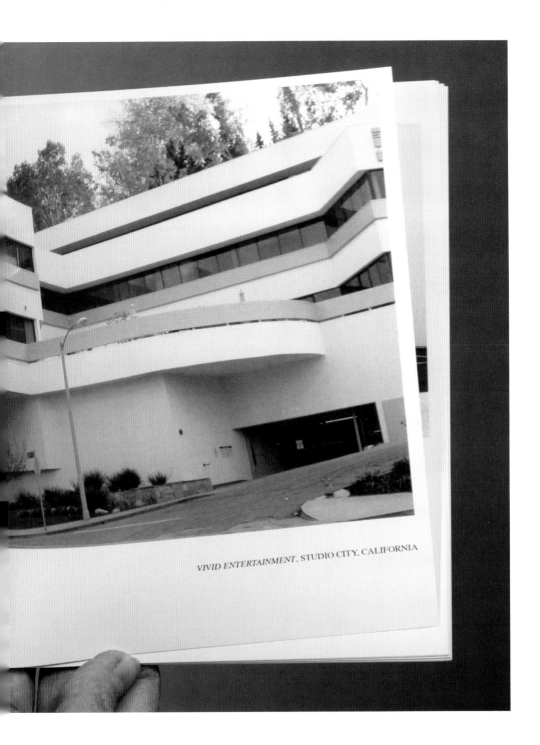

VIVID ENTERTAINMENT, STUDIO CITY, CALIFORNIA

Internal Combustion
(Twentysix Gasoline Stations)

Jan Freuchen, 2006

SPECIFICATIONS:

7 x 5.5 inches, perfect-
bound, 104 pages

EDITION:

500

PUBLISHER:

Norsk Kulturrad

A primitive bird trap stands on a snowy hilltop in one of Pieter Brueghel the Elder's famous paintings of early modern Dutch life. The simple construction consists of nothing more than a few planks of wood held up by a precarious post, below which bait lures the hunter's catch; with a simple movement the whole thing comes tumbling down, capturing the prey. This same figure introduces Jan Freuchen's *Internal Combustion,* and it establishes the morphological type for the first section of images that follows: 26 gasoline stations whose T-shaped canopies have toppled onto their sides, resembling nothing so much as that lean-to bird trap. Each of these hapless structures has failed under extreme weather conditions. The artist lifted the pictures from various Internet sources, settling on the final collection in order to achieve the greatest consistency within the typology. The next section of the book, "Internal Combustion," is a mash-up of found images and documentation of the artist's works. It includes a "utopian oil tower" based on Vladimir Tatlin's *Monument to the Third International;* here as well strong formal analogies reverberate between disparate subjects. Pillaging a range of cultural archives and historical events that loosely connect to his art objects, Freuchen traces connections between these images and the themes of ecological collapse, climate change, and disaster capitalism. Like one of Brueghel's proverbs, the suggestion of human folly is clear, as our most cherished dependencies set the traps that ensnare us.

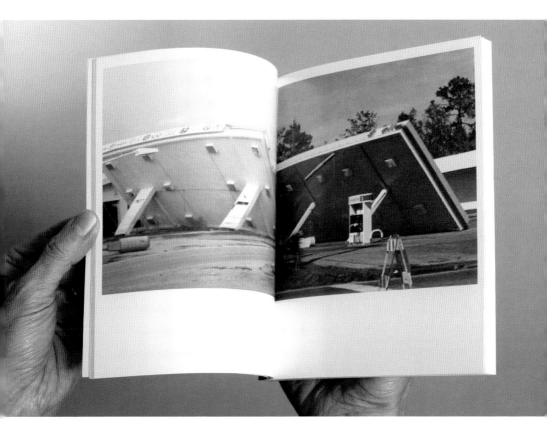

SEVEN

SUNS

JEN DENIKE

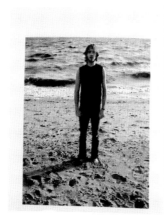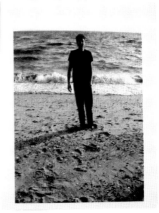

Seven Suns *Jen DeNike, 2006*

Two glassine sheathed front and back "covers" face-off in the middle of Jen DeNike's *Seven Suns*, forming the nexus of two otherwise structurally discreet publications. The first of these conjoined books features seven video stills distributed across 48 pages, respectively drawn from each of the seven channels of the artist's 2005 video installation, *Seasons in the Sun*. Each vertical image depicts a young man standing barefoot in the sand at a waterfront location. Their figures cast long shadows from the setting sun. Such an arrangement at least in still images invariably calls to mind Rineke Dijkstra's well-known portraits of awkward adolescents backed by seascapes. Yet DeNike's work shares little of the unqualified gravity of this antecedent. Here the subjects are caught with their mouths agape, apparently in mid-song: the video work from which the stills are extracted consists of each performer singing the 1970s hit single that gives the video its title, a ballad of a dying man saying farewell to friends and relatives. (The video installation also includes seven glass urns.) The theme is taken up more explicitly in the "second" book, adorned with the title "Five Artists / Two Writers / On Mortality." Any expectation of sober reflection on the topic is vanquished by artist Peter Coffin's contribution, an irreverent riff on a Bruce Nauman neon sign, which consists of the words "Blah, Blah, Blah, Blah, Blah, Blah, Blah, Blah Mystic Truths" unfurling in a spiral. When one realizes that seven *sons* unquestionably sing the seven renditions of "Seasons in the Sun," the word play of the titles further underscores the ambivalence towards the "pop" expression of supposedly serious concepts, which always risks veering into kitsch sentimentality.

SPECIFICATIONS: 7 x 5.5 inches, softcover, printed wrappers with glassine, perfect-bound, 96 pages
EDITION: 1000 PUBLISHER: The New Center of Contemporary Art, Louisville, Kentucky / Oliver Kamm 5BE Gallery

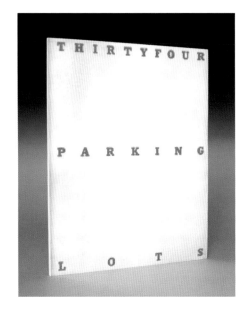

SPECIFICATIONS:

9.75 x 7.75 inches,
perfect-bound, 50 pages

EDITION:

100, signed & numbered;
plus open edition

PUBLISHER:

self-published

Thirtyfour Parking Lots on Google Earth

Hermann Zschiegner, 2006

In 2006 Google Earth was released for Mac operating systems. The year before Ruscha's *Then & Now: Hollywood Boulevard 1973-2004* had been published. Prior to that the musical provocateur Danger Mouse had produced the mash-up album *The Grey Album* using a capella vocals from rapper Jay-Z's *The Black Album* and samples from the Beatles' *The White Album*. Technological capability complemented a culture of historicity and remixing. Throw in the advent of Blurb's online print-on-demand self-publishing service, and Hermann Zschiegner had all of the necessary elements for conceptualizing a new version of Ruscha's *Thirtyfour Parking Lots*. The prototype included addresses for each of the subjects depicted; it was only left to the 21st century replicator to input these coordinates into the software, and a new image of the location was produced. Zschiegner's book strives to be as true to the original as possible, although he has maintained a number of artifacts of the digital production process: the photographs have not been rotated to match the orientation of the originals, and the book is printed in color. Additionally, Ruscha described one of the sites as merely "Unidentified Lot, Reseda." Nodding to this lacuna, the corresponding spread is left empty here.

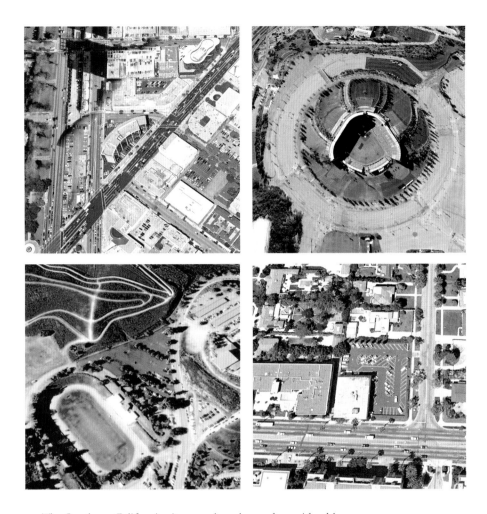

The Southern California cityscape has changed considerably in the intervening decades; it is apposite that the modes of production and distribution of pictorial imagery have also been transformed. Google Earth superimposes visual data accumulated from a variety of sources including satellite and aerial photography. Pursuant to this collagist method of pictorial modeling, Zschiegner's book registers some of the seams in what otherwise seems a totalizing technological gaze, places in which incompatible perspectives converge on the same topography.

149 Business Cards *John Tremblay,* 2006

Quaint though it may seem, long before we became friends on Facebook or shared connections on LinkedIn, two people might exchange business cards to mark their new acquaintance. This book reproduces one such token on each page. Crinkled, stained and worn, each was collected by artist John Tremblay over an indeterminate period of time. Thus the book functions as an archive of his relationships, as well as a functional Rolodex. However, this collection lacks any apparent organization for privileging particular people or businesses. As much as the reader may attempt to construct a biographical portrait of Tremblay, there is no way of knowing if each card corresponds to a close relationship or a chance meeting, soon forgotten. Cards for a gentleman's club and a homicide detective provoke particular interest among the litany of artists, curators and art dealers, restaurants, bars and auto mechanics. One artist evidently not in Tremblay's immediate network: Ed Ruscha, who nevertheless receives a tip of the hat in the acknowledgments at the end, no doubt in recognition of his *Business Cards*, 1968, in collaboration with Billy Al Bengston. Among the assembly is a business card for Loeffler Intercoms, whose address on the card became the home of Printed Matter, the famous non-profit promoter of artists' publications, where Tremblay's book and many of the other projects featured in *this* book are distributed. One wonders what contingency brought Tremblay in search of intercoms. Every card suggests a possible story, but this book is ultimately non-narrative.

SPECIFICATIONS: 8.85 x 5.5 inches, softcover, perfect-bound, 148 pages
EDITION: 250 PUBLISHER: One Star Press

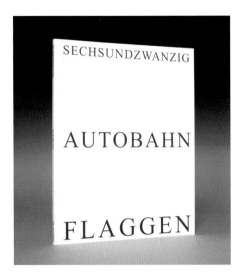

Sechsundzwanzig Autobahn Flaggen
Michalis Pichler, 2006

In 2006 Germany hosted the World Cup, arguably the most passionately followed international sporting event. Understandably, the home fans were inspired to show their support for *Die Nationalmannschaft*, the national team, which finished a respectable, if disappointing, third overall in the tournament. That summer Michalis Pichler photographed car-mounted German national flags along the side of the autobahn that had become unanchored from their chariots. Twenty-six of these orphans are included in this book, which is a conceptual crossover of Ruscha's book and John Baldessari's *The Backs of All the Trucks Passed While Driving from Los Angeles to Santa Barbara, California, Sunday, 20 January, 1963.* There is a certain bravura to photographing these accidents found by the sides of the road. Driving at high speeds does not permit much compositional deliberation between the moment of spotting the banner and snapping an exposure, regardless of if the photographer is also at the wheel. Spotting the flags remains difficult even within a still image. One lies at the base of a statue of the Berlin bear, the heraldic animal of the city. The collection of flags takes on symbolic significance as allegories of nationalistic pride. Perhaps some were jettisoned in rage following a stinging defeat. Others undoubtedly were stripped from their moorings at high speed in an occasion of Icarian hubris.

SPECIFICATIONS:
7 x 5.5 inches, printed wrappers with glassine, perfect-bound, 32 pages

EDITION:
600

PUBLISHER
Revolver

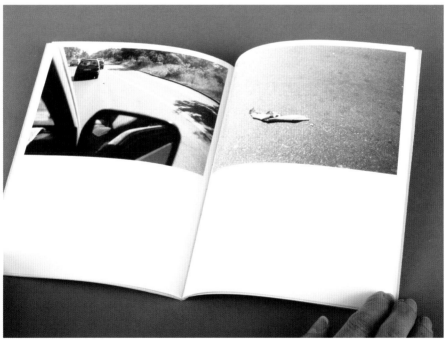

2007-2008

SPECIFICATIONS:
7 x 5.5 inches,
softcover, perfect-
bound, 48 pages

EDITION:
open

PUBLISHER:
self-published

Thirtyfour Parking Lots, Forty Years Later
Susan Porteous, 2007

Just to be clear, given Ruscha's predilection for ambiguous language and word play, in Susan Porteous's *Thirtyfour Parking Lots, Forty Years Later* it is the parking lots that have aged. This is not a book about how a photobook physically ages as an object (we can imagine what that might look like as well), but rather how the referents in the world submit to the passage of time. Porteous has updated the captions to reflect the changes in business and place names; for instance, a drive-in movie theater on West 3rd Street has made way for The Grove luxury shopping mall. At 10 by 8 inches, Ruscha's version was printed somewhat larger than his other books of the period. Porteous chose to stick to the smaller format in part because of the low resolution of her satellite image sources, which are widely available, although the credit page notes that the images are used without permission. The image quality is variable, and in many of the reproductions the halftone raster dots can be discerned. While Porteous is loyal to her model, even keeping the images in black and white, the image format has been changed in some cases, perhaps accommodating the shift in

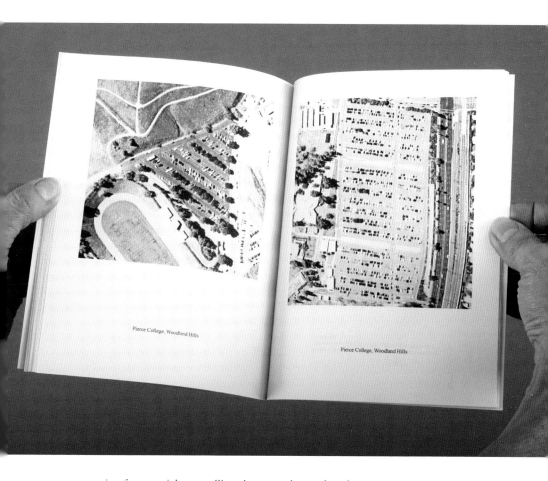

Pierce College, Woodland Hills

Pierce College, Woodland Hills

perspective from aerial to satellite photography so that the surface area depicted remains consistent with the earlier picture. Such fidelity to the original leads back to the question of the aging book and how, beyond its aesthetic and historical value, the book's data comes with an expiration date, subject to obsolescence and replaceable with more current information.

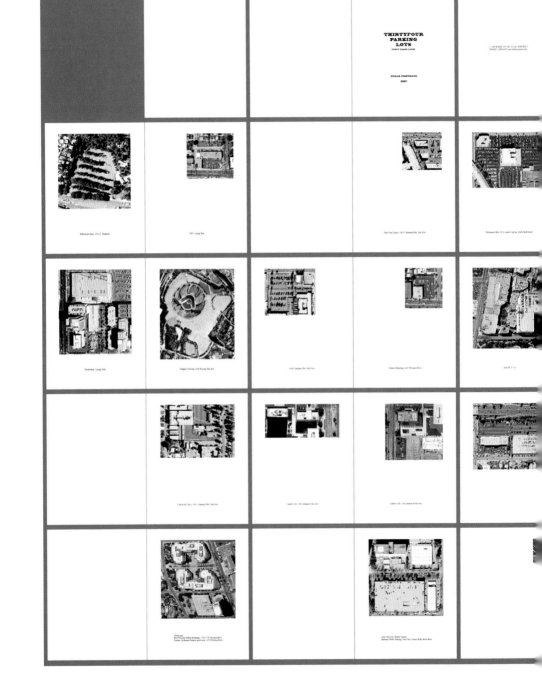

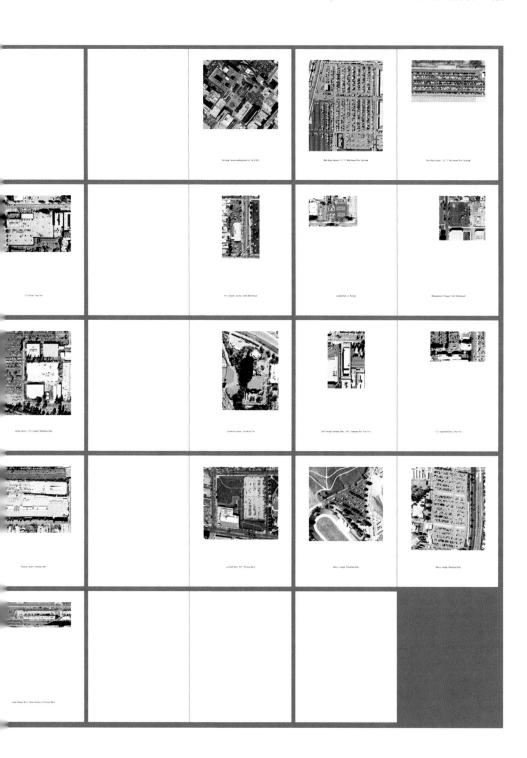

SPECIFICATIONS:

8.18 x 8.25 inches, softcover, perfect-bound, 62 pages

EDITION:

unknown

PUBLISHER:

self-published

Twenty-Four Former Filling Stations

Frank Eye, 2007

Upon receiving a copy of *Twenty-Four Former Filling Stations,* Ed Ruscha reportedly replied that it was "very British." Indeed. Frank Eye, "Image Maker," was the photographic pseudonym of one Charlie Hadfield. "Frank Eye" then might be a personal maxim as much as an authorial title. The twenty-four photographs in this edition are edited from a much larger archive, *444 Former Filling Stations, made in England in winter 2005/06,* and a note explains that the book "reflects the demise of small petrol retailers, mirroring changes in Frank Eye's own circumstances." Shot on overcast and drizzily days, an elegiac and melancholic tone suffuses the pictures. Pre-globalization filling stations haunt high street corners and lonely highway shoulders, the sense of passing time accentuated by slow-exposures in which the traces of spectral bodies drift through foggy streets. Fittingly, the epigraph is taken from Ovid's *Metamorphoses*: "What was before / Is left behind: what never was is now; / And every passing moment is renewed." Almost all of the photographs survey the ruins from across the road as though across a Stygian stream, the frank eye unflinching before the scene.

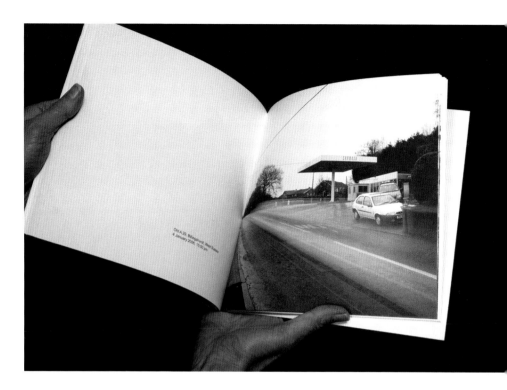

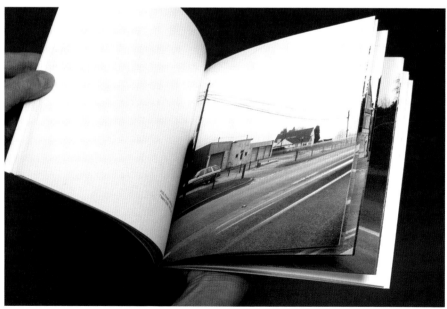

Every Mailbox On The Read Road
Reinhard Voigt, 2007

Reinhard Voigt, primarily a painter, has taken an idiosyncratic approach to his depiction of Read Road in the town of Red Hook, New York. A single band of images, flush to one another but without simulating a continuous surface, extends across the concertina folds of the book. Each of the images is composed such that the address numbers on a single box can be read, and the final picture of #129 provides a view back down the road towards a string of letterboxes from previous photographs. Seen against Ruscha's famous model, there is an explicit contrast between rural and urban organizations of space and time. Here, mailboxes metonymically index invisible buildings set back from the road, while inserting the address captions directly into the picture. In emphasizing these linguistic markers in the landscape, Voigt makes it a *road* that is *read* (but not *red*) in the form of a book.

Read Road is not so long, with not all so many mailboxes. But the photographs in this book were taken at all different times of day, and in all different seasons. The temporal disparity underscores the narrative aspect of the book, marking the photographic essay as a slowly gestating project in opposition to the drive-by attitude of Ruscha's cosmopolitan antecedent. One senses that Voigt has walked this road many times, returning once and again until the spirit strikes, and a picture is made.

SPECIFICATIONS:
7 x 5.5 inches,
accordion-fold
with hardcover slipcase

EDITION:
11

PUBLISHER:
self-published

Valley View Avenue at East Side of Santa Ana Freeway, La Mirada

Occupied Plots, Abandoned Futures - Twelve (former) Real Estate Opportunities

Occupied Plots, Abandoned Futures:
12 (former) Real Estate Opportunities

Joachim Koester, 2007

In revisiting the locations of Ruscha's presumptive *Real Estate Opportunities* 37 years after the fact, Joachim Koester's *Occupied Plots, Abandoned Futures: 12 (former) Real Estate Opportunities* raises the specter of what has been foreclosed — both regarding the sites documented and for artistic practices more generally. In some ways Koester's project stands as a straightforward venture into re-photography, so that the images testify to the changes time has wrought on a particular location. As the artist says, these are "spaces that by now have been sold, bought, built up and changed." But Koester's presentation suggests that one extend the re-photographic reading further.

In a related series, *histories* (2003-05), Ruscha was one of six seminal conceptual artists whose work Koester re-created, displaying the original images and his contemporary iterations side by side – including a single image from *Some Los Angeles Apartments*. With *Occupied Plots, Abandoned Futures*, Koester withholds the source image that would allow a parallel comparison in the manner of Ruscha's own *Then & Now*. While largely adopting the image and caption layout of *Real Estate Opportunities*, here the images are horizontal rather than square format, and each is underwritten by the title of the work as a whole, so that serialization and titling are simultaneously mantra and brand name. Koester eschews the distribution model of the book altogether, opting for elegantly printed silver gelatin prints from a large-format camera, framed on the gallery wall.

Only twelve of the 25 properties Ruscha selected have been retained. Koester describes his return to these locations as "engag[ing] in an archaeology of abandoned futures." In identifying the historicist construction of the work, the archaeological implies the loss and irretrievability of some aspect of the material. Ruscha's urban voids were highlighted for their latent potential, at the same time that he valued his books for the "Huh?" effect they provoked. Both the medium and the message of transmission had a critical indeterminacy to them that Koester implicitly suggests may now be impractical. His detail-rich prints embrace the contingency of each site, inviting a consideration of the processes that bind past and present. Koester describes the empty lots in terms of "psychic territory" and the "unconscious zone of the city." Accordingly, to re-photograph these places of lost opportunities might represent a return to the scene of an unresolved trauma.

Black and white silver-gelatin photogaph with text, 11 x 13.75 (image), 24.5 x 20.5 (framed), Galerie Jan Mot, Brussels, Belgium, 2007

Installation view of *Occupied Plots, Abandoned Futures: 12 (former) Real Estate Opportunities*,
twelve framed black and white silver-gelatin photogaphs with text, Galerie Jan Mot, Brussels, Belgium, 2007

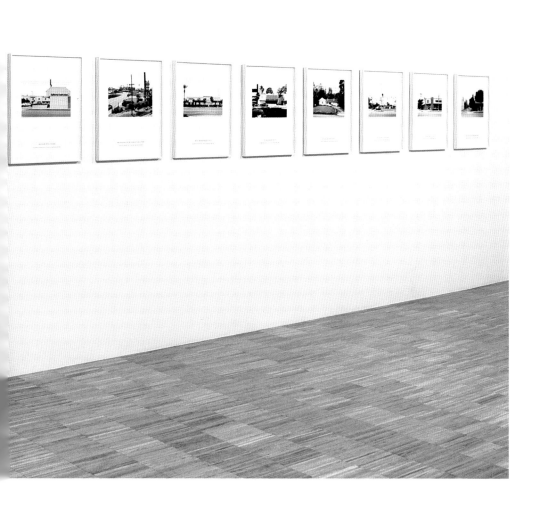

VINGT-SIX

STATIONS

(revisitée)

SERVICE

SPECIFICATIONS:
7 x 5.25 inches,
accordion-fold with
hardcover slipcase,
28 pages

EDITION:
5 + 1AP

PUBLISHER:
self-published

Vingt-Six Stations Service *(revisitée)*
Kai-Olaf Hesse, 2007

Kai-Olaf Hesse's beautifully photographed book opens with a striking, Lee Friedlander-like picture that tightly crops a section of a car, a monumental equestrian statue, and the Eiffel Tower in receding order. A photograph showing the supersonic Concorde airplane follows. This sequence progresses through modes of assisted transport — from horse to automobile to airplane — while the camera moves away from the tower as a symbol of industrialization. The book traces the *Route Bleue* from Paris to Menton, France, a roadway with strong cultural associations in some ways comparable to Route 66 in the United States. It too has been largely replaced with a major freeway. Hesse allows himself significant freedom within Ruscha's model, eschewing typology while emphasizing the culture of the road and the thematic of movement. Numerous photographs do not depict gas stations.

As the opening sequence suggests, this is a trip through historical time as well as through geographical space, revisiting a series of cultural mythologies. Service stations that are

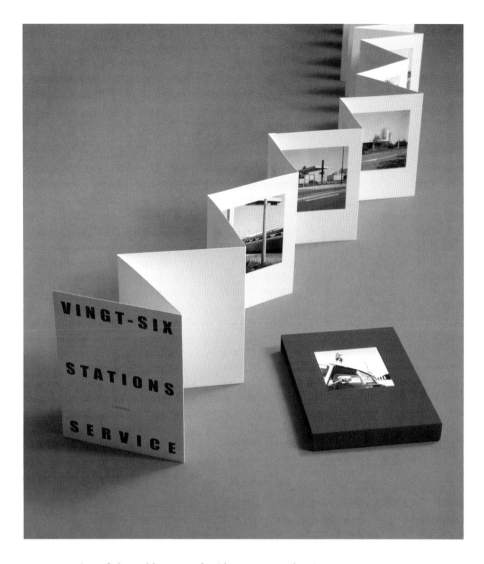

representative of the golden age of mid-century modernist gas stations are depicted, some long since closed. Like the Concorde, their aerospace-inspired designs are redolent of promising new frontiers for exploration and discovery. That our present age precludes such prospects is manifest in the metaphoric significance of Hesse's strategy of compositional framing: walls, fences, wires and other barriers repeatedly frustrate the camera's ability to obtain an unobstructed view.

Several Split Fountains and a Jack
Daniel Mellis, 2007

The phrase "several split fountains" accords with the ambiguous poetic language used by Ruscha, but also describes a technique of color application in color printing. Daniel Mellis was learning split fountain printing, which produces a smooth blending of colors in an even gradient, when he decided to utilize the process to parody the elder master. Ruscha first used the technique himself in the 1966 screenprint version of *Standard Station*, the now iconic motif inaugurated by *Twentysix Gasoline Stations*, and the gradual blending of colors reminiscent of postcard Hollywood sunsets and groundless backdrops recurred in his paintings, works on paper, and prints in the years that followed. For his part, Mellis combines these references, mimicking the typographical identity of Ruscha's first book, right down to the dedication to Patty Callahan. But Mellis diverges from his model on the final page with a jack from a 19th century French deck of playing cards that serves as his occasional printer's trademark.

Leaving the printing matrix of his letterpress blank so that the entire plate was inked, each of the split fountains is a sensuous rectangle of color bleeds. Still, irregularities in the ink rollers rupture the seamless apprehension of the vertical distribution of color by revealing the horizontal rolling motion of ink application. Like rock concert posters awaiting text or Ruscha paintings stripped of their bouncing objects and punning words, it stands to debate whether or not Mellis's inky fields are pictures at all. Splits abound: the ex-girlfriend of a 40-year-old dedication recalled, the ground without the figure to adorn it. All in all, it's the work of a knave.

SPECIFICATIONS:
11 x 8.66 inches, softcover, saddle-stitched, 36 pages

EDITION:
20

PUBLISHER:
Jack of All Trades Press

Hard Light

Rinata Kajumova and Achim Riechers, 2007

Hard Light, a 1978 Ruscha collaboration with Lawrence Weiner, is perhaps the least lucid cinematic storyboard ever, and one of the stranger books in Ruscha's oeuvre. This version by Rinata Kajumova and Achim Riechers does not make the narrative any less enigmatic. The uncaptioned photographs depict a mysterious sequence of events involving three young women, here staged in Volograd, Russia rather than Los Angeles, California. In several chapters taken up from Ruscha, pairs of the women engage in conversation on a waterfront, sit in a kitchen, drink from teacups, and dine at a sushi restaurant. Nothing very much seems to happen. Any drama discerned in minute gestures and expressions can hardly be resolved into meaningful interpretation. Unlike the original, there is no text to elucidate or further obfuscate the story; the adaptation is shot in color instead of black and white, but otherwise hews closely to the compositions and staging of its model. Absent the dialogue that would surely make these scenes more intelligible, the focus shifts to the details of the mise-en-scène, but it is questionable if cultural and historical specificity matter when interpretation remains absurd in any event. Both iterations of *Hard Light* are deliberately impoverished vehicles of narrative. Kajumova and Riechers's version pushes further, so that translation and exportation are ironically allegorized. Although the message seems to arrive in cross-cultural transmission, its meaning has been lost, if ever it existed.

SPECIFICATIONS: 7.5 x 5 inches, softcover, perfect-bound, 68 pages
EDITION: 300 PUBLISHER: self-published

Sixtytwo
Gasoline Stations

Gabriel Lester

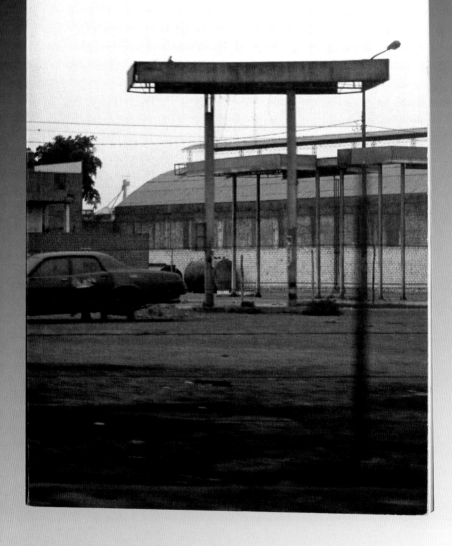

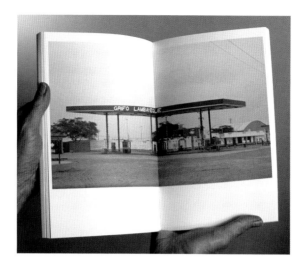

Sixtytwo Gasoline Stations
Gabriel Lester, 2007

Dutch artist and filmmaker Gabriel Lester photographed over 400 gas stations during a six-week road trip from Lima, Peru to Quito, Ecuador. Afterwards he considered producing a small publication of the images to illustrate his trip, only to discover that Ruscha had done something similar over 40 years earlier. Undeterred, he decided to publish 62 of his gas stations, creating a numerical palindrome with Ruscha's 26. Many of the photographs were taken from the open window of a car while in motion. Lester characterizes the filling stops as transitional spaces, purgatories "where one buys what one burns to get there." Grainy black and white images, the snapshots depict gas stations as sites of coming and going, but primarily as places of waiting: service attendants waiting for customers, customers waiting for tanks to fill, young boys waiting for something to happen, women waiting for rides, old men waiting for nightfall. Since many of the stations appear to have been built around the time Ruscha photographed their counterparts in the United States, this expectant quality applies to the specific structures as well. Whether the gasoline stations are actively doing business or lie fallow, Lester's photographs emerge as messages in which, as he says, "impressions of the past are received by the future."

SPECIFICATIONS: 9 x 5.5 inches, perfect-bound, 144 pages
EDITION: 10 PUBLISHER: self-published

EVERY LETTER IN "THE SUNSET STRIP"

SHEER TIP STUNTS

Every Letter in "The Sunset Strip"
Derek Sullivan, 2007

A game of anagrams with the fourteen letters of Ruscha's abbreviated title, Derek Sullivan's *Every Letter in "The Sunset Strip"* displaces the subject of inquiry from the specific geographic location to the orthographic sign associated with it. Although the original pictorial content of *Every Building on the Sunset Strip* has been expunged from this book, Sullivan substitutes Ruscha's concomitant interest in evocative or odd language. Into this additional allusive realm Sullivan submits his ludic word-game. Otherwise devoid of visual or typographical content, the right-hand side of each layout features a remix of the fourteen letters. Often scatological or sexual in nature, the results are genuinely humorous. Mining language's graphic materiality has it limits though: a series of blank pages occupy the end of the book. The artist left the edition open to continuous revision and additions, so that rather than signaling the exhaustion of possible permutations, the blank pages indicate the mutability of the work, which might be different with every printing produced on demand.

SPECIFICATIONS: 7 x 4.25 inches, softcover, perfect-bound, 64 pages
EDITION: open PUBLISHER: self-published

Persistent Huts
Derek Sullivan, 2008

Derek Sullivan's anagrammatic play on "The Sunset Strip" extends to this volume, with one such scramble of letters providing the titular category for a typology. However, here the referential function of language returns to serve as an ironic caption to the pictures. The accordion-fold *Persistent Huts* appears to document a series of haphazard tabletop architectural models. Closer inspection reveals the precarious forms to be crudely built out of six copies of another famous artist's book: Martin Kippenberger's *Psychobuildings* (1988). While his constructions share a certain formal eccentricity with the design observations photographed by Kippenberger, Sullivan's project is even more the tongue-in-cheek diversion of a somewhat bored child, thoughtlessly erecting structures with whatever materials lay at hand. Such expressions of whimsy mark a stark contrast with the strip architecture surveyed by Ruscha.

Photographed in black and white against neutral backdrops or amidst the detritus of the artist's workspace, Sullivan's arrangements could function as sketches in three dimensions. While some might charitably be seen to have pretensions to high design, others are patently absurd, hardly worthy of the name hut. Yet the prominence of Kippenberger's cover jacket, itself a lozenge template appropriated from Merve Verlag, undermines any attempt to see the forms purely architectonically. One wonders how Sullivan came by so many copies of the rare and now quite expensive publication. Persistence may be a function of dispersion. Even as further mediation and spoliation extend the life of such works, the very possibility of the structures' longevity is called into question: Sullivan's huts threaten to collapse under the weight of allusions to canonical works by other artists.

SPECIFICATIONS:
7 x 5.5 inches,
accordion-fold

EDITION:
26 signed and numbered

PUBLISHER:
Printed Matter

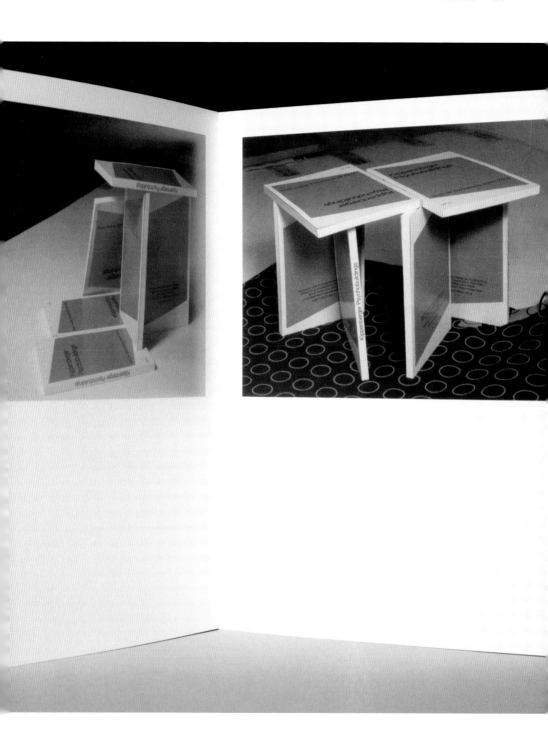

Stadien *Henning Kappenberg,* 2008

Henning Kappenberg's *Stadien* is composed of reproductions
of 25 aerial views of soccer stadiums that recall Ruscha's parking
lots, delicately rendered in pen and watercolor. Sampled from
the arenas of elite soccer leagues, the sites are primarily European,
but also include the home turf of several South American and
one African club. These illustrations resemble the effects of the
"trace contour" filter available to users of Photoshop, so that
areas of similar brightness in the picture are outlined with a
thin line. Rather than sharp edges corresponding to the physical
structure of the architecture, the contours translate an analysis
of relative effects of light. These factors point back to the
presumably photographic origin of the images. Kappenberg
complicates this programmatic aspect by filling in the grassy
playing fields of the stadiums with verdant watercolor. The
affective register of the areas of color throws Kappenberg's
analytic mode of drawing into stark contrast. As a result, the
alteration of information is made conspicuous as the images
migrate across media. Between strategies of algorithmic
abstraction and manual depiction remains the artist's intention
of communicating something roughly corresponding to
experience. In this regard, the choice of stadiums rather than
parking lots is decisive. In a short text, a devotee of the Berlin
club Hertha recalls attending the April 7, 1997 game that
launched his team back into the top flight Bundesliga. The fan
describes an almost sublime moment in which the stadium was
suddenly at capacity, and "the spectators were one with the
game, the game one with the 75,000 spectators."

SPECIFICATIONS:
7 x 5.5 inches, softcover,
perfect-bound, 104 pages

EDITION:
open

PUBLISHER:
Norsk Kulturrad

Foreclosure *Taro Hirano,* 2008

More a photo essay than a typology, Taro Hirano's *Foreclosure,*
2008 unites a number of the subjects of Ruscha's photo-
books within the framework of home mortgage defaults.
Striking out through the sprawling residential neighborhoods
of Southern California, *Foreclosure* registers the faded
promise of real estate opportunities gone awry. The book
opens with a desultory scene: a home with browned-out
grass and untended weeds provides the backdrop to a "for
sale" sign from American Realty, which reads as "American
Reality" at first glance. The following pages depict drained
swimming pools at vacated suburban homes and abandoned
budget motels. Their parabolic walls have become canvases
for graffiti artists and half-pipes for opportunistic skate-
boarders whose wheels leave sketch-like streaks. A trespassing
skater hops a backyard fence in the final image. The skaters'
repurposing of pools operates outside the normative
paradigm of property ownership and access, temporarily
restoring some degree of positive activity to these blighted
sites. Interspersed amongst the appropriated skate parks
are images of peculiar, anthropomorphic shrubbery and
palms, like pre-cut out Ruscha "colored people." The only
bursts of vibrant color amidst the desiccated lawns and
powder blue poured concrete pools seem to come from the
heartiest of flora. Evidently bougainvillea and oleander
are almost recession proof. Published in the midst of the
global financial crisis, Hirano's book concretizes the real
circumstances behind the abstract machinations involved
in the market collapse.

SPECIFICATIONS:
10 x 7.67 inches,
softcover, saddle-
stitched, 12 pages

EDITION:
200

PUBLISHER:
Nieves

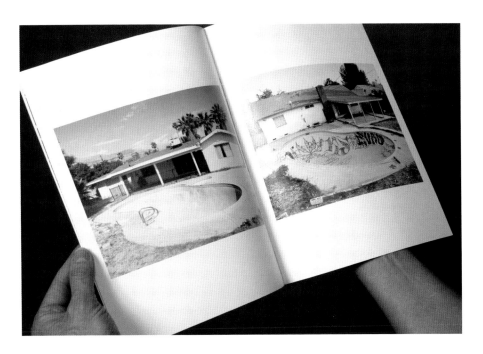

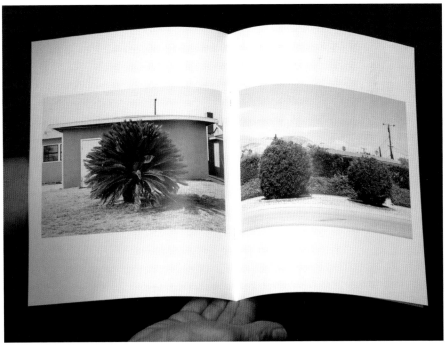

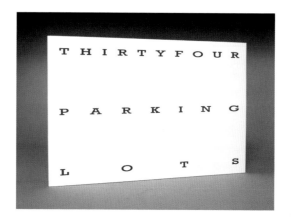

Thirtyfour Parking Lots
Travis Shaffer, 2008

SPECIFICATIONS:
5.5 x 8.5 inches,
softcover, perfect-
bound, 48 pages

EDITION:
400

PUBLISHER:
self-published

Travis Shaffer's homage retails for a price of $24.46. This information bears foregrounding because it forms a conceptual aspect of the project as a whole. The figure was determined by running the original price of Ruscha's first artist book (*Twentysix Gasoline Stations,* $3.50) through an online inflation calculator to arrive at the equivalent 2008 price for Shaffer's first book. In a similar way, Shaffer updates the conceit of *Thirtyfour Parking Lots,* farming out the labor of producing the photographs — as Ruscha did — but to Google Maps' satellite imagery database. The resultant images, in color, depict a broader area than the originals, such that individual parking lots appear in relation to the roadways that connect to them and the neighborhoods that surround them. Not that the photographs are inherently more meaningful. Extraneous information makes it difficult to discern which parking lot in the picture is the intended subject. Only truly distinctive locations such as Dodger Stadium stand apart.

In the satellite images, spatial information is flattened into a map-like appearance that preserves the cardinal-north orientation. By contrast, the earlier aerial photographs of Ruscha's book, taken from an airplane, remained perspectival pictures in which depth, angle, and direction registered the specific subject that produced them. No such subject stands behind the Google images; en lieu there is a programmer, a processor, and ultimately a virtual surfer of the data sets. Here, historical change is disclosed pictorially, technologically, and economically.

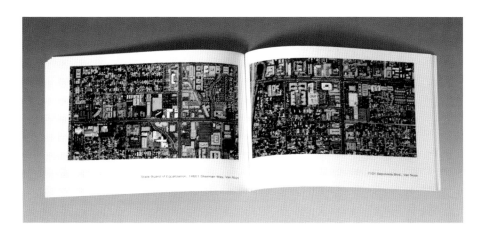

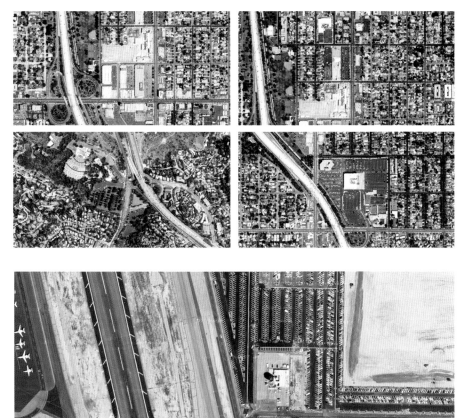

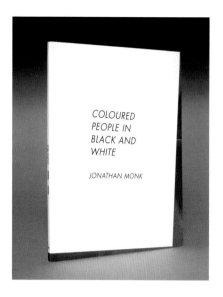

Coloured People in Black and White
Jonathan Monk, 2008

SPECIFICATIONS:
6.3 x 4.6 inches,
softcover, perfect-bound,
36 pages

EDITION:
500

PUBLISHER:
Argo Books

The introduction of the "u" of British English's proper rendering of "colour" into the title of Ruscha's *Colored People* intimates that Jonathan Monk's version of the same is deeply concerned with issues of translation in transmission and reproduction. The skewed margins of the cover reveal Monk's haphazard photocopy machine bootlegging. Ironically, this is the one image that is original to Monk's book. Although all fifteen of Ruscha's anthropomorphic desert flora are reproduced, the intermingled blank spreads of *Colored People* have been discarded, so that Monk's condensed edition numbers 36 rather than 64 pages. While the images themselves seem enlarged, the format here is slightly smaller, so that the "people" overrun the page. The middle section of one picture of a cluster of cacti has been excised where the binding of Ruscha's book prevented perfect contact with the copy machine. Photocopying sacrifices fidelity to the original in favor of expediency. But the reduction of the chromatic range of the book is not merely a side effect of its technological mediation. Rather, the possible racial valences of *Coloured People in Black and White's* anthropomorphizing title re-problematizes Ruscha's use of the term "colored people." Through such marks of difference, Monk's new edition pressures the idiom of Ruscha's artistic language.

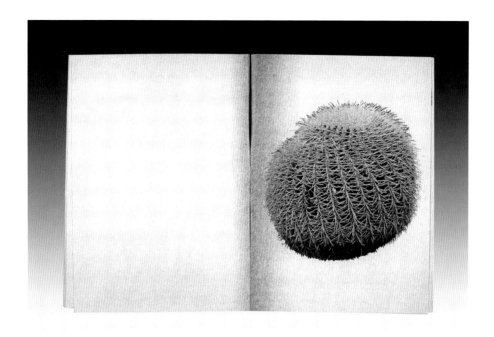

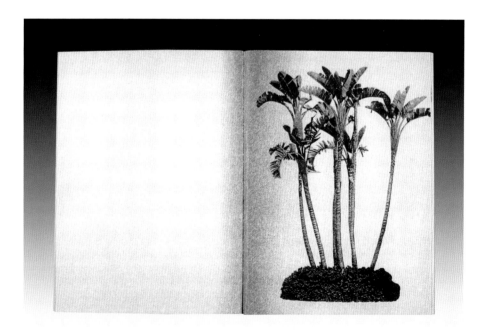

Every Instance Removed

Derek Stroup, 2008

SPECIFICATIONS:

5.90 x 7.87 inches,
softcover, perfect-
bound, 26 pages

EDITION:

500

PUBLISHER:

self-published

As though through cinematic montage, *Every Instance Removed* is a sequence of close-up details of the image that adorns the cover of the book. Derek Stroup photographed a gas station on the Garden State Parkway in New Jersey in a straightforward manner, but something is off about the picture. Each of the 12 fragments within serves to elucidate the action referred to in the book's title: the artist has digitally scrubbed every instance of language from the photograph. License plates, gas pumps, stickers, ornamental flags, and canopies: every surface is merely another space for inscription, and more explicitly the infusion of brand identity. The detail images serve as signposts that point to Stroup's intervention, so that the viewer projects their own expectation of language back into the picture. There is a pedagogical aspect to this presentation, as though the uncanny effect of the cover photograph requires elucidation and the

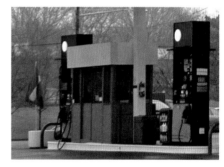

artist is generous enough to show what he has done. Yet by its
negative presence, and by the artist's emphasis of this condition,
language assumes a self-reflexive function. Certainly some of
the linguistic elements that have been removed fulfill essential
purposes. Still, language is revealed as an element of design as
much as a system of communication. Bereft of graphemes,
the publication critically illuminates the surfeit of information
that adorns spaces of relatively simple functional processes.
The strategy is a form of graffiti by subtraction.

Some Las Vegas Strip Clubs
Julie Cook, 2008

Night's temptations can seem far less appealing in the light of day. Or rather, the stagecraft that conspires to produce its seductions can be seen for the construction that it is. So would seem to be the premise of Julie Cook's *Some Las Vegas Strip Clubs*, shown unoccupied by customers or workers during the daytime. But the photographs reveal a more complicated approach to their subject, one that is both respectful of and incisive with regards to the surprising diversity and ultimate strangeness of erotic venues. The title winks at some of Ruscha's typological collections, exploiting the equivocacy of "strip" to substitute the teasing action of nude dancing for the horizontality of Sunset Boulevard. Cook's publication design is her own as well, with saturated images spilling full bleed across the page.

Interior décor makes for an intriguing index of the cultural myths and styles that inform fantasy. The businesses documented run the gamut from rococo caverns to sleek mod surfaces and from neoclassical temples to pop-bricolage dives. Cook is

SPECIFICATIONS:
6.7 x 6.7 inches,
softcover, perfect-bound,
150 pages

EDITION:
open

PUBLISHER:
self-published

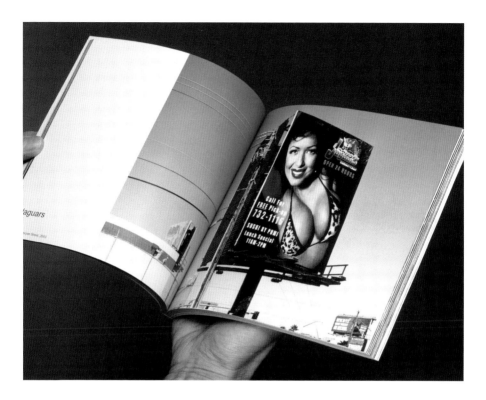

attentive to the architectural layouts that facilitate the customer experience, registering promenade entry halls and wraparound stage seating. Urinals in one bathroom are each equipped with live video feeds of the dance stage. Cook compares the club experience to being "on a film set." In an analogous way, the division between front and back of house areas or interiors and exteriors is stark. In client accessible interiors, the focus is on constructing a space conducive to fantasy. Photographs of club exteriors reveal the conventions of display and advertisement prevalent to the industry. Like the authors of *Learning from Las Vegas*, Cook has incorporated Ruscha's lessons of how "strip" architecture and signage address the gaze from the automobile. One venue's marquee simultaneously declares "World's Largest Gentleman's Club" and "Welcome Stamp and Coin Soc." In this mode of diurnal defamiliarization, the absence of bodies only heightens one's awareness of the collusion of libidinal and capital economies.

THE SUNSET STRIP

Some of the Buildings on the Sunset Strip
Tom Sowden, 2008

When Ruscha executed his survey of the Sunset Strip, he limited himself to the building addresses between 8024 and 9176. For his version, Tom Sowden expanded the parameters of the project, bringing within his compass the entire stretch of Sunset Boulevard from its origin at Figueroa Street in downtown Los Angeles to its terminus at the Pacific Coast Highway. Whether or not the entire range from 1069 to 17383 Sunset Boulevard actually falls under the designation "the Sunset Strip," the key modification to both the titular and visual lexicon is in the extent of comprehensiveness, from *Every* to *Some*. Sowden presents individual exposures instead of a continuous surface of building facades; spacing in the layout is not a function of static relationships between places. Rather than corresponding to commensurate real spaces, the gaps between images act as cognitive ellipses. Like Robbert Flick's *Parade Route*, Sowden's form approximates the subjective experience of space, with all its discontinuities and irregularities. Sowden may still be shooting his low-res snapshots (perhaps video stills) from a car, but the final representations function as notations of focused attention around distinctive landmarks like Mel's Diner or a shuttered Tower Records. If Ruscha's book pointed towards a cinematic visuality, Sowden's emphasizes the photographic, with its inherently fragmented representation of the real. With changing camera angles and motion blur, *Some of the Buildings on the Sunset Strip* underscores what was already true of Ruscha's take on Sunset Boulevard: that even seemingly neutral mechanical representation is predicated on subjective decisions, rather than naturally occurring principles.

SPECIFICATIONS: 7 x 5.5 inches (closed), 7 x 180 inches (open), softcover, accordion-fold
EDITION: 30 **PUBLISHER:** self-published

7100

7212

7979

7610

8351

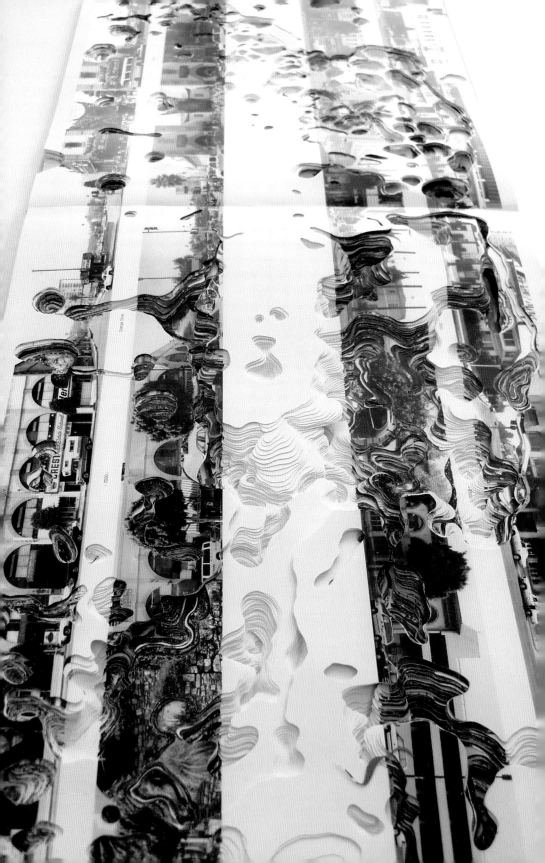

Cutting Book Series: Traveling into Then & Now
Artists Who Make "Pieces" and Artists Who Do Books
Noriko Ambe, 2008

For Noriko Ambe's *Cutting Book Series,* the artist meticulously excises abstract forms page by page from existing books, including Ruscha's 2005 book *Then & Now.* This late Ruscha photobook involved a two-step process: First, in July 1973, Ruscha gave Hollywood Boulevard the Sunset Strip, every-building treatment. Thirty years later he re-photographed the same locations, this time in color. The resultant panoramas, two each in color and black and white, were synched to allow side-by-side comparison and published in a single volume, to which Ambe laid havoc.

Ambe describes her approach as collaborative, developing out of an intense engagement with the existing artwork, or rather, its reproduction, which serves as her material. In this dialogic model of production, Ambe acts as a filter or screen for Ruscha's work; her cuts almost embody an historical consciousness on the page. Ambe's own mark making is constructive and constitutive even as each cutout is an act of mutilation. Insofar as Ruscha's book is already a topographical survey in pictures, Ambe's intervention in the object creates a completely new terrain, one that slices through the matrices of spatial and temporal representation already at play in *Then & Now.* The resultant landscape functions topologically as much as topographically, generating new relationships between disparate strata of the book-object. Rendered illegible according to the organizational logic of the original book, the *Cutting Book Series* proposes another modality of reception with Ambe as model spectator.

The problematic of the book as a final format for a visual artist is figured in another of Ambe's "conversations" with Ruscha. One of his catalogues, also dissected, is displayed propped open to a spread reproducing two 1976 pastels that figure an apropos binary — *Artists Who Make "Pieces"* and *Artists Who Do Books* — which Ambe further deconstructs.

SPECIFICATIONS: 12.5 (H) x 35.5 (W) x .87 (D) inches
COLLECTION: Glenn and Amanda Fuhrman

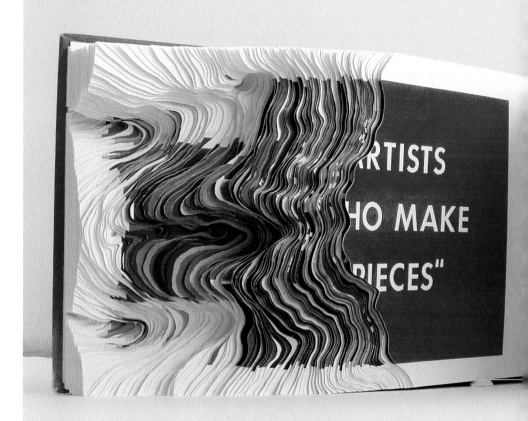

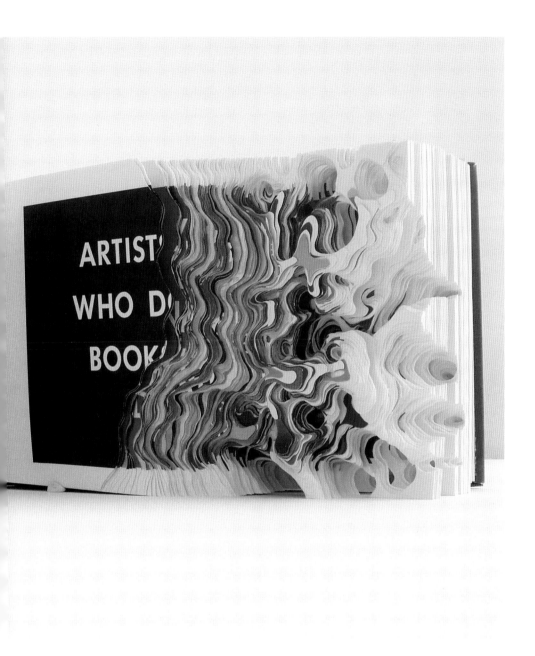

SPECIFICATIONS: 5.12 (H) x 14.5 (W) x 8 (D) inches
COLLECTION: Glenn and Amanda Fuhrman

SOME

BELSUNCE

APARTMENTS

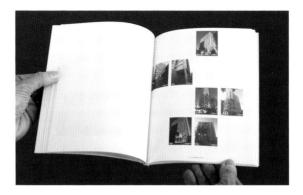

Some Belsunce Apartments
Anne-Valérie Gasc, 2008

Following the destruction of the historical center of Marseille in World War II, the municipal authorities set out to redevelop the district of Belsunce through the construction of large housing complexes, shopping districts, and commercial and government buildings. Anne-Valérie Gasc collected imagery of 34 such sites of "reconquest" in order to stigmatize the oppressive nature of stultifying architectural projects endemic to the area. Using low resolution streetviews downloaded from the French directory website *Pages Jaunes*, Gasc's book proceeds chronologically from the earliest postwar developments up to new construction projects in progress. Each of the locations is represented by an array of photos from different vantage points, as though the artist was casing the joint for some indeterminate plot. Most of the buildings can be characterized as Brutalist towers, barely indistinguishable from one another. Such images summon by-now familiar critiques of modernist architecture designed with socially progressive intentions, but that in actuality became symbols of oppressive conformism. As the epitome of this historical legacy, Le Corbusier's infamous Cité Radieuse lies not far away in Marseille.

Mobilizing publicly available information, Gasc charts an insidious history of urban redevelopment in her native France. She interprets Ruscha's photobooks as a recipe for architectural vigilantism, identifying fuel sources (gas stations), ignition (small fires), and victims (some apartments). In Gasc's hands, Ruscha's canonical formula has been adapted to construct what amounts to a handbook of targets to be destroyed or, less forcefully, critically reevaluated.

SPECIFICATIONS: 7 x 5.5 inches, softcover, printed wrappers with glassine, perfect-bound, 48 pages
EDITION: 700 PUBLISHER: self-published

2009

NUTSY'S ~~ROYAL~~ ROAD TEST

Tom Sachs

8-15-01

VERSION 0.63

Nutsy's Road Test, Version 0.63

Tom Sachs, 2009

Tom Sachs's Nutsy's is a 4,000 square foot installation that riffs on the corrupted legacies of utopian modernist architecture, namely Le Corbusier's Unité d'Habitation. One might ask, "Who is Nutsy?" The answer, provided by *Nutsy's Road Test, Version 0.63*, is that "Nutsy is the bank, the government and church. Nutsy is your boss, landlord and company store. He is your shrink and bicycle mechanic. Nutsy is the man. You fucking owe him." Comprised of elements in both 1:1 and 1:25 scale, Sachs's massive project includes a fully functional remote control racetrack, for which exhibition visitors are issued official driver's licenses. Only in part an architectural model, the installation creates internal economies necessary to sustain its operations, with a staff devoted to day-to-day operations and maintenance, and workers for the Nutsy's McDonald's. Encompassing distinctive neighborhoods, Nutsy's makes for a canny simulation that at once mimics the systems of a generic late capitalist society and makes them absurd.

Sachs has frequently released zines to accompany his major projects. Originally published in 2001, before many of the final elements of *Nutsy's* were built or fully conceived, *Nutsy's Road Test* was used to bolster studio morale and for fundraising to support the production of the project; a Dollar Cut: Dub Version was rereleased in 2009. Comically DIY, the zine documents a grandiose, albeit schizophrenic, project in progress. The allusion to Ruscha's *Royal Road Test*, and the appropriation of its vandalized cover page, is only one of the many art historical items that Sachs, an inveterate bricoleur, delightfully throws into the mix.

SPECIFICATIONS: 8.5 x 5.5 inches, softcover, saddle-stiched, 24 pages
EDITION: 100 **PUBLISHER:** self-published

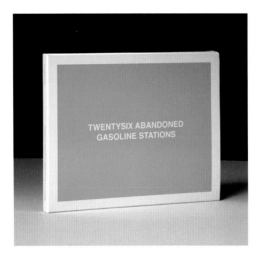

Twentysix Abandoned Gasoline Stations
Eric Tabuchi, 2009

Like Jeff Brouws, Eric Tabuchi adapts the conceit of *Twentysix Gasoline Stations* to a time after customer service has been terminated. All of the former filling stations in this collection are located in the vicinity of the Île-de-France, the administrative region surrounding Paris. Crucially, the edition is not bound, but rather exists as 26 loose printed cards with color images. As a result the impulse to construct a linear narrative of a road trip is repelled by the infinite shuffling that is almost inevitable with each viewing. In fact the notion of a thoroughfare that these businesses once serviced is absent in the images. Almost all of the pump machines have been removed and branding stripped, leaving the skeletal canopies as the only evidence of past functionality. Tabuchi's framing of the structures, set amidst desolate landscapes, furthers the sense of dislocation and abandonment. Andy Warhol admiringly asked Ruscha how he had managed to take all of the pictures for *Twentysix Gasoline Stations* without people in them; Tabuchi incorporates one exception to this typological convention, an image in which the passengers of two caravanning vehicles take shelter beneath a sentinel canopy. These figures, as the exception, heighten the sense of a post-apocalyptic world in which survivors have taken on a nomadic existence, scavenging the ruins of an architecture that was once a symbol of promise, hope and limitless horizons.

SPECIFICATIONS:
6 x 7.5 inches, boxed set of twenty-six color postcards

EDITION:
500

PUBLISHER:
Frances Loewy

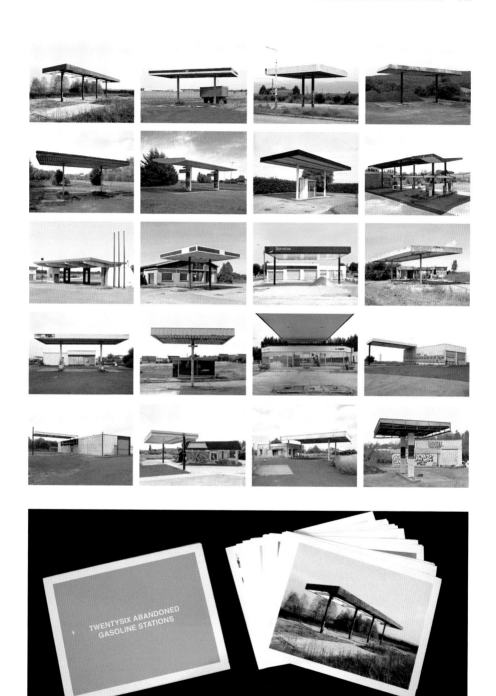

SPECIFICATIONS:
6 x 4 inches, softcover,
perfect-bound, 88 pages

EDITION:
500

PUBLISHER:
A-Jump Books

History of Photography in Pen + Ink
Charles Woodard, 2009

Charles Woodard's mini-survey of the history of the photo-
graphic medium is in many ways anathema to photography's
communicative structure. Like Kota Ezawa's *History of Photography
Remix*, this project uses a non-photographic mode of represen-
tation to reflect on photography. Producing a collection of pen
and ink doodles is a far cry from letting "Nature substitute her
own inimitable pencil," as William Henry Fox Talbot described
photography. But for the student compelled to memorize a
large quantity of photographic images, translation into hand
wrought pictures can serve as a handy mnemonic strategy. Such
was the genesis of Woodard's charming *History of Photography.*
As an undergraduate completing his degree in photography,
Woodard made quick sketches of famous photographs on 3 x 5
inch index cards to prepare for an exam in his history of
photography course. Among the 43 imitated photographs is
Hollywood Bowl from Ruscha's *Thirtyfour Parking Lots*, 1967.

Ed Ruscha
Hollywood Bowl (from *Thirty-four Parking Lots*)
1967

The drawings raise numerous questions about memory and memorization, art historical interpretation, canon formation, and the essence of photography: Why was this particular image chosen for the photographic survey? What are the consequences of divorcing a single image from its original context within a typological publication like Ruscha's? What kind of information is transmitted in the hand-drawn sketch? Is the significance of a photograph primarily pictorial? Interestingly, Woodard's book does not disregard medium specificity: every sketch is captioned with the artist's name, title of the work, the technical medium of the object, and the year it was produced. All except for the Ruscha, which says "*Hollywood Bowl* (from *Thirtyfour Parking Lots*)." By contrast, a photograph by William Eggleston is identified as an image from the book *William Eggleston's Guide,* and also as a dye-transfer print. Even submitted to a reductive system of transmission, Ruscha's enigmatic book works are hard to draw clear conclusions about, but they sure are memorable.

Stains

Eric Doeringer, 2009

Ruscha's portfolio of *Stains* (1969) remains one of the most unconventional of fine art multiples. Entirely forgoing a printing matrix, each of the stains is a unique example in an edition of 70, with the marks merely the material residue of their nominal content rather than an iconic correspondence. As such, the *Stains* are not so much pictures as artifacts. Eric Doeringer has expressed his longstanding interest in the way in which the "hand" of the artist was withdrawn in the conceptual art practices of Ruscha and others. Doeringer's version of *Stains* thus stands in a peculiar relationship to its prototype. The notion of non-autographic mark making seems stretched to its limits, even as the conceptual framework of Doeringer's *Stains* rests upon the primacy of authorship and attribution by foregrounding its parasitic relationship to Ruscha's work.

While Doeringer's earlier series of *Bootlegs* were hasty and self-declared "copies," works like *Stains* are more careful, even slavish, remakes which complement or supplement the originals rather than substituting for them. There is an endearing self-effacement to this practice, not least in *Stains'* devotion to an already absurd cabinet of gastronomic, bodily, industrial, and domestic maintenance substances. Of course, Doeringer's fresh marks have yet to undergo the transformations of aging to which Ruscha's unstable originals have been subjected. Yet visual resemblance is mostly beside the point; identity here is a material property, such that Doeringer has attempted to match the staining substances, paper and box as closely as possible. Re-creation in this case means a form of understanding through mimesis.

SPECIFICATIONS: 12.5 x 11.5 x 1 inches, mixed media on paper, 78 pages, unbound in handmade box
EDITION: 10 PUBLISHER: Copycat Publications

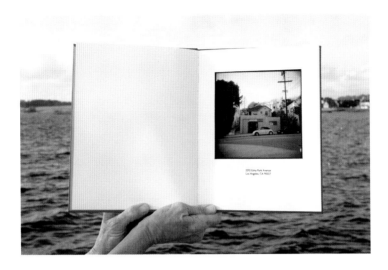

Various Studios and Homes Inhabited by Ed Ruscha
Chris Svensson, 2009

Savvy Hollywood entrepreneurs have long made a buck offering tours and guidebooks to the homes of the stars. Chris Svensson accomplishes something similar with his collection of *Various Studios and Homes Inhabited by Ed Ruscha.* Four localities fitting the description were shot with plastic lens toy cameras, with the idea that more could be added if knowledge of other creative haunts were acquired. Along with each deadpan, real-estate-style snap of the property in question, Svensson provides an address. How did he come by all of this private information and history? It's not clear. Perhaps a narrative can be decoded in the progression of residences. A certain mode of art historical interpretation might link environmental factors associated with artistic biography to the style and evolution of the artist's work. However, Svensson's project seems more parodic. A 21st century *Lives of the Artists*, it's as if Vasari had painted episodes from Michelangelo's life in the master's signature style. At the very least, each instance of photography also marks a pilgrimage. As such, Svensson both participates in and makes fun of the hagiographic treatment of a celebrated figure.

SPECIFICATIONS: 8 x 10.3 inches, hardcover, unknown number of pages
EDITION: unknown **PUBLISHER:** self-published

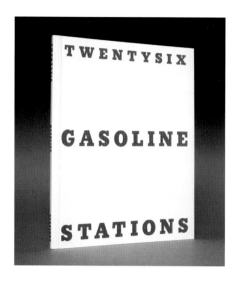

Twentysix Gasoline Stations
Michalis Pichler, 2009

Each of the photographs in Michalis Pichler's *Twentysix Gasoline Stations* depicts a filling station owned by a single corporation, Total, in the German states of Brandenburg, Thuringen, Sachsen-Anhalt and Mecklenburg-Vorpommern. The colophon includes a droll bibliography, the sole contents of which are "Edward Ruscha, *Twentysix Gasoline Stations*, 1962." But in contrast to Ruscha's book, Pichler's variation is a rigorously uniform architectural typology in the spirit of Bernd and Hilla Becher. All of the images are produced in a consistent format and set on the right-hand page. Though the number of pumps differs for each specimen, the artist has framed his views so that the "wings" of each gas station extended to roughly the same place in the composition. Pichler has included images of service stations on opposite sides of the freeway in which both east and westbound stations are almost entirely identical. The rest stop thus becomes a landmark that paradoxically fails to orient the traveler. When buildings look the same wherever one goes, one wonders if one has gone anywhere at all — an effect enhanced with every turn of the page. The empire of corporate design envelopes all. Although close looking reveals subtle distinctions among these conformist architectural sites, Pichler's commitment to emphasizing similarity is explicit. On the final page the photographer holds a sheet of paper in front of the

SPECIFICATIONS:
7 x 5.5 inches, softcover, printed wrappers with glassine, perfect-bound, 36 pages

EDITION:
600

PUBLISHER:
Printed Matter

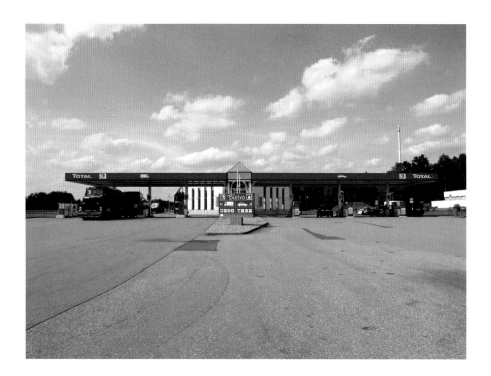

camera with the typed phrase "the eccentric stations were the
first ones I threw out," presumably obscuring the view of one
such outlier. So much for an objective survey. Pichler's book is
a willfully crafted trip into a dizzying world — or perhaps a
comforting one — in which one knows what to expect on the
road ahead.

Twentysix Gasoline Stations Revisited
Martin Möll, 2009

Unlike when Ruscha's *Twentysix Gasoline Stations* was originally published, today the images within it no longer represent the contemporary; they have been consigned to the domain of history. Did things truly look like that? We have little mechanism of authenticating the pictures' likeness. The photograph itself documents a limited degree of the place history; the details of the picture are all that endure. Even if, utilizing the caption identifications of business name, town and state that Ruscha provides, one goes to these towns along Route 66, as Martin Möll has done, there is no guarantee that the photographed location will be recognizable as such. In many cases, the original gas station no longer remains or the structure has been modified beyond recognition. Lacking the address numbers that might have anchored each photo to a specific tract of land, other forms of knowledge are necessary to locate the image in real space. In some cases a street sign supplies a clue, or a distant topographical landmark can enable a perspectival reconstruction. In other instances, oral histories transmitted by locals may offer the means of securing the image to its site. Having attempted to stand where Ruscha stood as closely as possible, Möll presents his own photographs of the contemporary as framed silver gelatin prints, for which the image size corresponds to the reproductions in Ruscha's book, and installs them according to the original image sequence. Even as they re-establish the spatial configuration of a long-passed moment and offer a means of historical comparison, these art works also allegorize the complicated knowledge acquired by photographic means. The shape of time begins to emerge.

Installation view of *The Conspiracy*, twenty-six framed black and white silver-gelatin photogaphs, Kunsthalle, Bern, Switzerland 2009

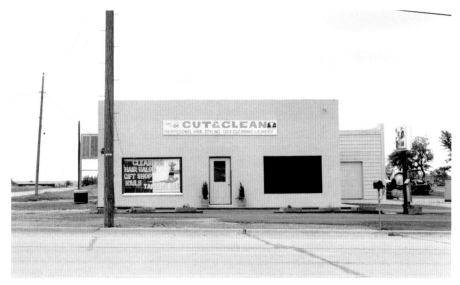

SPECIFICATIONS:

7 x 5.5 inches, softcover,
printed wrappers with
glassine, perfect-bound,
48 pages

EDITION:

1000

PUBLISHER:

self-published

Some Los Angeles Apartments

Eric Doeringer, 2009

Eric Doeringer's *Some Los Angeles Apartments* is a re-photography project based on Ruscha's book of the same name. The younger artist has devotedly maintained the format of the book and the pictures within, right down to approximating the original vantage points and camera angles used by Ruscha. Quite literally, Doeringer has followed in his footsteps. Despite seeming formulaic on the surface, the individual photographs and the historical comparisons they precipitate hold considerable interest. The most obvious differences between Ruscha's apartments and Doeringer's are the designs of the cars that flank the sidewalks and the typography of the signs adorning the properties. Once evocative sobriquets such as "Fountain Blu" and "Lee Tiki" have failed to survive the ensuing nearly half century. Some locations have changed more significantly, the originals torn down and redeveloped. It seems, however, that most are still Los Angeles apartments. Many have had a facelift or cosmetic renovation; Doeringer does the same for Ruscha's book.

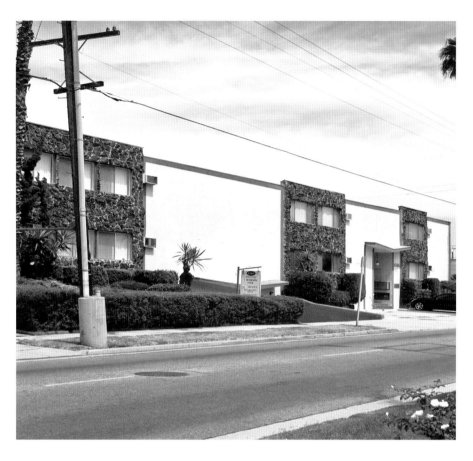

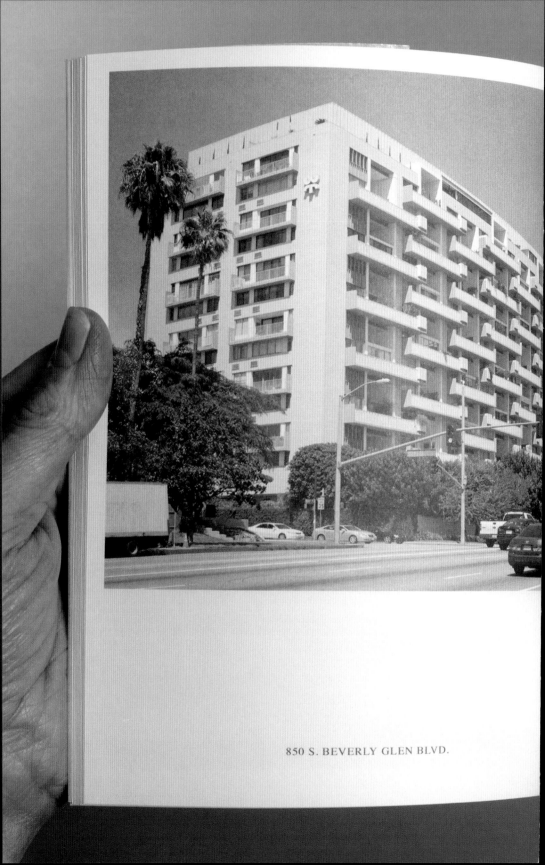

850 S. BEVERLY GLEN BLVD.

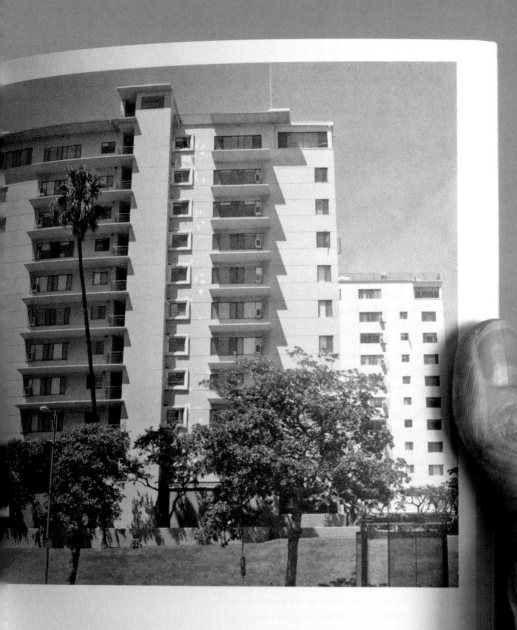

10401 WILSHIRE BLVD.

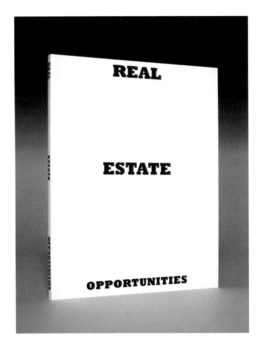

SPECIFICATIONS:

7 x 5.5 inches, softcover, printed wrappers with glassine, perfect-bound, 48 pages

EDITION:

1000

PUBLISHER:

self-published

Real Estate Opportunities

Eric Doeringer, 2009

As he did with *Some Los Angeles Apartments*, Eric Doeringer updates *Real Estate Opportunities* using the same approach. Here the changes are generally more dramatic. Most of the opportunities have been realized: the properties developed and franchises such as Starbucks and Subway have taken root, along with residential homes and places of worship. In an apropos development, one location houses a photo lab. Other lots still lie fallow. Perhaps unsurprisingly, one such site awaiting investment is an eroding hillside in Hollywood – precariously positioned given the earthquake zone. Framed within the discourse of property hawking, these pictures, along with those in *Some Los Angeles Apartments*, still seem to carry an instrumental value. Their subject matter, besides acquiring a historiographic dimension, remains within the domain of capital, and thus susceptible to exchange. In that sense they are all still opportunities, all still subject to sale and lease. Unlike Joachim Koester, Doeringer seems unconcerned with "abandoned futures;" he terms his ongoing engagement with Ruscha's works "recreations," suggesting an innate pleasure to his compulsion to repeat what Ruscha has already done.

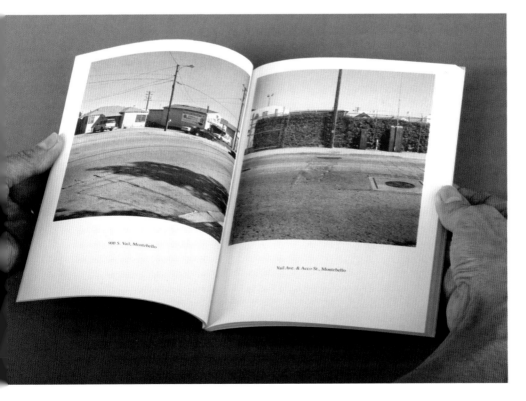

900 S. Vail, Montebello

Vail Ave. & Acco St., Montebello

VARIOUS

FIRES

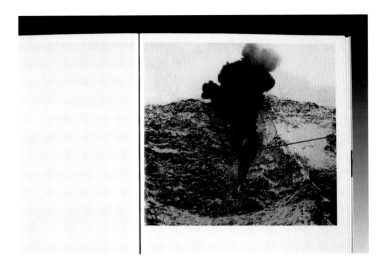

Various Fires and Four Running Boys
Thomas Galler, 2009

Like a Promethean parable in pictures, Thomas Galler's *Various Fires and Four Running Boys* shows the catastrophic potential of fire. A thick black band bisects the cover where the adjective "small" of Ruscha's original title has been redacted. All of the images in the books are appropriated from the news media. Other than depicting flames and explosions they share no direct connection, but represent a range of natural disasters, wars, terrorist attacks, violent accidents, riots, and political coups, as well as situations in which the cause or purpose of the fire cannot be discerned. The colophon indicates that the caption-less photographs were taken all over the world in Belgrade, California, Cagliari, Zurich, Hanoi, Moscow, and other unknown locations. The conflagrations re-presented are fires of destruction and violence, not succor and warmth. At once horrifying and strikingly beautiful, the book questions the role of sensationalistic imagery within media representations that are complicit with the culture of spectacle. In the final image the titular four boys run away from the camera through debris that could be confused with confetti raining down on the streets. Their heads are shrouded, their identities and purpose concealed — as intractable as the meaning of the images in the rest of the book.

SPECIFICATIONS: 7 x 5.5 inches, softcover, printed wrappers with glassine, perfect-bound, 48 pages
EDITION: 500 PUBLISHER: Edition Fink

VARIOUS

BLANK

PAGES

VARIOUS

BLANK

PAGES

Various Blank Pages

Doro Boehme and Eric Baskauskas, 2009

As with all effective works of *trompe l'oeil*, Doro Boehme and Eric Baskauskas' book is not exactly what it appears to be. Or rather, it is exactly what the title purports it to be, but with an added layer of significance. Upon close inspection the pages of the book are illustrated-full bleed with double page spreads from some indeterminate publication, devoid of any images or text. Most pages have no discernible detail other than the occasional handling crease. But periodically an image on the verso can be seen through the paper: here the outline of a palm tree, there the title page to Ruscha's *Various Small Fires and Milk*. Empty pages are prescribed as the negative condition of Ruscha's numerical parameters for his earliest artist books, which had to be inserted into the standardized formats of book construction: only 26 gas stations for 48 pages. Appropriately, the book concludes with three spreads of entirely white pages that have not been printed with any ink. The final image is a bird's eye view of a well-used ink pad and rubber stamp turned on its side to reveal the words "Joan Flasch Artist's Book Collection, School of the Art Institute of Chicago." This library, where both the authors worked at the time, is the presumptive source of all the blanks, and the stamp is used to mark an item in its collection. Wittily, Boehme and Baskauskas's book contains pictures of blank pages, unprinted-blank pages, and a picture of (an) ink (pad). Of course, there is no way to know if *all* of the blank pages are sourced from Ruscha books.

SPECIFICATIONS: 8 x 6 inches, softcover, perfect-bound, 66 pages
EDITION: 50 **PUBLISHER:** self-published

Twentythree Bankers Blink
Jochen Manz, 2009

Portraiture and the human figure are conspicuously absent from the repertoire of Ruscha photobooks, unless one thinks *Colored People* qualifies. With *Twentythree Bankers Blink,* Jochen Manz moves the Ruscha typology into new territory. The photographs inside depict employees of the bank HSBC at a moment when the camera's shutter incidentally caught them with their eyes closed. A note on the publisher's website indicates that the book is dedicated to "Ed Ruscha and the so called 'Financial Crisis' of 2008/2009. and a blink [*sic*]." In fact, these images were rejects from a commission to make portraits of company leadership, made shortly before the crisis. Technically, they remain attractive pictures, with even lighting and a narrow depth of field that invite the reader to contemplate each visage. Although they fail to satisfy the original purpose of the sitting, there is nothing grotesque about the images. Instead the photographs portray a moment of precariousness and vulnerability, in which the subject's self-composure for the camera has failed. In short, and with quite political implications, these pictures portray people who are not entirely in control of their actions. Some of the bankers are smiling and laughing with remarkable sincerity. Others are poised as though withdrawing into the world of sleep or imagination. In reverie, meditation, or involuntarily "caught," they are undeniably human. For while Manz's book is a well-deserved provocation to the perpetrators of global financial collapse, the gesture is leavened with sympathy.

SPECIFICATIONS:
7.87 x 5.75 inches,
softcover, perfect-bound,
24 pages

EDITION:
250

PUBLISHER:
White Press

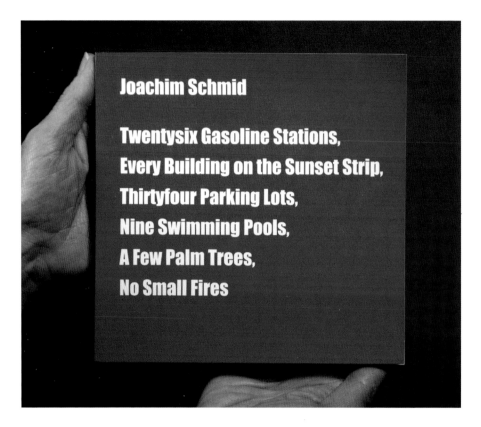

Twentysix Gasoline Stations, Every Building on the Sunset Strip, Thirtyfour Parking Lots, Nine Swimming Pools, A Few Palm Trees, No Small Fires
Joachim Schmid, 2009

SPECIFICATIONS:
6.75 x 6.75 inches,
softcover, perfect-
bound, 198 pages

EDITION:
open

PUBLISHER:
self-published

In 1990 Joachim Schmid founded The Institute for the Reprocessing of Used Photographs as a private venture to serve as a public utility for coping with the visual pollution that is the result of a culture glutted on photography. The Institute promised nothing less than the safe, professional reprocessing of all photos and, if necessary, their ecological disposal. A similar spirit informs the current bookwork under consideration. Given the widespread availability of photographs, the search engine replaces the camera, sorting through the miasmic imagery. Working with several of Ruscha's best-known books as topical models, quintessential Los Angeles subject matter could be represented without the author leaving the confines of his Berlin studio.

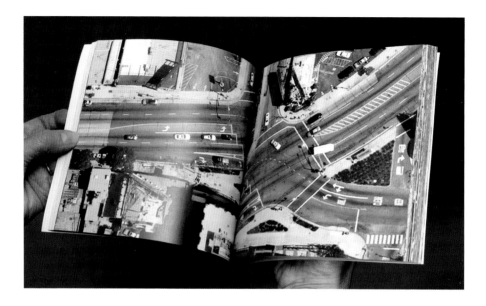

In this conglomeration of Ruscha subjects, the various visual conceits, whether cutout plants, continuous tracking shots, color versus black and white, are reduced to the single representational strategy of color aerial surveillance. Other than the Sunset Strip, which is geographically specific, there is no information to distinguish any of the sites or forms depicted. Nine swimming pools get consolidated into three photos, each with a triad in close proximity; they have none of the cool allure of Ruscha's. The section devoted to *A Few Palm Trees* is the most pictorially interesting. Each of the trees casts a long shadow that registers the shape of the tree such that it resembles our day-to-day, earthbound impression: the shadow image becomes more real than the thing itself. Finally, there are no small fires. Schmid's volume exists as a collection of Ruscha subjects, but with a difference from their prototypes. The question is what type of relationship to the world is symbolically ordered through this shift in representation? Figured pictorially and in the production of the work, distance is the rule. Then again, pictorial content may be beside the point entirely, the whole gambit merely an exercise to keep The Institute's recycling in motion, Ruscha's prescriptive titles become bits of programming code.

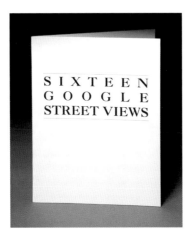

Sixteen Google Street Views

Jon Rafman, 2009

SPECIFICATIONS:

11 x 8.5 inches,
softcover, perfect-bound,
48 pages

EDITION:
100

PUBLISHER:
Golden Age

"Does not Google's mode of recording the world make manifest how we already structure our perception?" An answer in the affirmative to this rhetorical question drives Jon Rafman's *Sixteen Google Street Views.* The infiltration by Google's databases of satellite and street-level imagery into a wide range of everyday uses has an undeniable effect on contemporary visuality and ways of knowing the world. Rafman is anxious about the detached, indifferent recording of image systems like Street View, but believes that by identifying its method, alternative modes of experience become possible. This publication is comprised of images sourced from Street View that the artist considers resistant to the totalizing technological apparatus that produces them. Some images he has found himself and others are drawn from blogs and other online communities of surfers. Many of the 16 pictures recall celebrated works from the history of street photography and figurative painting. Capturing amusing and poignant gestures or suggesting the enduring presence of the individual, the spirit of the work is essentially humanistic. Even the surveyor is under surveillance: the final image perfectly catches a reflection of the Street View car in a mirror. There is an undeniable virtuosity to having sifted through the profuse volume of banal visual information to find intriguing photographs — decisive moments even. The question is whether pictures which conform to established aesthetic conventions retain transformative powers under this newly explicit epistemic regime, or if they are ultimately conservative expressions of yearning for forms of being that have long since been foreclosed.

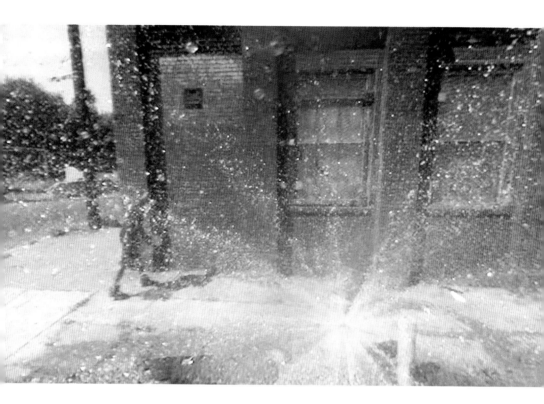

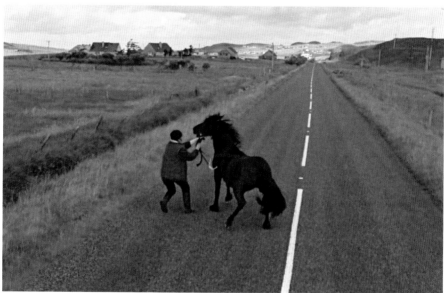

SPECIFICATIONS:

7 x 5.5 inches,
softcover, perfect-bound,
56 pages

EDITION:

open

PUBLISHER:

Parasitic Ventures Press

Twentysix Gasoline Stations 2.0

Michael Maranda, 2009

Appearing under the imprint of Parasitic Ventures Press, this
book almost polemically avoids assigning authorship. Nevertheless,
it includes an entry for the catalogue of the Library and Archives
Canada that identifies Michael Maranda as the editor and designer
of the volume. Version 2.0 is a 21st century rag-picker's recon-
struction of Ruscha's *Twentysix Gasoline Stations* using images
entirely culled from internet sources. The bootlegging editor
has found an impressive array of images to reconstitute the volume
here, with the full range of image fidelity and intervening digital
noise. From full page scans and table top shots that emphasize
the book as object, to thumbnail icons and reproductions over-
laid with color re-photographic views, *Twentysix Gasoline Stations
2.0* might be taken as a catalogue of methods for picturing
images in books. The title page of Ruscha's third edition, which
includes specifications for the three editions he produced, in
this context cleverly points to the inevitability of further
iterations. A note at the end of the book assures the reader that
"Absolutely no effort has been made to secure permission for
use of any images reproduced within this book."

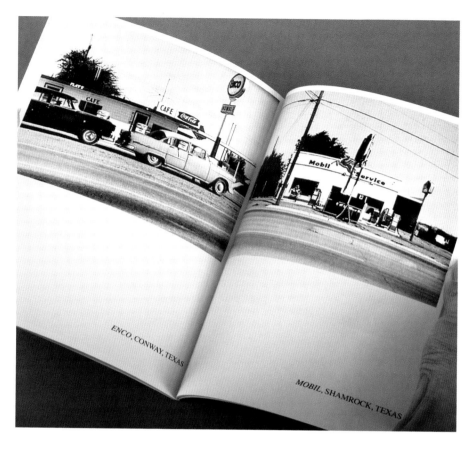

This publication is part of Parasitic Ventures Press's
"saprophagous series," books that "feed off of the decaying
detritus of textural history." Alongside the image-based work
of Ruscha are Marcel Proust's *All the Names 'In Search of Lost
Time'* (note from the artist: "Marcel Proust is unable to comment
on this critical edition of his work") and a 2nd revised edition
of Kant's three critiques, which helpfully rearranges all of the
letters in the three massive works into alphabetical order,
resulting in page after page of the same grapheme repeated.
The publishing activities of the press draw on approaches to
literature and media modeled by avant-gardes such as Oulip and
Dada. In this model both image and text are representational
units to be reconfigured, with the parasite unabashedly pillaging
the canon.

2010

Nine Swimming Pools Behind A Broken Glass

Tanja Lažetic, 2010

SPECIFICATIONS:
7 x 5 inches, softcover,
perfect-bound, 36 pages

EDITION:
100

PUBLISHER:
Zavod P.A.R.A.S.I.T.E.

Using the subjects and titles of Ruscha's books as linguistic foils, Tanja Lažetic engages the historical legacies and contemporary politics of her native Slovenia. *Nine Swimming Pools Behind A Broken Glass* consists of digital video stills in which a figure in a red dress strikes the glazing of framed promotional images of swimming pools with a hammer. Thus a single image fuses both the pool and broken glass of Ruscha's book. The pictures under attack were appropriated from Yugoslavian tourism brochures dating from the 1960s and 1970s. Ruscha's pools were amenities of private residences, unoccupied by human figures. By contrast, Lažetic's scenes are of public parks and resorts, in which the experience of carefree pleasure is available to all, albeit presumably for a price. A couple skips hand in hand towards the inviting pool; in another image a boy with an inflatable tube skids down a slide into a school of splashing friends. The video stills capture the moment when the hammer collides with the glass pane, which splinters into spider web cracks across the surface of the advertising picture. In the process, Lažetic shatters the myths promulgated through the archival pictures of an open society on holiday, showing them to be just another carefully crafted fantasy.

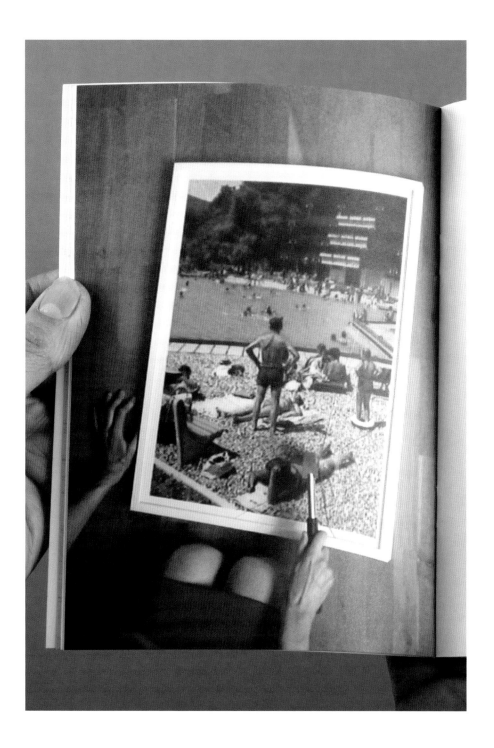

Coloured People in Black and White (Yellow)

Tanja Lažetic, 2010

International travel reappears allegorically in Tanja Lažetic's *Coloured People in Black and White (Yellow).* The title alludes to Jonathan Monk as well as Ruscha, but the color yellow does not appear within this black and white publication. Still, yellow is the color of Ruscha's book jacket, and it also describes the general complexion of the eight imported food products featured within. Each of these originates from eight different countries, which are identified in handwritten captions. A banana from Ecuador, a raisin from Chile, and ginger from China are among those that mug for the camera; their portraits are followed by a negative image, in which the tonal values of the original are reversed. More odd than informative, each specimen is further anthropomorphized by its handwritten caption. The 16 pictures here are drawn from an installation of 416 photographs entitled *The Migrants.* Pairing the identification card-style photograph of each migrant with its shadow image, Lažetic draws attention to the hidden labor and networks of exchange that bring sustenance to our door, regardless of local growing seasons. Yellow or not, the look of scientific applications of the camera imbricates banal grocer's stock with the discursive formations that administer life.

SPECIFICATIONS:
7 x 5 inches, softcover, perfect-bound, 36 pages

EDITION:
150

PUBLISHER:
Zavod P.A.R.A.S.I.T.E.

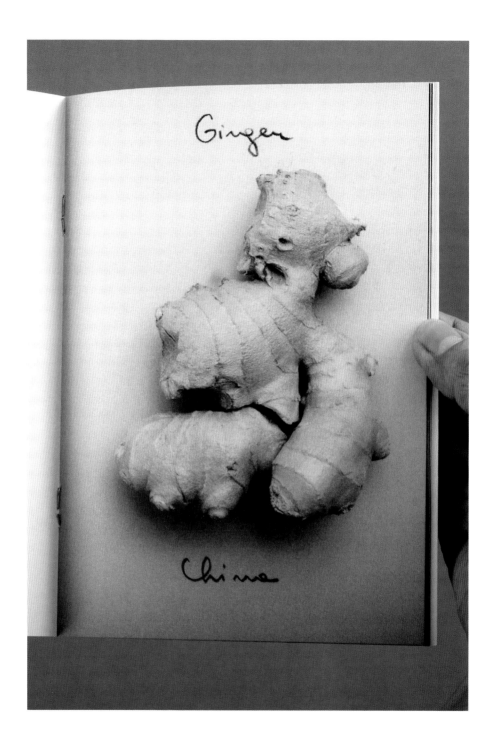

Every coffee I drank in January 2010

Hermann Zschiegner, 2010

SPECIFICATIONS:
9.5 x 7.5 inches,
softcover, perfect-bound,
76 pages

EDITION:
open edition

PUBLISHER:
self-published

In an era in which transnational corporate coffee is available on what seems like every corner, the New York City bodega coffee culture is a surprisingly resilient figure of resistance. For a few quarters one can still buy a decent cup of joe at nameless outposts across the city. *Every coffee I drank in January 2010* is the first in a series of tributes to New York produced 10 years after Hermann Zschiegner adopted the city as his home. As the title indicates, this book is both diary and homage. Caffeine produces its own neuroses of addiction. One documented here is the obsessive fascination with patterned stains produced on a plastic lid by a beverage and its consumer. Ruscha's own *Stains* (1969) were produced by 70 different substances, both more and less personal than this one.

Zschiegner's coffees of January reside one to a page. Rectos feature the topside of a single lid, versos the corresponding bottom. On days when no coffee was consumed, a spread is left blank; some days, for reasons unknown, required more than one dosage. As metonyms and indexes of the coffee that has been consumed, the uniqueness of each lid gives the respective drink a specificity that might otherwise be lacking from a straightforward inventory. The day's consumption becomes a ritual act that produces a drawing — an unconscious and aleatory form of mark making worthy of Fluxus actions or Brassaï and Dali's "involuntary sculptures." Utterly banal and familiar, yet personal and evidentiary, these photographs capture the imponderabilia of everyday life.

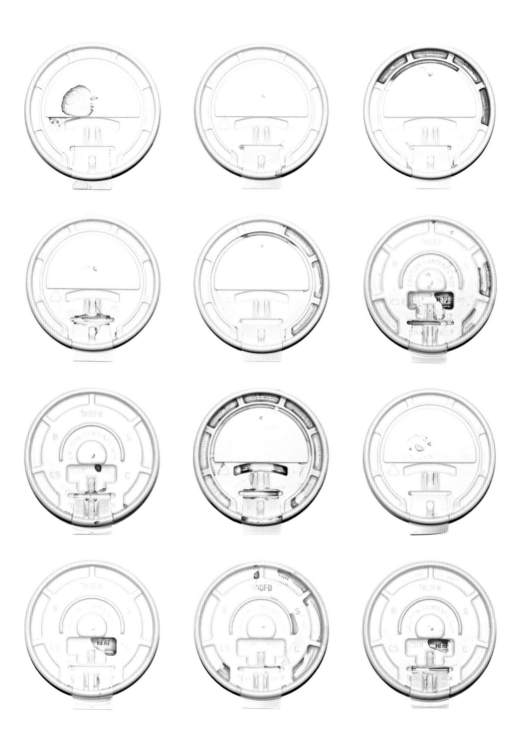

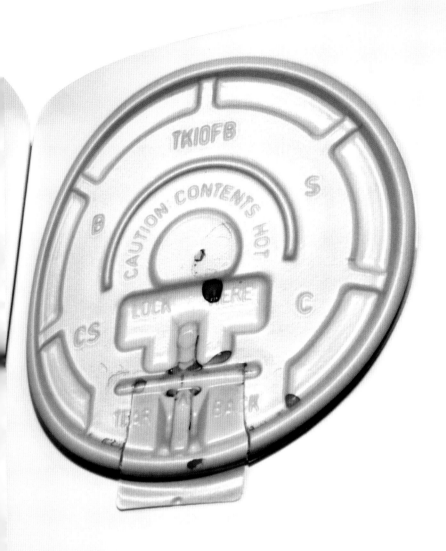

Nineteen

Potted

Palms

Nineteen Potted Palms
Clara Prioux, 2010

All photographed in Strasbourg, France, Clara Prioux's potted palms flaunt their artifice and kitsch when decontextualized. The book is bound in felted covers, which incorporate a surprising tactile effect. Left floating on the white paper page, their inherent alien quality is actually restored to these plants. Indeed they are non-native strangers in France. Although its subject matter is biologically closer to *A Few Palm Trees*, like *Colored People*, this book suggests possible valences of personification, especially in view of France's well-publicized issues with immigrant populations and the meaning of who and what is truly "French." Introduced to the streets of Strasbourg during the summer months, the plants carry connotations of exoticism and vacation destinations beyond northern Europe. Each of the palms is housed in a dark green wood-slatted plant box or chartreuse pot, never to truly lay down roots. Although Prioux has included the street address where each subject was found, flora such as these are mobile signifiers for seasonal deployment, adding exotic connotations to any location.

SPECIFICATIONS: 7 x 4.25 inches, softcover, perfect-bound, 48 pages
EDITION: 40 PUBLISHER: self-published

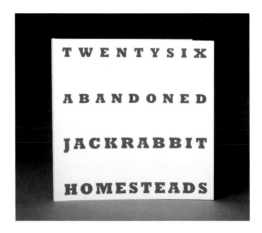

Twentysix Abandoned Jackrabbit Homesteads
Kim Stringfellow, 2010

SPECIFICATIONS:
6.75 x 6.75 inches,
softcover, perfect-bound,
58 pages

EDITION:
25

PUBLISHER:
self-published

Set in the creosote populated Mojave Desert, California's Morongo Basin was once the site of one of the last great American land grabs. The 1938 Small Tracts Act continued a long tradition of U.S. federal government efforts to spur development and thus dispose of purportedly useless land. Homesteaders were encouraged to apply for leases on unclaimed plots of land up to five acres; if necessary improvements were made within five years, a federal deed or "patent" could be applied for and the parcel purchased for an appraised price, usually between $10 and $20 per acre. As befits a particularly mid-century inflection of homesteading, the opportunities in Morongo Basin attracted a wide range of weekend adventurers and misfits from Southern California's urban areas who exploited the cheap offering to fulfill a slice of the American dream. With its name suggestive both of the small mammals native to the high desert and the slapdash rapidity of construction, the jackrabbit homestead is often a single room dwelling, little more than four walls and a roof — enough to claim a patent. The photographs of twenty-six examples collected here, each now abandoned and in varying states of disrepair and ruin, are a small selection of Kim Stringfellow's broader survey of the local landscape's cultural history. Decades old realty signs and crude scrawls in aerosol spray paint advertise the availability of these dream homes to the next wave of perhaps nonexistent pioneers. In these pictures of abandoned aspirations, the entropic forces of the desert win out over the promise of the real estate opportunity.

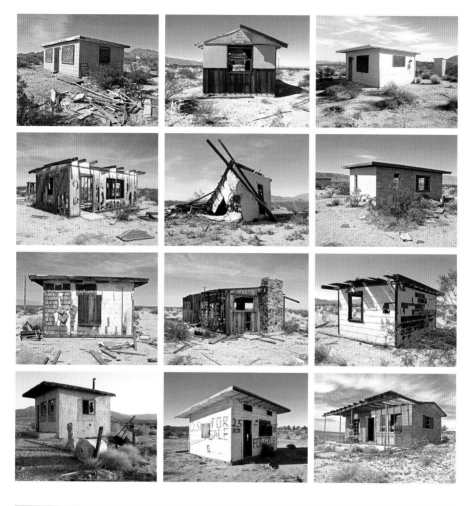

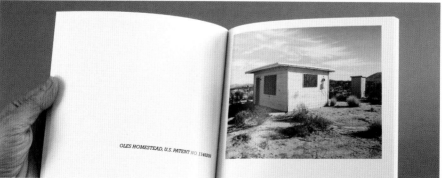

OLES HOMESTEAD, U.S. PATENT NO. 1146806

Various Unbaked Cookies and Milk
Marcella Hackbardt, 2010

SPECIFICATIONS:
9.75 x 7.75 inches,
softcover, perfect-bound,
38 pages

EDITION:
100

PUBLISHER:
self-published

Taking Ruscha's absurdist typology into the domain of "women's work" and stereotypes of female subjectivity, Marcella Hackbardt's droll *Various Unbaked Cookies and Milk* consists of 15 images of balled dough on parchment paper, followed by an exacting replication of Ruscha's photograph of a glass of milk and empty plate. As in *Various Small Fires and Milk*, all of the images are reproduced with a yellow varnish, except for the last, which is rendered in black and white. The slavish devotion to the production specificity of Ruscha's original here seems knowingly neurotic. If the implicit invocation of *Various Small Fires* is disregarded, then Hackbardt's typology and final image of milk has a colloquial matter-of-factness to it: cookies and milk. But the homey snack remains an unattained desire, its gratification deferred. What these goods need is to be *baked*— they need fire, in a sense. This unfinished quality of the subject matter ironically problematizes the notion of homage in and of itself, and the dependence on the (male) predecessor's work as referent in order to substantiate its own meaning. Recalling Martha Rosler's 1975 video, *Semiotics of the Kitchen*, Hackbardt delights in the slippage between putative gender roles and ironic mimicry.

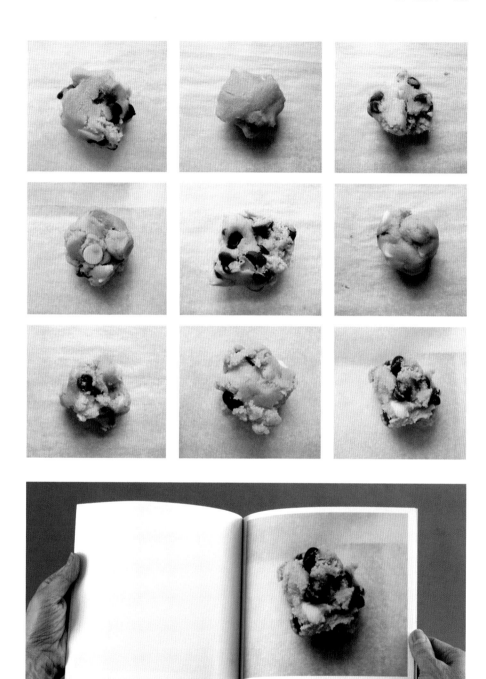

SPECIFICATIONS:
MEGA CHURCHES

5.5 x 5.5 inches,
softcover, perfect-bound,
28 pages

EDITION:
1000

PUBLISHER:
self-published

Eleven Mega Churches
NYSE: CBL Mall Maps
Real Estate Opportunities:
A 2010 International Investment Guide

Travis Shaffer, 2010

SPECIFICATIONS:
MALL MAPS

6.75 x 6.75 inches,
softcover, perfect-bound,
112 pages

EDITION:
open

PUBLISHER:
self-published

Subsequent to his 2008 version of *Thirtyfour Parking Lots*, Travis Shaffer produced a trio of publications that again make use of Ruscha's procedures as a means of investigating the intersections of finance, cultural geography, and the built landscape, and their emergence in the visual field. Like the earlier publication, *Eleven Mega Churches* is constituted from appropriated satellite imagery. Here too, parking lots figure centrally, but as a corollary effect of the primary subject matter. In linking houses of god to the infrastructure of automobile culture, Shaffer's aerial views provoke a deeper consideration of the relationship of contemporary religious institutions to patterns of suburban development. The overhead views of churches resonate with the plan views of *NYSE: CBL Mall Maps*. Shaffer compiled shopping guides to all 87 of the regional malls owned by the real estate investment fund CBL & Associates, traded on the New York Stock Exchange under the symbol CBL and one of the largest such funds in the United States. Presented along with a short text from the company's investment package, comparison of the morphology of these cathedrals of capitalism

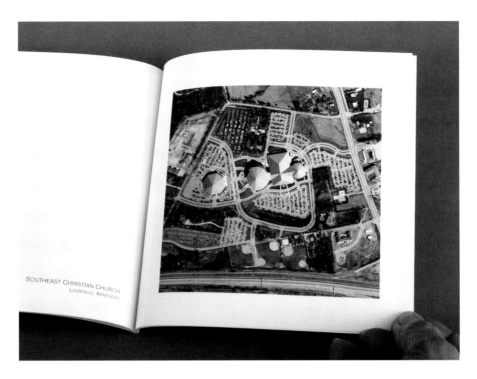

reveals patterns in the spatial organization of consumer experience. Large department stores serve as nodal points within the architecture, with JCPenny, Dillard's, Sears and Macy's cropping up at many of the locations.

While pictorially continuing the cartographic conceit, *Real Estate Opportunities: A 2010 International Investment Guide* develops a macroeconomic theme. The twenty nations with the highest per capita external debt are profiled in order of decreasing level of indebtedness. A monochrome map of the territory that is in the red appears alongside data indicating each country's debt according to three metrics. "This guide," Shaffer deadpans, "serves to enhance one's ability to identify nations who in their current fiscal standing are most in need of, or receptive to, international investment." For Shaffer, as with other artists surveyed here, Ruscha's precedents provide a rubric in which to insert his social concerns as serious play in the realm of the aesthetic.

SPECIFICATIONS:
REAL ESTATE
OPPORTUNITIES

6.75 x 67.5 inches,
softcover, perfect-bound,
26 pages

EDITION:
open

PUBLISHER:
self-published

Finland

External Debt 271,200,000,000

Debt per capita 51,073

Debt percentage of GDP 143.95%

SPECIFICATIONS:
9.75 x 7.75 inches,
softcover, perfect-bound,
106 pages

EDITION:
open

PUBLISHER:
self-published

Fifty-one US Military Outposts
Mishka Henner, 2010

With *Fifty-one US Military Outposts,* Mishka Henner charts the physical manifestations of the ongoing deployment of United States armed forces abroad. Beyond the association with *Thirty-four Parking Lots* serviced by the aerial views presented here, in fact these sites serve variously as gasoline stations, apartments and real estate opportunities, not to mention shelters to other activities irreducible to euphemistic characterization. All of the images, drawn from the public domain, are captioned with the outpost name, its geographical coordinates, and the host nation; Henner has selected stations in 51 different alphabetically sequenced countries. Some are famous or infamous, such as the CIA Predator drone launch site Shamsi Airfield in Pakistan or Bagram Air Force Base in Afghanistan, with which the book begins. The collection raises the question of how the United States has negotiated permanent military operations within the jurisdiction of sovereign nations. Most are almost certainly the result of peace treaties from past conflicts; others are perhaps

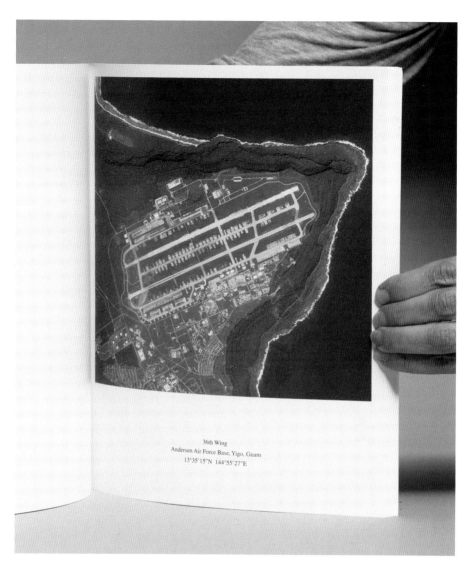

36th Wing
Andersen Air Force Base, Yigo, Guam
13°35'15"N 144°55'27"E

the price exacted for trade agreements or additional forms
of American support. Though devoid of textual explication,
Henner's bureaucratic archiving of the sites underscores the
dire portents of strategic occupation. Ensuring tactical mobility
and access requires long-term investment, such that foreign
military presence remains long after the cessation of hostilities.
The sun never sets on the American military-industrial complex.

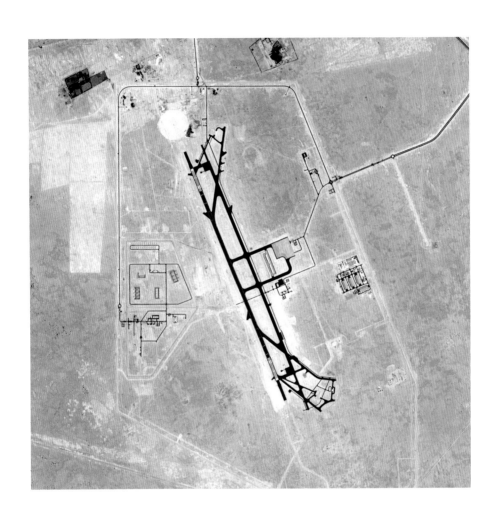

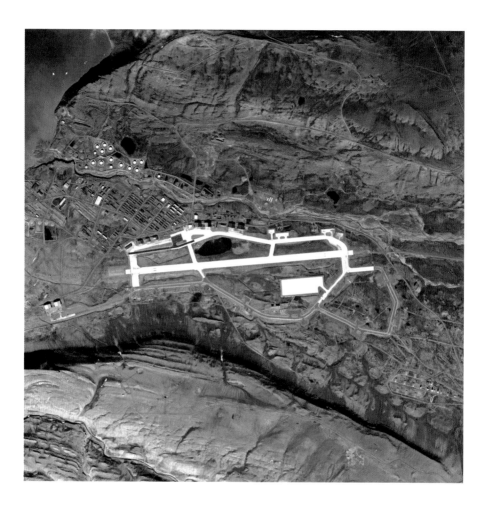

39 Sources and One Sink
On The Las Vegas Strip
Robert Pufleb, 2010

SPECIFICATIONS:
7.75 x 9.75 inches,
hardcover, 82 pages

EDITION:
40

PUBLISHER:
self-published

One occasionally hears of an ecologically conscious or
misanthropic pioneer living "off-the-grid." Embedded within
this turn of phrase is a reality rarely brought into consideration
of day-to-day life — that is, the extensive grid of utility services
that undergirds the conditions of modern habitation. This
mostly invisible network of water, electricity, gas and telecom-
munications forms an elaborate knot within the city. Working
in a mode of critical revelation, Robert Pufleb seeks to draw
attention to the system of resource "sources" that lie underfoot.
It seems not insignificant that he chooses as his test site Las
Vegas: that most artificial of cities, in which the natural is never
more than *trompe l'oeil.* Every exposure is centered on one lid,
portal or access point as the surfacing of the rhetorical grid.
For the photographs frame each source as a synecdoche for the
broader infrastructure. These utility covers inconspicuously
identify themselves with text, but obscure the actual processes
that bring light to the city. Such banal artifacts serve to further
mystify the appearance of seemingly limitless supply. Each
becomes an emblem for the consumption of the finite resources
that fuel a booming metropolis. The book contains 39 illustrations,
each apparently a "source." Together they map the collective
"sink" that is the Las Vegas Strip.

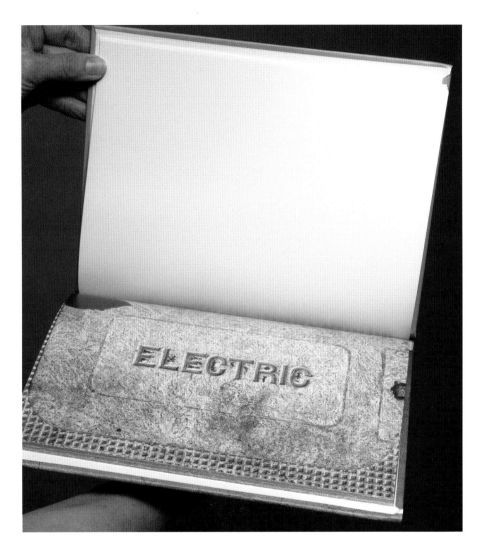

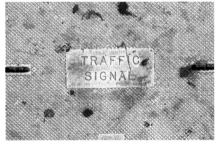

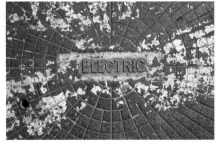

DEAD

GAS

STATIONS

Dead Gas Stations

Bill Daniel, 2010

Bill Daniel's modestly sized book might well be the program for a funeral. Spare and quiet portraits of the departed adorn the interior pages. But the sense that this might be a poetic dirge gradually drains from the pages. The blunt force of the opening salvo, "*dead* gas stations" having none of the polite tact demanded by whispered condolences, weighs on one's perception of the pictures. The collapsed and damaged structures evince a certain violence; they might well be crime scenes. Photographed on the road between Texas and California, each could be the setting for a Cormac McCarthy story.

Dead Gas Stations was produced under the umbrella of Demand and Supply 5, a print-on-demand project by Brooklyn-based publishing venture The Holster. Offered as a modest riff on Ruscha's precedent, the pictures were taken as preliminary 35mm studies to be revisited later with a large-format camera. A long-time adherent of life on the open road, Daniel has seen his passion for petroleum-propelled internal combustion leavened by his awareness of the environmental impact of fossil fuel consumption. Created against the backdrop of the questionable motives behind the prolonged war in Iraq and a personal interest in the implications of peak oil extraction, Daniel's pictures imagine a troubled, futuristic landscape. Any romantic nostalgia for the innocence of Ruscha's and Daniel's highway adventuring is poisoned by this postcard of modern ruins. Contemplating these images of casualties, the testimonial services of the eulogy and the criminal investigation become allied.

SPECIFICATIONS: 7.5 x 5 inches, softcover, saddle-stitched, 12 pages
EDITION: 50 **PUBLISHER:** The Holster

ONE

GASOLINE

STATION

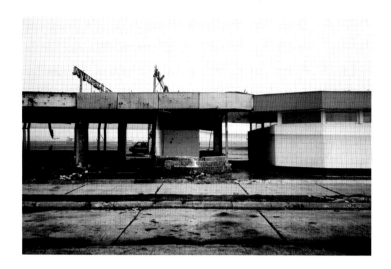

One Gasoline Station
Dejan Habicht, 2010

Printed on gridded graphing paper, Dejan Habicht's *One Gasoline Station* has an austere economy to its presentation. As the poster is unfolded, the service station in question appears in two photographs: one taken at an oblique angle to the main structure occupies the back cover; the second large frontal shot covers one entire side of the broadsheet. Most of the glass windows of the structure are gone, the signage is in ruins, and brick walls crumble. In the far background, a car and a truck can be made out beyond a stretch of grass, presumably driving by on the highway. A third car, closer to the camera but still behind the delapidated station, stands parked, partially obscured by the building. The same vehicle occupies the first spread of the unfolded poster: there it appears as a small black and white cut-out image of a car running into the centerfold; it leads into a quote on the facing page: "Gasoline station on the E70 route in Croatia was photographed in August 2001. The parts of the E70 that go through former Yugoslavia formed part of the so-called Brotherhood and Unity Highway until 1991." This roadway, built under President for Life Josip Broz Tito, was intended to symbolize the promises of freedom, mobility, and an open society, but sections were severely damaged during the violent wars that led to the dissolution of Yugoslavia.

SPECIFICATIONS: 8 x 5.75 inches, broadsheet, 6 pages, color ink-jet
EDITION: open PUBLISHER: Zavod P.A.R.A.S.I.T.E.

Sechsundzwanzig Wiener Tankstellen

Sechundzwanzig Wiener Tankstellen

Stefan Oláh, Sebastian Hackenschmidt, 2010

The title of this book is deliberately misleading: within appear 36 photographs by Stefan Oláh depicting 34, not 26, different gas stations. The artist has both trans*lated* and trans*posed* Ruscha's iconic concept to the setting of 21st century Vienna — one of his paintings is even digitally inserted into the cover photograph. As a result, the differences between the projects are striking. Unlike Ruscha's quintessentially American take on the automotive culture of the open road, Oláh's color photographs depict gas stations immersed in a dense urban milieu. In Vienna, car culture had to find a niche within an urban layout that evolved well before the introduction of automobiles and the infrastructure necessary to support them. Many of the gas stations are embedded within multi-use architecture, rather than freestanding buildings of distinctive corporate design. Which is not to say that these pictures do not bear traces of corporate branding; here too one encounters BP and Shell. If anything, the pictures testify to the global hegemony of petroleum markets. Nevertheless, the idiosyncrasy of these gas stations and their adaptation to the specific demands of the Viennese context is striking. Alongside Oláh's vertical and horizontal format photographs, art historian Sebastian Hackenschmidt contributes an essay.

SPECIFICATIONS: 8.75 x 6.75 inches, softcover, perfect-bound, 80 pages
EDITION: 800 **PUBLISHER:** Roma Publications 143

One Thousand Two Hundred Twelve Palms
Mark Ruwedel, 2010

SPECIFICATIONS:

11.25 x 14.25 inches,
hardcover, 28 pages

EDITION:

500

PUBLISHER:

Yale University
Art Gallery

The titles of Ruscha's photobooks range from absurd specificity to vapid generality, from numerical inventory to *some, various* or *a few.* No such indeterminacy for Mark Ruwedel's book of palm trees. Ruwedel takes the Ruscha conceit of nomination to another level: the 1212 palm trees of this book's title refers not to an arboreal census depicted photographically, but rather to a sum of the numbers in Southern California desert place names containing palm. Una Palma, Four Palms Spring, Five Palms Spring, Seven Palms Valley, Seventeen Palms Oasis, Twentynine Palms, Fortynine Palms Oasis, 100 Palms, Thousand Palms Oasis: the nine places enumerate 1212 nominal trees. In a short statement included in the publication, Ruwedel writes, *"Twentysix Gasoline Stations. 101 Strings. 200 Motels.* ... There is something appealing about names of titles with numbers in them; they refer to the countable and the contained, no matter how large the quantity. They seem at once definitive and humorously arbitrary."

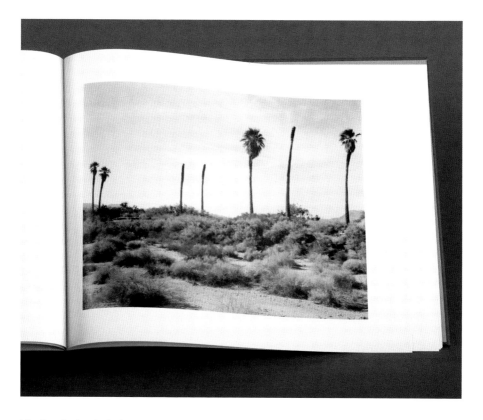

The book also includes a short history of the region and provides information on the one species of native palms.

Naming is a form of landmarking, and the preponderance of palm-indexing places speaks to their appearance as exclamation points on the desert horizon — literal oases in a harsh, shadeless landscape. Photographs taken at Una Palma and Four Palms Spring depict just what their names describe. Other images are not such literal illustrations of their toponymic captions. 100 Palms is the site of a Surrealist gesture: three roadside trees are improbably adorned with ladders hanging from their high branches. No explanation is offered. Close to Una Palma, maps denote a spot called One Palm. Ruwedel searched for the namesake, but to no avail. Evidently a visual correspondence corroborating the referentiality of the toponym was necessary to merit the making of a photograph. Otherwise this volume would have a different title.

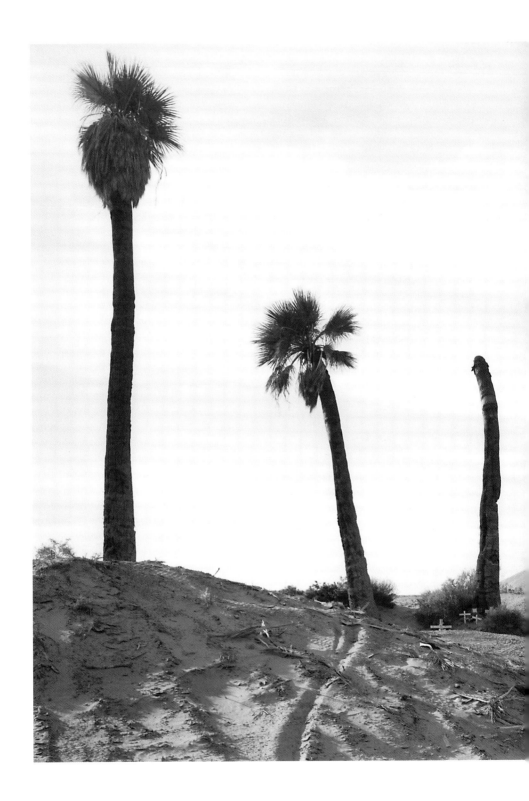

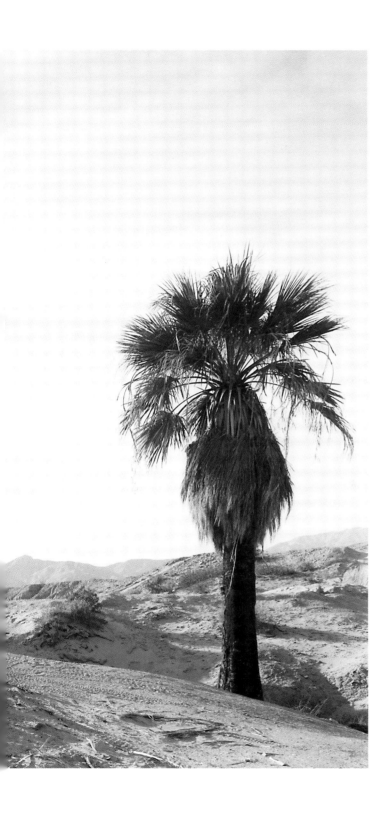

Twelve Los Angeles Corners (and Nothing Broken)
Marc Valesella, 2010

SPECIFICATIONS:
7 x 5.5 inches,
softcover, perfect-bound,
38 pages

EDITION:
100

PUBLISHER:
self-published

If Ruscha wanted his first books to incite the reader to say, "Huh?" then Marc Valesella suggests his viewer might begin by asking, "WHAT?" The first reaction arises from not understanding, while the second is predicated on failed recognition. Valesella prescribes this response to the pictures in his book *Twelve Los Angeles Corners (and Nothing Broken)* by inserting the question in blue text on the first page following the title boards. Midway through the book more text indicates the viewer's presumed epiphany: "you are taking pictures of corners!" The ambiguity of the title and the Ruscha reference suggests the subjects might be street corners, but one quickly realizes that they are the corners of buildings. In this shift of focus, Valesella's aesthetic genealogy moves from the deadpan real estate snapshots of Ruscha to the photographic abstractions of Aaron Siskind and others. Closely cropped to exclude surrounding context, the images have a surprising flatness considering the actual spatial recession of the subject matter. Photography is used for almost exclusively aesthetic purposes. Many images resemble hard-edged abstract paintings, with stucco passing for richly textured impasto. Tonal differences arise from shifts between direct sunlight and shadow on perpendicular surfaces. In other cases adjacent walls are painted different colors. Valesella takes a self-deprecating wisecrack at the decorative appeal

of these pictures, anticipating the response, "But, honey, it
will look good above the new couch…" Even here then, the
"Nothing Broken" of the title points back to Ruscha's swimming
pools, and what might be a shared interest in the aesthetic of
cool Southern California living.

Tadej Pogačar

Various (Small) Pieces of Trash

Various (Small) Pieces of Trash
Tadej Pogačar, 2010

The photographs in Tadej Pogačar's book document a single location in the city of Santa Cruz de Tenerife in the Canary Islands. Beginning with tightly framed close-ups of litter, the photographer gradually raises his viewfinder to reveal a broader swath of these garbage strewn scenes by the middle of the book. As more contextual information is admitted, an empty lot emerges surrounded by newly constructed buildings. A paved esplanade with freshly planted trees passes by the blighted site. Although the title recalls *Various Small Fires*, the photographs have more in common with the forensic imagery of *Royal Road Test*. The area has accumulated detritus, its disuse and lack of maintenance the symptoms of a redevelopment process foreshadowed by the surrounding real estate investment. If only revealed temporarily then, Pogačar investigates this open stratum of evidence for future historians. Sifting through the refuse of the everyday, the artist functions as an archaeologist of the present. The final image shows the foundations of a leveled structure, one that very well could have been a gas station. A colonial outpost of the Castilian kings, the Canary Islands served as an important stopover for the conquest of the New World. Against the backdrop of centuries of imperialism, seemingly inconsequential details in this small book open on to the grand forces of economic and historical change active in an otherwise unremarkable landscape.

SPECIFICATIONS: 8.5 x 6.25 inches, softcover, perfect-bound, 48 pages
EDITION: 100 PUBLISHER: Zavod P.A.R.A.S.I.T.E.

2011

PEANUTS

PEANUTS

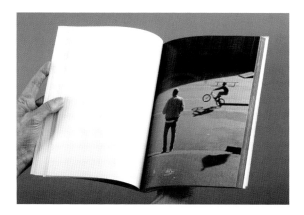

Peanuts *Dan Colen,* 2011

If one were to judge a book by its cover, then *Peanuts* sure looks like *Crackers.* But rather than the storyboard for a film, as is the case for the latter, Dan Colen's book is comprised of stills from the artist's already completed first film. The images follow the lanky artist as he wanders the streets of Manhattan, with the duration of the walk ostensibly structured around the time it takes to consume a bag of peanuts. Colen gazes up at skyscrapers, interacts with doormen, meets with a wide range of public art, and encounters familiar neighborhood characters. Navigation of the full range of the city seems contrived: one wonders if Colen truly walked from Lower Manhattan up to the Apollo Theater in Harlem and then back down to the Hudson Yards on the West Side. No matter — it is a love sonnet to the city, with Colen drawing on a richly textured tradition including Baudelaire's flâneur, Joyce's Leopold Bloom, the Situationist *dérive,* and Charlie Brown comics.

The narrative reaches a tongue-in-cheek self-referential climax when it cuts from the Staten Island Ferry to Time Square for a face-to-face with a massive Planters' Mr. Peanut billboard. With its gritty yet casual premise and engagement with a wide range of pop-, sub- and high-cultural elements, *Peanuts* functions as a précis of Colen's painterly practice more generally. The book doubles as the catalogue to Colen's exhibition at the Astrup Fearnley Museum of Modern Art, and includes critical essays and reproductions of his artwork. Several series of paintings simulate falling confetti or accumulated bird shit, while others are composed with masticated chewing gum, linking representation and facture in the material. Here too, Colen leaves his traces on the canvas of the city: a trail of discarded peanut shells strung across the landscape.

SPECIFICATIONS: 9.5 x 6.75 inches, softcover with dust jacket, perfect-bound, 240 pages
EDITION: unknown PUBLISHER: Astrup Fearnley Museum of Modern Art

Every Building on Burnet (burn-it) Road
Keith Wilson, 2011

SPECIFICATIONS:
7.125 x 9.375 inches
(closed), 7.125 x 54
feet (open), hardcover,
81 pages, accordion-fold
with slipcase

EDITION:
12

PUBLISHER:
self-published

Keith Wilson reports that Austin, Texas's Burnet Road was once declared "the ugliest road in America." Both fascinated and repulsed by the mélange of independent businesses and big box corporate retail outlets, he has set out to document the 11.6 mile thoroughfare. Ruscha's iconic continuous panorama and accordion construction supply the format for shining an unflinching light on this landscape. If the Sunset Strip already exerted a force within the collective imaginary, Burnet Road and others like it throughout the United States are largely taken for granted. Excluded from guidebooks and chamber of commerce promotions, Burnet Road serves as an important link between the inner suburbs of Austin and the satellite exurbs. The publication featured here is the first of three planned volumes that will document the entire length of Burnet Road. Part one documents the most heavily traveled southern section radiating outward from Austin. This 4.1 mile length translates to a 54-foot-long span of parallel photographic bands. Wilson's straightforward, exhaustive survey makes the case for considering the patterns of human and commercial circulation within American cities. Representation provides a mode of being attentive to such forces. As zoning and development continue to shape the cultural and built landscape, Burnet Road is shifting even as Wilson attempts to pin it down.

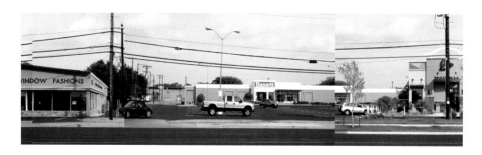

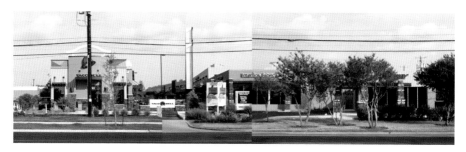

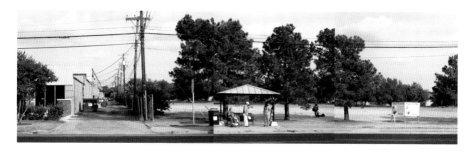

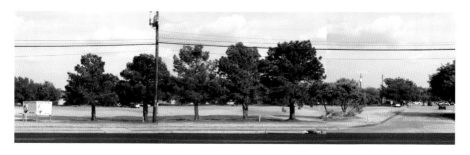

Real Estate Opportunities
Wendy Burton, 2011

SPECIFICATIONS:
9.75 x 7.75 inches,
softcover, perfect-bound,
40 pages

EDITION:
100

PUBLISHER:
For A Small Fee, Inc.

Washed in natural winter light from a nearby window, this collection of abandoned architecture turns Ruscha's conceptual gambit into a stanza of natural philosophy. Their incubating purpose fulfilled and the chicks flown, such nests await the annual return of the parents or their appropriation for another's roost. Having seized upon these avian real estate opportunities, Wendy Burton tenderly photographed the found homes as tabletop objects of wonder. Originally devised to avoid detection by predators in the wild, the abscission of the native deciduous habitat exposes the nests to the careful eye of the artist on her regular walks. Consistent with her other projects investigating abandoned *human* constructions, Burton invites the viewer to ruminate on what she calls the "unspoken histories" of her subjects. Providing a close-up view of the nests' structural complexity and the artifacts of their occupation, the photographs are nearer in style to Dutch master still lifes than Ruscha's famous deadpan snapshots. Thus they betray a warm intimacy. Still, the nests remain simultaneously precious poetic phrases and remarkable feats of natural engineering. Presented here as interiors within an interior, the photographs raise questions on the meaning of dwelling and of making one's home. Such doggedly material memories appear as though collected in an early modern cabinet of curiosity, of which this book is an apt 21st century equivalent.

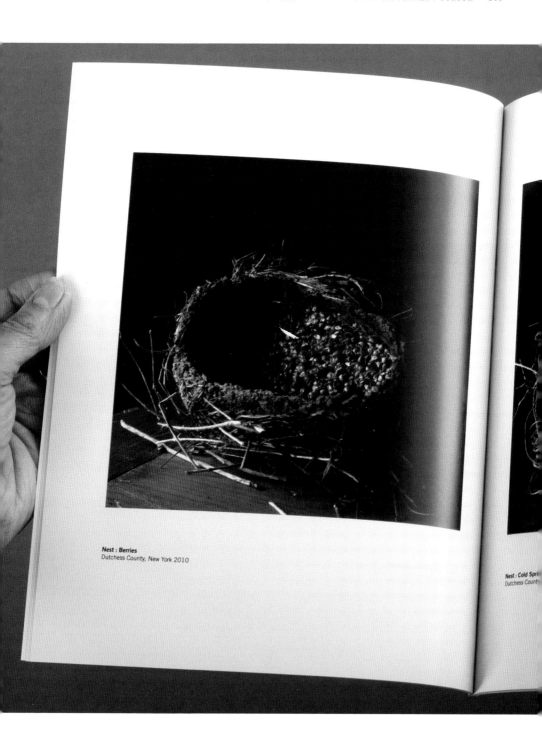

Nest : Berries
Dutchess County, New York 2010

Nest : Cold Spri
Dutchess County

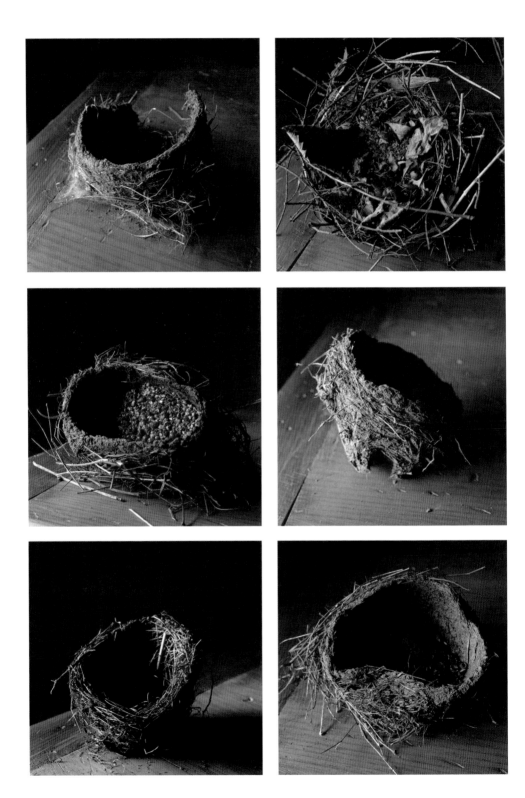

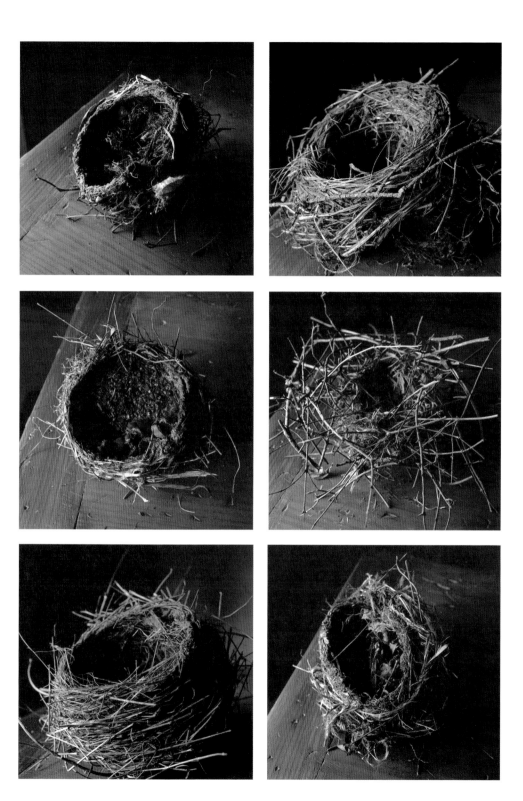

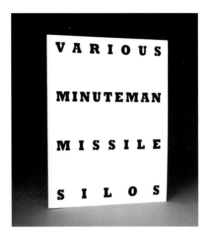

Various Minuteman Missile Silos
Jeff Brouws, 2011

Decades after the dissipation of Cold War tensions, nuclear fears are hardly the factor in the national conscious of the United States that they once were. But the infrastructure of nuclear warfare and the potential for deployment certainly remain. Jeff Brouws has been interested in this forgotten aspect of the American cultural geography since the 1980s, when he began his project *After Trinity*. Revisiting the topic in recent years, he expanded on photographs taken in 1987 of the N-flight of missile silos in Colorado by shooting silos in North Dakota. In many ways the ideas manifest in this book are the inverses of Brouws's *Twentysix Abandoned Gasoline Stations*: while failed gas stations were private enterprises servicing the public, the missile silos are instruments of the public trust — the federal government — that are inaccessible to the population they serve and which persist despite their growing obsolescence. Distributed far from dense population centers, this latent martial threat simmers below the threshold of everyday discourse. In Brouws's photographs chain link fence screens the view of many of the silos, foregrounding the barrier as a metaphor for the relationship of the military industrial complex to the citizens it is appointed to protect. At the same time, the book serves to make missile silos visible by disseminating their likeness beyond the limits of their remote geographical location. The landscapes represented are a mixture of industrial wastelands and sublime prairie interrupted by tea-green silos. Bunker

SPECIFICATIONS:
9.75 x 7.75 inches, softcover, perfect-bound, 40 pages

EDITION:
100

PUBLISHER:
For A Small Fee, Inc.

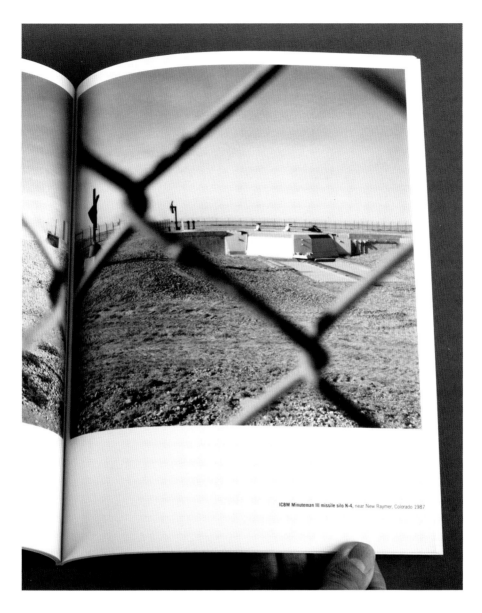

ICBM Minuteman III missile silo N-4, near New Raymer, Colorado 1987

aesthetics necessarily sacrifices good design in favor of inconspicuousness. The form of the exposed missile hatches seems innocuous enough, but no small fire comes from these bombs. Brouws's allusion to Ruscha infuses the serious subject matter with a sardonic twist.

NINE

LIVE

SWIMMING

POOLS

NINE LIVE SWIMMING POOLS

ANDREAS SCHMIDT

Nine Live Swimming Pools *Andreas Schmidt*, 2011

Between 9:49 and 10:12 PM, Greenwich Mean Time, on Friday, March 11, 2011, Andreas Schmidt logged on to nine live video feeds aimed at swimming pools in Europe, the United States, and the Cayman Islands. Still images were captured from each broadcast, and these constitute *Nine Live Swimming Pools*. All of the webcams were accessed via a publicly accessible webcam aggregator. The *raison d'être* for these live streaming views may be to offer prospective resort guests a view of the luxury that awaits them. Regardless, their availability feeds a culture of surveillance and voyeurism. In less than half an hour, an individual like Schmidt at his computer in London can spy on locations all over the globe. Under cover of night — or any time of day, really — he can watch daylight sunbathers across the Atlantic. The internet and the optical media it facilitates obliterate distance as an impediment to visual perception. Of course, the cameras located in France, Bulgaria and Italy all look on dark prospects at that hour. But an eerie ambience pervades all of the images: even the larger resorts are completely empty of human figures. These "live" pools seem nothing of the sort. Surveying this ominous screen, one wonders what crime scene or disaster is represented. Perhaps even in a post-apocalyptic world the webcams will continue streaming their live feed to an absent audience.

SPECIFICATIONS: 6.75 x 6.75 inches, hardcover, 22 pages
EDITION: 100 PUBLISHER: self-published

Artists / Contributors Biographies

NORIKO AMBE (B. 1967 SAITAMA, JAPAN) lives and works in New York and Tokyo. She received her BFA in oil painting from Musashino Art University, Tokyo, in 1990. She started in 1999, using paper, "Linear-Actions Project Cutting / Drawing." She individually cuts and stacks hundreds and thousands of pieces of paper to create an original topography; trying to embody the synchronicity between humans and nature. The works have been exhibited at solo shows at Pierogi, New York; Josée Bienvenu Gallery, New York; The FLAG Art Foundation, New York; Lora Reynolds Gallery, Austin, Texas; and SCAI, Tokyo; group shows at the Contemporary Arts Center, Cincinnati; The Drawing Center, New York and more. The "Flat Globe, Above NY" piece is in the permanent collection of the Whitney Museum of American Art, New York.

EDGAR ARCENEAUX (B. 1972 LOS ANGELES, CALIFORNIA) lives and works in his Los Angeles hometown. He received his MFA from California Institute of the Arts in 2001. Arceneaux's work resides in the collections of the Whitney Museum of American Art, New York; The Museum of Modern Art, New York; the San Francisco Museum of Modern Art; Walker Art Center, Minneapolis; The Museum of Contemporary Art, Los Angeles; the Los Angeles County Museum of Art; and the Ludwig Museum, Cologne, Germany, among others. He recently had a solo exhibition at the Museum of Contemporary Art Detroit, and has an upcoming solo show at the Museum für Gegenwartskunst in Basel, Switzerland.

ERIC BASKAUSKAS (B. 1984 SAN FRANCISCO, CALIFORNIA) lives and works in Chicago, Illinois, where he received his MFA from the School of the Art Institute of Chicago in 2011. He holds a BA in Visual Arts from the University of California, San Diego in 2006. His graphic work is included in several private and public collections throughout the US and he spends his free time writing and hitting drums for BRAIN VACATION.

DORO BOEHME (B. 1959 HALLE (SAALE), GERMANY) received her MFA from the Staatliche Kunstakademie Stuttgart and an MLIS from Dominican University, River Forest, Illinois. She selected Chicago for a one-year artist's residency sponsored by the Ministry of Culture and Sciences in 1989 and moved there permanently in 1993. Currently she teaches, writes, and works as the curator of the Joan Flasch Artists' Book Collection in the Flaxman Library at the School of the Art Institute of Chicago.

JEFF BROUWS (B. 1955 SAN FRANCISCO, CALIFORNIA) has spent more than twenty-five years documenting the American cultural landscape, increasingly using photography to explore the historical underpinnings of socioeconomic and political issues. He is the author of seven books, including *Approaching Nowhere* (W.W. Norton, 2006). His *Twentysix Abandoned Gasoline Stations* is in the special collections of The Museum of Modern Art, The Art Institute of Chicago, and the Bibliothèque Nationale de France. Brouws's photographs are in numerous private and public collections, including Harvard's Fogg Museum, the Princeton University Art Museum, the San Francisco Museum of Modern Art, and the Whitney Museum of American Art. He lives in Stanfordville, New York.

DENISE SCOTT BROWN (B. 1931 NKANA, ZAMBIA) is a founding principal of the firm Venturi, Scott Brown and Associates, Inc. whose work and ideas have influenced generations of architects and planners. She has led and contributed to dozens of major design and planning projects for academic, civic, cultural, and municipal clients, including the Mielparque Nikko Kirifuri resort; the Toulouse provincial capitol building; Penn's Perelman Quadrangle; programming for the National Museum of the American Indian; and planning for cities, towns, and campuses. Her awards include the National Medal of Arts and the American Institute of Architects Topaz Medallion. She now spends much of her time writing; *Having Words* is her recent book of essays.

WENDY BURTON (B. 1951 NEW YORK, NEW YORK) studied Intaglio Printmaking at Brandeis University with Michael Mazur and engraving with Dadi Wirz at Atelier Garrigues. She began making photographs in 1998. Her first solo show was at the Craig Krull Gallery in 2000. She is represented by the Craig Krull Gallery in Santa Monica, California, the Robert Klein Gallery in Boston, Massachusetts, and Lee Marks Fine Art, Shelbyville, Indiana. Her work is included in the following collections: Photographic Archives at the University of Louisville, Kentucky; The North Dakota Museum of Art, Grand Forks, North Dakota; the San Francisco Museum of Modern Art; and the Santa Barbara Museum of Art.

DAN COLEN (B. 1979 LEONIA, NEW JERSEY) lives and works in New York. He graduated with a BFA in Painting from the Rhode Island School of Art and Design in 2001. Colen's work resides in the collections of the Whitney Museum of American Art, New York; The Astrup Fearnley Museum of Modern Art, Oslo Norway; and has been exhibited at the New Museum, New York; Macro Future Museum, Rome, Italy; Saatchi Gallery, London; the 2006 Whitney Biennial; The Royal Academy; PS1 Contemporary Art Center, Long Island, New York; and The National Museum of Art, Architecture and Design, Oslo.

JULIE COOK (B.1960 ST ALBANS, HERTFORDSHIRE, ENGLAND) lives and works in London and is an artist whose work is photography based. She studied photography at Westminster University and London College of Communication. Her book publications include the award-winning *Baby Oil and Ice*, *Striptease in East London*, *Zeropolis*, *Stripping Las Vegas*, *A Contextual Review of Casino Resort Architecture*, and *The Architect's Guide to Fame*. Cook has also produced a series of artist books: the *Las Vegas Diaries*, *Some Las Vegas Strip Clubs*, *Beauties of Today, Vols 1–4* and *Reno*. She is currently working as a Senior Lecturer in Photography at University of East London and is a member of ABC Artists' Book Cooperative.

JENNIFER DALTON (B.1967 LOS ANGELES, CALIFORNIA) lives and works in Brooklyn, New York. She earned a BA in Fine Art from UCLA and an MFA from Pratt Institute in Brooklyn. She received a Pollock/Krasner Foundation Grant in 2002 and a Smack Mellon Studio Fellowship for 2005-2006, and she has spent time in residence at Yaddo, the MacDowell Colony, and the Millay Colony. Her work has been discussed in *Artforum*, *ArtNEWS*, *Art + Auction*, *Art in America*, *The New York Times*, and *The Washington Post*, among other publications. Her work has recently been exhibited at Winkleman Gallery and Flag Art Foundation, New York, New York; John Michael Kohler Arts Center, Sheboygan, Wisconsin; and Smack Mellon Gallery, Brooklyn, New York.

BILL DANIEL (B.1959 DALLAS, TEXAS) has exhibited film, photography, and installation work at The Museum of Modern Art, New York; Sweets Lounge, Biloxi, Mississippi; The New Museum, New York; Wayward Council, Gainesville, Florida; Yerba Buena Center for the Arts, San Francisco; 24/7 House, Columbus, Ohio; Museum of Contemporary Art, Los Angeles; Beehive Collective, Machias, Maine; Walker Arts Center, Minneapolis; Sky High Skateboards, Milwaukee, Wisconsin; IFFR, Rotterdam; OKC Infoshop, Oklahoma City; Redcat, Los Angeles; Moose Lodge #1735, Austin, Texas; Deitch Projects, New York; Railroad Blues, Alpine, Texas; Sluggos, Pensacola, Florida; The Smell, Los Angeles; Plan B, New Orleans.

JEN DENIKE (B.1971 NORWALK, CONNECTICUT) received her MFA from Bard College in 2002. DeNike has exhibited internationally, including at The Museum of Modern Art, New York; KW Institute for Contemporary Art Berlin; Palais de Tokyo; MoMA PS1; Julia Stoschek Collection; Brooklyn Museum; CCS Hessel Museum; EMPAC; Performa Biennial 2009; Experimenta Biennial Australia 2009; Tensta Konsthall Sweden; CAHM Houston; Deichtorhallen Hamburga; Cobra Museum Netherlands; Zendai Museum of Modern Art Shanghai; MACRO Rome; and Kunstlerhaüs Stuttgart. Her video work was included in the exhibition *Commercial Break* at the 54th Venice Biennale (2011).

ERIC DOERINGER (B.1974 CAMBRIDGE, MASSACHUSETTS) received a BA from Brown University and an MFA from the School of the Museum of Fine Arts, Boston. He has had solo gallery shows in New York, Los Angeles, and Toronto and exhibited at museums including MoMA PS1, MUSAC, La Musée d'Art Moderne de la Ville de Paris, The Whitney Museum, The Currier Museum, and The Bruce Museum. Doeringer recently completed the Volunteer Lawyers for the Arts Art & Law Residency and curated *I Like The Art World And The Art World Likes Me* at the EFA Project Space in New York City.

STAN DOUGLAS (B.1960 VANCOUVER, BC CANADA) lives and works in Vancouver. Since 1990 his films, videos and photographs have been seen in exhibitions internationally, including Documentas IX, X and XI (1992, 1997, 2002) and three Venice Biennales (1990, 2001, 2005). Public collections are housed at National Gallery of Canada, Ottawa; Vancouver Art Gallery, Vancouver; Tate Collection, London; Guggenheim, New York; MoMA, New York; and Centre Georges Pompidou, Paris. A comprehensive survey of his work, *Past Imperfect: Works 1986–2007*, was mounted by the Württembergischer Kunstverein and the Staatsgalerie Stuttgart in the fall of 2007. In 1986, he organized a touring exhibition of Samuel Beckett's media works for the Vancouver Art Gallery titled *Samuel Beckett: Teleplays*, and in 2006 co-curated *Beyond Cinema: Art of Projection* for the Hamburger Bahnhof, Berlin. Between 2004 and 2006 he was a professor at the Universität der Künste Berlin and is a member of the Core Faculty in the Graduate Department of Art Center College of Design in California.

HARLAN ERSKINE (B.1977 NEW YORK, NEW YORK) is a photographer who received his MFA from the School of Visual Arts in 2009. He has been exhibited at the Bas Fisher Invitational, the Miami Art Museum, Locust Projects Annual Fundraiser, Lemon Sky Projects, and the Ambrosino Gallery, which has shown his photography at the PalmBeach3, Art Basel Miami Beach and Pulse art fairs. In 2006, a photograph from Erskine's series, *Ten Convenient Stores*, was included in an exhibition at the Miami Art Museum, curated by Andy Goldsworthy, entitled *Modern Photographs: The Machine, the Body and the City — Selections from the Charles Cowles Collection*. The show was comprised of artwork donated to the museum's permanent collection. In 2008, Erskine's first solo show, *Black Sun Project*, was exhibited at the Bas Fisher Invitational in Miami, Florida.

KOTA EZAWA (B.1969 COLOGNE, GERMANY) received his MFA from Stanford University in 2003. Ezawa transforms found footage from television, cinema, and art history into simplified vector-based animations, slide projections, lightboxes, sculptural objects, and prints. His work can be found in numerous museum collections, including the Museum of Modern Art, New York; the Metropolitan Museum of Art; the San Francisco Museum of Modern Art; and the Hirshhorn Museum and Sculpture Garden, Washington, DC. His recent publications include *Odessa Staircase Redux*, (ECU Press/JRP Ringier, 2010), and *The History of Photography Remix*, (Nazraeli Press, 2006). He received a Louis Comfort Tiffany Foundation Award in 2003, a SECA Art Award from the San Francisco Museum of Modern Art in 2006, and a Eureka Fellowship in 2010. Ezawa lives and works in San Francisco.

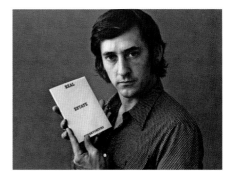

ROBBERT FLICK (B.1939 AMERSFOORT, HOLLAND) is a Southern California artist who uses photography as his primary medium. Flick received a BA at the University of British Columbia and an MA and MFA at the University of California, Los Angeles, where he studied with Robert Heinecken. He has been exhibiting his photographs for over 30 years, and his work has been shown and collected at numerous private and public venues both nationally and internationally. He has been the recipient of two NEA Fellowships, a Guggenheim Fellowship, and was a Getty Scholar at the Getty Center for the History of Art and the Humanities. A 30-year retrospective of his work was held at the Los Angeles County Museum of Art in 2004 accompanied by a major monograph "Robbert Flick: Trajectories" jointly published by LACMA and Steidl Verlag, Germany. His work is represented by Rose Gallery in Santa Monica and Robert Mann Gallery in New York. From 1976 until 2006 he headed the photography program at the University of Southern California Roski School of Fine Arts.

JAN FREUCHEN (B.1979 STAVANGER, NORWAY) is an Oslo-based artist working with installations, drawings, sculptures and constructions. Freuchen's deconstructive artistic practice reconsiders human achievements — including avant-garde art — in the light of a non-linear, dynamic theory where natural processes and the feedback loops of contemporary cultural expressions provide the fundaments. He holds a degree from Kunsthøgskolen in Bergen and Staatliche Hochschule für Bildende Künste, Frankfurt am Main. Among Freuchen's recent exhibitions are: *F.A.Q.* (2010), Erik Steen Gallery, Oslo; *Momentum*, the Nordic Biennial, Moss; *If you destroy the image(...)* (2008), Bergen Kunsthall; *Lights On* (2008); Astrup Fearnley; and *Destroy Athens* (2007), 1st Athens Biennial.

ANNE-VALÉRIE GASC (B.1975 MARSEILLES, FRANCE) has a Doctorate Thesis in Arts from Panthéon-Sorbonne University in Paris. She created GASC DÉMOLITION to run her projects — an artistic enterprise that determines the strategies appropriate to the disturbances of the world. She sees Ruscha's *Some Los Angeles Apartments* as the last book of a violent trilogy: *Twentysix Gasoline Stations* determines gasoline as the best flammable liquid; *Various Small Fires* presents a succession of small flames as detonators; and *Some Los Angeles Apartments* appears to her as the architectural, neutral, and anonymous inventory of targets to destroy. Her *Some Belsunce Apartments*, one of her artist books, lists specific architectures from the reconstruction of the Belsunce district in Marseille. The succession of these buildings, in which every image is directly downloaded via the web and presented in chronological order, clearly creates the various vague politics led by the municipality in a unique purpose: the "reconquest of the city center of Marseille," according to the usual public formula.

THOMAS GALLER (B.1970 BADEN, SWITZERLAND) is an artist whose work revolves around issues of media representation, the importance of authorship and transfer of found materials, and reflects a critical social attitude of products and phenomena of mass culture. His works are created through a multistage process of searching, analyzing, selecting and re-contextualizing the chosen material. The essence of Galler's work draws on wide-ranging global issues. His personal environment is rarely the source of his work, which originates in vastly different parts of the world and is usually linked to contemporary or historical flashpoints around the globe: the Red Army Faction (RAF), African child soldiers, Iraq, the Middle East, Vietnam or the Second World War, etc. The artist is widely traveled and has worked in Paris, New York, and Cairo.

MARCELLA HACKBARDT (B.1959 STANWOOD, MICHIGAN) currently lives in Mount Vernon, Ohio. She received her MFA from the University of New Mexico in 2000. Solo exhibitions include those at The College of Wooster Art Museum, Alaska Pacific University, and the Weston Gallery in Cincinnati. Two of her projected works have been performed at the Ingenuity Festival of Art and Technology, Cleveland, and her work has been included in exhibitions at The Center for Fine Art Photography, Fort Collins, Colorado; MOCA Cleveland, and SohoPhoto in New York. Hackbardt is an Associate Professor of Art at Kenyon College in Gambier, Ohio.

DEJAN HABICHT (B.1960 LJUBLJANA, SLOVENIA) studied philosophy and ethnology at the University of Ljubljana but never finished his studies. He works in the fields of photography, video and artist's book. His work has been shown in group exhibitions at venues that include Moderna galerija, Ljubljana (2000, 2003, 2005, 2006, 2007, 2008, and 2010); Ars Aevi, Sarajevo (2001); Neuer Berliner Kunstverein, Berlin (2001); the Gallery of Extended Media, Zagreb (2004); Museum 25th May, Belgrade (2009); and the Biennial of Graphic Arts, International Centre of Graphic Arts, Ljubljana (2007, 2009). He lives in Ljubljana and works as a professional photographer in Moderna galerija, Ljubljana.

CHARLES ANDREW HADFIELD (1947–2008) was born in Surrey, England. He joined the BA Photography course at Brighton prior to which he already had a long and successful career as a bank manager. He had worked abroad, including in Paris, and brought a huge wealth of experience, energy and a "Frank Eye", as well as invested much passion and a deep interest, in history and photography. Charlie realized many experimental and innovative projects, culminating in *Without Trial* (2005). This installation comprised of photos, video and sound about Breendonk Camp (1940-45), a Nazi concentration camp in Belgium, and was exhibited at the Old Market, Brighton. *Without Trial* remembers the names of each political prisoner who had been murdered in Breendonk. Charlie's alter ego, Frank Eye, produced the bookwork *444 Former Filling Stations* over a six-month period in 2005/6. Frank Eye had been greatly inspired by Ed Ruscha's *Twentysix Gasoline Stations* project, and it gave him a framework for his own road trip across England with his trusted Hasselblad. During the Brighton Photo Fringe, a selection of photographs was exhibited and the book was launched at City Books in Brighton. Had he been able to stay in this world for longer, he would have continued to surprise us with more great projects.

MISHKA HENNER (B.1976 BRUSSELS, BELGIUM) lives and works in Manchester, England. His works often employ Internet search engines, online forums and mapping tools to inform the creation of visual works relating to photography, surveillance, and the military-industrial complex. His first book, *Winning Mentality*, was acquired by the Tate in London in 2010. In the summer of 2011, he became one of five key artists to be highlighted as representing a new era of photography in the *From Here On* exhibition at Les Rencontres d'Arles in France. He is a member of the ABC Artists' Book Cooperative.

KAI-OLAF HESSE (B.1966 WITTINGEN, GERMANY) lives in Braunschweig , working as a freelance photographer and book designer since 2006. He has worked as a photo assistant prior to studying Communication Design at the University of Essen (Folkwang), subsequently receiving a diploma at the Hochschule für Grafik und Buchkunst HGB in Leipzig with Professor Joachim Brohm. He has also worked at the Bauhaus, Dessau, before spending several years abroad. Working from 1998 to 2006 in Berlin, he has had numerous international exhibitions and publications and held various teaching positions. He is a member of the German Photographic Academy (DFA) and co-founder of BerlinPhotoWorkshops. Recent books include *Cerna Hrezda* (2010), *92/05, 05/09* (2009), and *Topography of the Titanic* (2007).

TARO HIRANO (B.1973 TOKYO, JAPAN) studied Photography as Contemporary Art at Musashino Art University, and then founded skateboard magazine, *Sb*, where he currently serves as photography editor. Hirano opened an art gallery "No.12 Gallery" in Shibuyaku, Tokyo. In 2005, his first photography book *Pool* (Little More) was published, followed by *Going Over* (Nieves) in 2006, *Barabara* (Little More) in 2007, *Foreclosure* (Nieves) in 2008, and his newest book, *Work Space* in Tokyo (Magazine House) in 2011.

DOMINIK HRUZA (B.1976 VIENNA, AUSTRIA) attended the University of Applied Arts Vienna and University for Art & Design Helsinki from 1994 to 2001. Hruza is interested in art projects examining social and political questions. In 1996 he worked with the artists' group WochenKlausur in Salzburg and Vienna, Austria. In 2005 he participated in the World Information City Campaign in Bangalore, India. He has exhibited his work at the Kunsthalle Exnergasse, Vienna, in 2005, and partook in the De-Revolution exhibition at IG-Bildende Kunst, Vienna, in 2006. His work has also been featured at the Brno Design Biennial (2006); and Eco-Triennale "block4" Kharkiv, Ukraine (2009). He is Artist-in-Residence at University Jan Evangelista Purkyne at Usti nad Labem, Northern-Behemia, Czech Republic.

STEVEN IZENOUR (1940–2001) was born in New Haven, Connecticut. He joined Venturi, Scott Brown and Associates, Inc. in 1969 and led numerous award-winning architectural, exhibition, and graphic design projects. He combined a genius for design with a deep love of the American vernacular. Alongside Bob and Denise of VSBA, he co-authored the seminal *Learning from Las Vegas*. Steve's design for a house on Long Island Sound was exhibited at the Centre Georges Pompidou and won a National American Institute of Architects Honor Award. His work also included the Camden Children's Garden, a Bicentennial lighting scheme for the Benjamin Franklin Bridge, and contributions to the *Out of the Ordinary* traveling retrospective on the firm's work.

HENNING KAPPENBERG (B.1965 OBERG, GERMANY) studied at the Academy of Fine Art in Braunschweig, Germany from 1988 to 1994, where he received his BFA in 1993 and MFA in 1994. Kappenberg made his first artist's book (one copy only) in 1988 titled *The First Born is Dead*. In 1991 he received a special award from Germany's Ministry of Arts and Science. He is one of the founding members of the artist group Familie Kartenrecht (2004). Since 1988, he has had numerous shows, mostly in Germany. He has lived and worked in Berlin since 1995, and received a grant to work in Stuhr-Heiligenrode, Germany in 1998–1999.

JOACHIM KOESTER (B.1962 COPENHAGEN, DENMARK) is an artist who lives and works in Copenhagen and New York. He has had solo shows at the Museo Rufino Tamayo, Mexico City (2010); The Power Plant, Toronto (2010); Moderna Museet, Stockholm (2007); and Palais de Tokyo, Paris (2006). His work was shown in the Danish Pavilion at the 2005 Venice Biennale, and he further participated in various other exhibitions; most recently in the 29th São Paulo Biennial (2010); Dance With Camera, Contemporary Arts Museum, Houston (2010); and Animism in Extra City, Antwerp and Kunsthalle Bern (2010).

TANJA LAŽETIC (B.1967 LJUBLJANA, SLOVENIA) graduated from the University of Ljubljana with a degree in architecture. She works in the fields of photography, video, performance, installation and artist's book. Her work has been shown in group exhibitions at venues including Moderna galerija, Ljubljana (2000, 2003, 2005, 2006, 2007, 2008, and 2010); Ars Aevi, Sarajevo (2001); Neuer Berliner Kunstverein, Berlin (2001); ZKM, Karlsruhe (2001); the Gallery of Extended Media, Zagreb (2004); Museum 25th May, Belgrade (2009); and the 28th Biennial of Graphic Arts, International Centre of Graphic Arts, Ljubljana (2009). She lives in Ljubljana.

GABRIEL LESTER (B.1972 AMSTERDAM, NETHERLANDS)
started his artistic endeavor with music, stumbled
into literature, studied cinema, and then finally became
a visual artist. Lester's many interests and expertise
explain the themes, methods and nature of his present
(art) work. Most of his films, performances,
architecture and spatial installations have an implicit
narrative layer, strong cinematic influences, sequential
constructions and an obvious sense of rhythm.
His work can be found in various public and private
collections, film festivals, and exhibition venues.
Some of his most recent projects include *Suspension
of Disbelief* at the Rotterdam Boijmans museum, the
film *The Last Smoking Flight*, *BIG BANG* at London's
Bloomberg space; *High Light* in South Korea's
Anyang Public Art Project; and the feature film
The Remigrant.

JONATHAN LEWIS (B.1970 LONDON, ENGLAND) lives
and works in London. He received an MA in History
of Art from Cambridge University in 1995. Lewis's
work resides in the collections of the Victoria and
Albert Museum, London; Société Française de
Photographie, Paris; and George Eastman House,
International Museum of Photography and Film,
Rochester, New York, among others. He is represented
by Bonni Benrubi Gallery in New York and is a
member of the ABC Artists' Books Cooperative.

JOCHEN MANZ (B.1967 BAVARIA, GERMANY) lives
and works in Cologne with his wife and two daughters.
He received his Master in Photography in Dortmund
in 1994. Various exhibitions in Germany and abroad
followed. Since 1996, Manz has worked on assignments
for European companies and photography campaigns
all over the world. In 2007/08 he worked intensively
in Mumbai, India, on the film project, *Om Shanti
Om*. In 2010 his major work focused on Hiroshima
and the Mazda car plant, with a book entitled *Hiroshima
Rising* released in 2011. In addition, he teaches at
the University of Design in Pforzheim and the
University of Applied Science in Cologne.

**MICHAEL MARANDA (B.1966 PRINCE ALBERT,
SASKATCHEWAN)** resides in Toronto. He has received,
though not necessarily earned, degrees in political
science, photography, and visual and cultural studies.
Assistant curator at the Art Gallery of York University,
he is involved with two small presses, Parasitic Ventures
Press and the Book Bakery. Upcoming exhibitions
venues include Art Metropole (Toronto) and Artexte
(Montreal), where he will be installing the complete
run of *ARTFORUMx*, a visual analysis of the history
of advertising in *Artforum* magazine.

DANIEL MELLIS (B.1981 CHICAGO, ILLINOIS)
received his MFA from Columbia College Chicago
in 2011. He has been making artist's books for five
years. His work is in the collection of Joan Flasch
Library at the School of the Art Institute, Yale
University Library, and University of California
Berkeley, among others. He also holds degrees in
mathematics from the University of Chicago and
the Massachusetts Institute of Technology.

JERRY MCMILLAN (B.1936 OKLAHOMA CITY, OKLAHOMA)
moved to Los Angeles with his childhood friends
Ed Ruscha and Joe Goode in 1958. The three of
them lived together while attending the Chouinard
Art Institute. McMillan established himself in
the Los Angeles art scene by creating advertisements
for *Artforum*, posters for galleries, exhibition catalogues,
and becoming a leading figure in photo-sculpture.
In 1966 he became the first photographer to have a
one-person exhibition at the Pasadena Art Museum.
McMillan's work resides in the collections of the Art
Institute of Chicago; The Museum of Modern Art,
New York; the Museum of Contemporary Art, Los
Angeles; and the San Francisco Museum of Art,
among others.

MARTIN MÖLL (B.1972 BERNE, SWITZERLAND)
currently lives and works in his hometown. In his
photography, Möll often traces inconspicuous
everyday phenomena, proceeding in a strict manner
and according to strict criteria. He is co-founder of
the GAF (Group of Autodidactic Photographers)
and has worked as a freelance photographer for
newspapers, magazines, and music publications. He
is completing his MFA at the University of the Arts
in Berne (2010–2012). Exhibitions include: *not here
not now*, Austria (2010, solo); *The Conspiracy*, Kunsthalle
Bern (2009); and *In the Country of Last Things*, Biel/
Bienne (2003). He received residency scholarships in
Krems, Austria (2010) and Cité Internationale des
Arts, Paris, France (2007). He is represented in the
Art Collection of the Kanton of Berne and has
received the Award of Distinction for *Twentysix
Gasoline Stations Revisited* from the Kanton of Berne
in 2011.

SIMON MORRIS (B.1968 CHICHESTER, ENGLAND) is a conceptual writer and teacher. His solo exhibitions include presentations at the Freud Museum (London, 2005); The Telephone Repeater Station (Catterick, 2003); and Printed Matter, Inc. (New York, 2002). He participated in The First Festival of Media and Electronic Art (Rio de Janeiro, 2005) and EAST International (Norwich, 2005), plus numerous other group exhibitions internationally, including shows at The VOX Centre for Contemporary Image (Montreal, 2009) and Art Metropole (Toronto, 2004). He is the author of numerous experimental books, including *bibliomania* (1998); *interpretation [vol. I & II]* (2002); *The Royal Road to the Unconscious* (2003); *Re-Writing Freud* (2005); and *Getting Inside Jack Kerouac's Head* (2010). In 2011 he was made writer-in-residence at the Whitechapel Gallery, London.

TOBY MUSSMAN (1941–2010) was born in Lima, Ohio. He graduated from Yale University and attended the Sorbonne while working at the Herald Tribune in Paris. For the newspaper, he covered art gallery vernissages (Ileana Sonnabend's, he said, were the best) and there began his lifelong passion for art and film. He studied art history at New York University, worked for Robert Motherwell and Andy Warhol, at the Factory, and was an art critic for *Artforum*. He worked in the TV and film industries in Los Angeles, where he befriended Ed Ruscha. He received two grants from the Pollock-Krasner Foundation.

MAURIZIO NANNUCCI (B.1939 FLORENCE, ITALY) has devoted himself since the mid-sixties to exploring the multifaceted interrelations between language, writing and visual images, drawing on concepts and linguistic ideas (neon texts from 1967) and employing a wide variety of media, including photography, video, artist's books and records, sound installations and promoting several parallel art projects. He founded in 1968 Exempla Editions and was a co-founder in Florence of Zona non-profit art space (1974/1985) and of Zona Archives. He was editor of *Méla* art magazine and of Recorthings sound label and since 1998 is one of the promoters of the activities of Base progetti per l'arte. He has engaged in a number of neon writing projects in public space and took part several times in the Venice Biennial, Documenta Kassel and Biennials of Sydney, Istanbul, and Valencia. His work has been exhibited in and collected by many important museums around the world.

NEW CATALOGUE: LUKE BATTEN (B.1968 SANTA MARIA, CALIFORNIA) AND JONATHAN SADLER (B.1965 SACRAMENTO, CALIFORNIA) Luke received his MFA from the School of the Art Institute of Chicago in 2000, and Jonathan received his MFA from the Museum School of Fine Arts, Boston in 2001. Their studio is based in Chicago, where they have worked for the past ten years. Under the banner of New Catalogue, their work has been exhibited at the Museum of Contemporary Art, Chicago; The Museum of Contemporary Photography, Chicago; and the 2005 International Biennale of Contemporary Art, Prague. They are currently working on a solo exhibition in collaboration with composer Judd Greenstein from New Amsterdam Records at the Scottsdale Museum of Contemporary Art, Arizona for 2012.

JOHN O'BRIAN (B.1944 BATH, ENGLAND) is an art historian at the University of British Columbia, Vancouver, who occasionally makes art instead of art history. His books include *Ruthless Hedonism: The American Reception of Matisse*; *Beyond Wilderness*; and *Clement Greenberg: The Collected Essays and Criticism*, which he edited. His current research is on the engagement of photography with the atomic era, and his next book, *Atomic Postcards: Radioactive Messages from the Cold War*, was published in 2011.

MICHALIS PICHLER (B.1980 BERLIN, GERMANY) is a poet and conceptual artist based in Berlin. He graduated as an architect (TU Berlin) and in Fine Arts/Sculpture (KHB Weissensee). He works conceptually, often in series and with vernacular material. He recently performed at the Venice Biennale; Literaturwerkstatt, Berlin; MOCA Skopje; Stichting Perdu, Amsterdam; Badischer Kunstverein, Karlsruhe; MOMA PS1, New York; and held solo exhibitions at Revolver, Frankfurt, and Printed Matter, New York. Pichler has published around 15 books with Revolver, Frankfurt; the Cneai, Chatou; Printed Matter, New York; AGRA Publications, Athens; and others. He is cofounder of the annual artist Miss Read Book Fair taking place at KW, Berlin.

TADEJ POGACAR (B.1960 LJUBLJANA, SLOVENIA) is an artist and the artistic director of the P74 Center and Gallery, based in Ljubljana, Slovenia. He is the founder and director of the P.A.R.A.S.I.T.E. Museum of Contemporary Art, a virtual artistic institution and P.A.R.A.S.I.T.E. Institute, a non-profit cultural institute that supports education and presentation of contemporary art and culture. He has exhibited widely, recently at the MCA Vojvodina, Novi Sad, 10; Istanbul Biennial; 49th São Paulo Biennial; NGBK, Berlin; ZKM, Karlsruhe; Stedelijk Museum, Amsterdam; among others. He has been the recipient of the Franklin Furnace Grant in 2001 and Shrinking Cities Grant in 2004.

SUSAN PORTEOUS (B.1980 SHEFFIELD, ENGLAND) is a book artist, whose work explores both sculptural and traditionally bound books that investigate issues of form, content, word, and image, using both handmade and commercial production methods. Since receiving an MFA from California State University, Long Beach in 2008, Porteous has continued to show work regularly in juried and invitational exhibitions throughout America and in Europe and was recently included in the publications; *500 Handmade Books* and *Playing with Books*. Porteous currently lives and works in Denver, Colorado, where she teaches sculpture and digital art at both Metropolitan State College of Denver and Regis University.

CLARA PRIOUX (B.1989 LE MANS, FRANCE) has lived and traveled in different places. She received an MFA from the ESAD Art School of Strasbourg, in France (2012), as a student of the Equipe I, a class directed by Manfred Sternjakob. Prioux is interested in the question of conscience: in how Man deals with his existence and creates illusions as an escape from his own anguish. She is involved in various mediums. She participated in a group exhibition curated by Les Commissaires Anonymes at the ESAD of Strasbourg (in 2008) and two other group exhibitions at La Douëra, in Malzéville and at the ESAD of Strasbourg (in 2012).

ROBERT PUFLEB (B.1969 BERLIN, GERMANY) lives and works in Düsseldorf, Germany. Having studied Visual Communication at the University of Wuppertal and University of Southern California, Los Angeles, he uses the medium of photography to document and investigate the exotic within everyday life. Considering the artist's book as a "natural home" for his photographic work, he focuses on urban street stills as well as on "poetic snapshots" of his personal environment. He has shown in numerous national group exhibitions as well as in one solo exhibition in Düsseldorf.

JON RAFMAN (B.1981 MONTREAL, CANADA) is an artist, filmmaker, and essayist. He holds a BA in Philosophy from McGill University and a MFA from the School of the Art Institute of Chicago. His new media work has gained international attention and has been exhibited at Fotofest Gallery in Houston, FutureEverything in Manchester, England, the Woodmill in London, Ars Electronica Festival in Linz, Austria, Future Gallery in Berlin, the Museum of Contemporary Art of Rome, and the New Museum in New York City. Rafman's *Nine Eyes of Google Street View* project has been featured in *Modern Painters*, *National Public Radio*, *Fast Company*, *Wired*, *Libération*, and *Harper's* Magazine.

ACHIM RIECHERS (B.1958 HANNOVER, GERMANY)
lives and works in Cologne, where he has focused his interest on photography since 1999. Riechers' work is held in major collections, including Photographische Sammlung, SK Stiftung Kultur, Cologne and Caldic Collection, Rotterdam. After traveling around Russia for more than ten years, he published several photo books on different topics. His most recent work, *Kol Kolos,* was published by Kjubh, Kunstverein Köln.

DAVID RUSS (B.1960 BRISBANE, AUSTRALIA) is a graduate of the Queensland University of Technology, where he studied visual arts and education. In 1977 he began his professional career working as a graphic artist in the advertising industry before emerging as a fine artist in the 1980s. His experience as a graphic artist continues to influence his visual aesthetic and concise approach to the mediums of painting, drawing, printmaking, and photography. The controlled surfaces of Russ's paintings and drawings carry both the graphic suggestion of photomechanical reproduction and the nuances of handcrafted artwork. Inspired by the Freudian concept of "the uncanny," the artist's recent work highlights the uncertainty and mutability of the human condition, acutely conveyed through notions of vanishment, dislocation, and desire.

MARK RUWEDEL (B.1954 BETHLEHEM, PENNSYLVANIA)
received his MFA from Concordia University, Montreal in 1983 and taught photography there from 1984 to 2001. Since 2002, he has taught photography and art theory at California State University, Long Beach. Ruwedel has exhibited internationally for more than twenty-five years and his work is represented in many public collections, including at the Getty Museum, LACMA, SFMOMA, the Metropolitan in New York, Yale Art Gallery, FNAC of France, and the Tate Modern, among many others. Recent solo exhibitions include *Records* (Yossi Milo Gallery, 2012) *Now it is Dark* (Gallery Luisotti, 2010), *Imprints* (Peabody Essex Museum, 2010), and *Westward* (Yossi Milo Gallery, 2009). A survey of work with an accompanying book, *Written on the Land,* toured Canada from 2002 to 2006. In 2008, the Yale Art Gallery published *Westward the Course of Empire,* a monograph on Ruwedel's photographs of abandoned railroads in the American and Canadian wests.

TOM SACHS (B.1966 NEW YORK, NEW YORK) is a sculptor, probably best known for his elaborate recreations of various Modern icons. A lot has been made of the conceptual underpinnings of these sculptures: how Sachs samples capitalist culture: remixing, dubbing, and spitting it back out again, so that the results are transformed and transforming. Equally, if not more important, is his total embrace of "showing his work." All the steps that led up to the end result are always on display. This means that nothing Sachs makes is ever finished. Like any good engineering project, everything can always be stripped down, stripped out, redesigned and improved.

JOACHIM SCHMID (B.1955 BALIGEN, GERMANY)
is a Berlin based artist who has been working with found photographs since the early 1980s. His work has been exhibited internationally and is included in numerous collections. In 2007, Photoworks and Steidl published a comprehensive monograph *Joachim Schmid Photoworks 1982–2007* on the occasion of his first retrospective exhibition.

JEAN-FRÉDÉRIC SCHNYDER (B.1945 BASEL, SWITZERLAND) is a painter, conceptual artist and installation artist. After training as a photographer, he had his first success exhibiting works on panels derived from pop art (1967–1969). These were followed by further conceptual works and installations. He has had solo shows at the Kunstmuseum Basel; the Galerie Eva Presenhuber in Zurich; the Galerie Barbara Weiss, Berlin; the Akron Art Museum in Akron, Ohio; as well as at galleries in France, the Netherlands, Austria, and Italy.

YANN SÉRANDOUR (B.1974 VANNES, FRANCE) is an artist whose primary interest is in the notion of reading and the book form. His interstitial and mimetic approach is developed out of works, publications, and existing products by other authors and artists. His last book, *Inside the White Cube* (Overprinted Edition), was published by JRP|Ringier in 2009. He is represented by GB Agency, Paris.

TRAVIS SHAFFER (B.1983 SOMERSET, PENNSYLVANIA)
lives in Lawrence, Kansas, where he is a Visiting Assistant Professor of Photo Media at the University of Kansas. He has had recent solo exhibitions at Texas Tech University, Lubbock (2010); Land of Tomorrow Gallery, Louisville (2010); and Institute 193, Lexington (2010). Shaffer has participated in group exhibitions and artist's book fairs throughout the United States, Canada, and Europe. Shaffer's work is included in the collection of Yale University's Beinecke Rare Book and Manuscript Library; The University of the West of England's Centre for Fine Print Research; and The University of Colorado-Boulder's Photobook Collection.

TOM SOWDEN (B.1974 BRISTOL, ENGLAND) received his MA from Camberwell College of Arts, London, in 2004. He lives and works in Bristol, making books, videos, prints, photographs and teaches at the University of the West of England. With a long-standing fascination in the work of Ruscha and those who emulate him, Sowden, with Michalis Pichler, has co-curated the touring exhibition of Ruscha tribute books, *Follow-ed (After Hokusai)*. Sowden's work is held in many major British book arts collections, including the Tate Gallery, London; University of the Arts, London; Winchester School of Art, Winchester; and Manchester Metropolitan University, Manchester.

KIM STRINGFELLOW (B.1963 SAN MATEO, CALIFORNIA) is an artist/educator residing in Joshua Tree, California. Her work and research interests address ecological, historical, and activist issues related to land use and the built environment through hybrid documentary forms that incorporate writing, digital media, photography, audio, video, installation, and locative media. She teaches in the Multimedia area as an Associate Professor in the School of Art, Design, and Art History at San Diego State University. She received her MFA in Art and Technology from the School of the Art Institute of Chicago in 2000.

DEREK STROUP (B.1970 NEW HAVEN, CONNECTICUT) received his BA from Williams College and his MFA from the University of California, San Diego. His recent images explore the presence and absence of language in public space. His sculptures, photographs and paintings are in numerous public and private collections, including The Contemporary Museum, Honolulu; Paul Allen/Art CollTrust, Bellevue, Washington; and The Artist Book Collection at the Museum of Contemporary Art, Chicago. He has participated in solo and group exhibitions nationally, including The Museum of Contemporary Art, San Diego; The Contemporary Museum, Honolulu; the Los Angeles County Museum of Art; Quint Contemporary Art, San Diego, California; PS 122, New York; among others.

DEREK SULLIVAN (B.1976 RICHMOND HILL, ONTARIO, CANADA) is a Toronto-based artist. He is a graduate of York University (1998) and received his MFA from the University of Guelph, in 2002. Recent solo exhibitions include Tatjana Pieters, Gent; Librairie Florence Loewy, Paris; and White Columns, New York. Recent group exhibitions include *Art Read*, Glenn Horowitz, East Hampton, New York and *Architecture of Survival*, Komplot, Brussels. His collaboration with Gareth Long, *The Illustrated Dictionary of Received Ideas*, has been performed at venues that include PS.1, Queens, New York; Art Metropole, Toronto; Artexte, Montréal; and Kate Werble Gallery, New York City.

CHRIS SVENSSON (B.1979 LANDSKRONA, SWEDEN) lives and works mostly in Los Angeles, California.

ERIC TABUCHI (B.1959, PARIS, FRANCE) lives and works in Paris. He didn't train in art, rather sociology. It's through this analytical approach that he began photography. He has published several artist books, among them *Alphabet Truck*, and most recently, *Hyper Trophy*, a compilation of his work in twelve volumes. He recently had a solo exhibition, where he presented photographs and installations, at the Palais de Tokyo in Paris and at the Maillon and the Chambre in Strasbourg, France.

JOHN TREMBLAY (B.1966 BOSTON, MASSACHUSETTS) lives and works in Brooklyn, New York. His public and private collections include: a work on paper, Fogg Art Museum Boston MA; various objects, Cabinet des Estampes, Geneva; a book, Museum of Modern Art, New York; a painting, Albright Knox, Buffalo; and a few paintings at Musée des beaux-arts de La Chaux-de-Fonds. Corporate collections include The Daimler Collection, Germany, and Nokia, Finland, among others. In August 2010 he had a solo exhibition at Francesca Pia Gallery, Zurich, Switzerland. He also had a solo exhibition at Triple V in Paris in 2012.

MARC VALESELLA (B.1955 GRANVILLE, FRANCE) received a BA in mechanical engineering in Paris. An autodidact at photography, he started taking pictures in 1975 while working for Guy Bourdin in Paris. He learned silver gelatin printing from 1977 to 1979 under the guidance of Jean Loup Sieff. After a brief incursion into fashion photography, he moved to Los Angeles in 1986. Valesella has focused on using the medium of photography to capture what the eye cannot see rather than traditional pictorial photography, which has led him to an abstract approach paired with total control of his craft.

LOUISA VAN LEER (B.1968 BOSTON, MASSACHUSETTS) received her MFA from CalArts in 2006 and her BFA and B.Arch from Rhode Island School of Design. She lives and works in Los Angeles, where she continues her multi-discipline practices that span sculpture, photography, installation, public art, and architecture. She has exhibited her work throughout Southern California and at Rhode Island School of Design, Virginia Commonwealth University, White Flag Projects, St. Louis, and internationally at Schalter, Berlin; Gallery Lara, Tokyo; and Level Gallery, Brisbane. Her artist book *Fifteen Pornography Companies* is in the collection of San Francisco Museum of Modern Art; Art Institute of Chicago; Yale University Beinecke Rare Book Library, New Haven; Chelsea College of Art & Design, London; University College London; and Tate Gallery, London.

ROBERT VENTURI (B.1925 PHILADELPHIA, PENNSYLVANIA) is a writer, teacher, artist, and designer. A founding principal of the firm Venturi, Scott Brown and Associates, Inc., along with wife and partner Denise Scott Brown, as well as generations of collaborators and architects, Bob has helped to redefine what architecture can be — expanding its limits, language, and imaginative potential. His work includes the Sainsbury Wing of London's National Gallery; a provincial capitol building in Toulouse, France; a chapel for Episcopal Academy; renovation of the Museum of Contemporary Art, San Diego; dozens of major academic projects; and the ground-breaking Vanna Venturi House. Mr. Venturi's awards include the Pritzker Architecture Prize and the Presidential National Medal of the Arts.

REINHARD VOIGT (B.1940 BERLIN, GERMANY) studied at the Academy of Fine Arts in Hamburg, Germany. His paintings are in the collections of the Museum of Modern Art, New York; Eli Broad, Sun America Collection, Santa Monica, California; and in Germany at the Museum für Konkrete Kunst, Ingolstadt, Sammlung des Landes Baden-Württemberg, and the Staedtische Galerie, Wolfsburg. In fall 2010, his work was included in an exhibition at the DRAWING ROOM in London (selected by Thomas Scheibitz) and has an upcoming solo show at BQ in Berlin. Previous exhibitions were held at Kunsthalle Baden-Baden (1970); Gallery Ginza 5, Tokyo (1974); Kunstverein Hannover (1976); Wilhelm-Hack Museum, Ludwigshafen (1983); Angles Gallery, Santa Monica (1993); BQ, Cologne (2003); Kunsthalle Düsseldorf (2003) and BQ, Berlin (2009).

HENRY WESSEL (B.1942 TEANECK, NEW JERSEY) received a BA degree from Pennsylvania State University in 1966 and an MFA degree from the State University of New York at Buffalo in 1972. In 1971, he was awarded the first of two John Simon Guggenheim Memorial fellowships. He has also received three National Endowment for the Arts grants. In 2007, he was the subject of a retrospective exhibition at the San Francisco Museum of Modern Art. He first garnered widespread critical attention during the early 1970s in an exhibition at the Museum of Modern Art, and as one of the young photographers included in the New Topographics exhibition at the International Museum of Photography in Rochester, New York. Wessel's photographs are included in many major collections, including the Art Institute of Chicago; the Center for Creative Photography, University of Arizona, Tucson; Fogg Art Museum, Harvard University, Cambridge; Los Angeles County Museum of Art; The Metropolitan Museum of Art, New York; and the Victoria and Albert Museum, London. Currently, Wessel is on faculty in the photography department at the San Francisco Art Institute.

KEITH WILSON (B.1974 DECATUR, GEORGIA) received his MFA in film production from The University of Texas-Austin in 2009. Wilson's documentary films, *Southern Family*, *Lesbian Grandmothers from Mars*, *When the Light's Red* and *The Shrimp*, have screened internationally, including the South by Southwest, London International and the New York Underground Film Festivals and the United States National Gallery of Art. His photography project, *Hyde Park Apartments*, was exhibited at the Sofa Gallery, Austin, Texas and can be found in a monograph from Publication Studios, Berkeley.

CHARLES WOODARD (B.1987 HUNTINGTON, NEW YORK) is an MFA degree candidate in Film and Video Production from the University of Iowa. Woodard is a board member of the Bijou Cinema, and won the Best Experimental Film award at the 2009 Big Apple Film Festival. He is currently working on a series of short films entitled, *An Incredibly Mundane Task*.

MARK WYSE (B.1970 SANTA MONICA, CALIFORNIA) lives and teaches in Los Angeles, California. He received his MFA from Yale University in 2001. His most recent book, *Seizure*, was published by Damiani in 2011. Wyse's work resides in the permanent collections of the Metropolitan Museum of Art, New York; Museum of Contemporary Art, Los Angeles; The Los Angeles County Museum of Art; The Art Gallery of New South Wales; and the Yale University Art Museum. Wyse's exhibitions have been reviewed in *The New York Times*, *The New Yorker*, *Artforum*, *The Los Angeles Times*, *Art on Paper*, *The Village Voice* and *Art in America*.

HERMANN ZSCHIEGNER (B.1971 INNSBRUCK, AUSTRIA) received his MS in Architecture from Columbia University in 2000. He lives and works with his wife and daughter in Brooklyn. Hermann is the principal of the award-winning interactive design agency Two-N. He has been publishing print-on-demand books since 2005, and he is a member of the ABC Artists' Books Cooperative. His work has been shown at Printed Matter, as well as at the Rencontes d'Arles 2011. His collection of books referencing Ed Ruscha's Artist Books is the basis of this publication.

CONTRIBUTORS

MARK RAWLINSON (B.1970 STOCKPORT, ENGLAND) is
Associate Professor in Art History at the University
of Nottingham. He has published two monographs,
*Charles Sheeler: Modernism, Precisionism and the Borders
of Abstraction* (I.B. Tauris, 2007) and *American Visual
Culture* (Berg Press, 2009). His current research focuses
on late twentieth-century American photography,
especially the influence of the New Topographics
movement.

PHIL TAYLOR (B.1985 ARLINGTON, VIRGINIA)
is pursuing his PhD in the Department of Art
& Archaeology at Princeton University, where his
research focuses on 20th century art and the history
of photography. Prior to coming to Princeton he
received his BA in English Literature with a minor
in Photography from the University of Southern
California. Despite his birthplace, he considers
Portland, Oregon home. In 2011 he contributed
an essay, "Specific Exposures: The Photography
of Hans-Christian Schink," to the catalogue *Hans-
Christian Schink* (Hatje Cantz). Previously Taylor
curated the exhibition *Of the Refrain* (2008) at
Robert Mann Gallery in New York.

PHOTOGRAPHY CREDITS

Luke Battan and Jonathan Sadler, pp. 78-79;
Wendy Burton, pp. 262-63; Jennifer Dalton, pp. 98-9,
100-01; Eric Doeringer, pp. 184-85, 193, 197 (top
right and left); Stan Douglas. pp. 82-83; Harlan
Erskine, pp. 105 (bottom), 106-07; Kota Ezawa,
p. 109; Robbert Flick, pp. 86-87; Jan Freuchen,
p. 115 (lower right and left); Marcella Hackbardt,
p. 227; Genevieve Hanson, pp. 170, 172-73; Mishka
Henner, pp. 234-35; Kai-Olaf Hesse, pp. 140-41;
Joachim Koester, pp. 134, 136-37; Jerry McMillan,
pp. 17 (left), 23, 25, 93, 272; Martin Möll, pp. 190-91;
Jonathan Monk , pp. 71, 268 (courtesy Yvon Lambert,
Paris), 285 (courtesy Casey Kaplan Gallery, New York);
Michalis Pichler, p. 123 (top), 189 (top); Susan Porteous
pp. 128-29; Robert Pufleb, p. 237 (bottom right and
left); Jon Rafman, p. 209; Mark Ruwedel, pp. 246-47;
Yann Sérandour, pp. 95, 277; Travis Shaffer, p. 159
(middle and bottom); Tom Sowden, p. 167; Kim
Stringfellow, p. 225 (top); Derek Stroup, p. 163 (bottom
right and left); Chris Svensson, pp. 186-87; Eric Tabuchi,
p. 181 (top); Marc Valesella, p. 249 (bottom right and
left); Louisa Van Leer, p. 111 (top); Reinhard Voigt,
p. 133 (top); Henry Wessel, pp. 50-51; Keith Wilson,
p. 257; Hermann Zschiegner, pp. 119, 219, 220-21.
All other book photography © 2013 Jeff Brouws, and
pp. 4-5.

The covers of Ed Ruscha's books are reproduced
with permission © 2013 Ed Ruscha, pp. 9, 13, 19, 27.

EDWARD RUSCHA, 1024¼ N. WESTERN AVENUE, HOLLYWOOD, CALIFORNIA 90029 (213) 871-8002

Ed Ruscha's generosity toward his fellow artists is
noteworthy. In a correspondence dated October 1991,
Ruscha not only grants Jeff Brouws whole-hearted
approval to appropriate the type treatment and layout
of his 1962 book *Twentysix Gasoline Stations*, but also
offers to purchase the first twelve copies of *Twentysix
Abandoned Gasoline Stations*.

Notes

1. According to Kevin Hatch, "Although the book is often dated 1963, the first edition of *Twentysix Gasoline Stations* was copyrighted and published in 1962." Kevin Hatch, "Something Else": Ed Ruscha's Photographic Books, *October*, Vol. 111 (Winter, 2005), fn.9, p. 109.

2. By describing Ruscha-as-artistic-material, I am referring explicitly to Theodor Adorno's description of what constitutes artistic material; a description which itself owes much to Walter Benjamin's insights from the essay, "The Work of Art in the Age of Mechanical Reproduction" (1936) regarding the effect of technologies of reproduction on the production and reception of art. Adorno says: "Material…is what artists work with: It is the sum of all that is available to them, including words, colours, sounds, associations of every sort and every technique ever developed. To this extent, forms too can become material; it is everything that artists encounter about which they must make a decision." Theodor W. Adorno, *Aesthetic Theory*, (1970), trans., Hullot-Kentor, Robert, University of Minnesota Press, Minneapolis, 1997, p. 148.

3. Hatch, "Something Else" (2005), p. 108.

4. Charles Demarais, *Proof: Los Angeles Art and the Photograph, 1960-1980*, Los Angeles: Fellows of Contemporary Art; Laguna Beach: Laguna Art Museum, 1992, p. 26. "Daydream" appears thus to signify suspicions about the truth of this statement's hypnogogic origins; besides the precision of Ruscha's recall, there is some similarity to a key influence on Ruscha, Jasper Johns, who claimed he dreamed of painting a flag; so the next day he painted, *Flag*.

5. A.D. Coleman, "My Books End Up in the Trash" in Ed Ruscha, *Leave Any Information at the Signal*, Cambridge, Mass; London: The MIT Press, 2002, pp. 46-7. Demarais cites a version of "The Information Man" [Demarais, *Proof* (1992), p. 26] with an interesting footnote for the source (fn. 42, p. 34): "Interview between Ultra Violet and Ed Ruscha," 6 July 1971, unpublished typescript, roll 1869, Margery Mann Papers, Archives of American Art, Smithsonian Institution, Washington D.C. A slightly longer passage, including supposedly original interview responses appears without attribution in A.D. Coleman, "My Books End Up in the Trash," *New York Times*, 27 August 1972. This is the version that also appears in Ed Ruscha, *Leave Any Information* (2002), pp. 46-50.

6. Philip Leider, "Critical Response to *Twentysix Gasoline Stations*," *Artforum*, September 1963, in Sylvia Wolf, *Ed Ruscha and Photography*, Whitney Museum of American Art/Steidl, 2004, p. 120. Or, one could equally refer to the title of John Coplans' interview with Ruscha originally published in *Artforum* in 1965: "Concerning *Various Small Fires*: Edward

Ruscha discusses his Perplexing Publications." Coplans' interview can be found in Ruscha, *Leave Any Information* (2002), pp. 23-27.

7. Margaret Iverson, "Auto-Maticity: Ed Ruscha and Performative Photography," *Art History*, Vol. 32, No. 5, December, 2009, p. 843.

8. A.D. Coleman, "I'm Not Really a Photographer" (1972) in Douglas Fogle, *The Last Picture Show: Artists Using Photography 1960-1982*, Minneapolis: Walker Art Center, 2003, p. 23.

9. About the photobook *Various Small Fires,* Ruscha admits to John Coplans: "Yes, the whole thing was contrived." John Coplans, "Concerning *Various Small Fires*: Edward Ruscha discusses his Perplexing Publications" in Ruscha, *Leave Any Information* (2002), p. 25.

10. Coplans, "Concerning *Various Small Fires*" (2002), p. 23.

11. David Bourdon "Ruscha as Publisher" [or All Booked Up] (1972) in Ruscha, *Leave Any Information* (2002), p. 41.

12. On Frank's *The Americans* Ruscha says: "He captured America so beautifully, at a particular historical time. That had a heavy impact on my thinking, and yet the imagery doesn't necessarily translate into any kind of direct influence on my work." In Sylvia Wolf, *Ed Ruscha and Photography*, Whitney Museum of American Art/Steidl, 2004, pp. 20-1.

13. Nancy Foote, "The Anti-Photographers" (1976) in Douglas Fogle, *The Last Picture Show: Artists Using Photography 1960-1982*, Minneapolis: Walker Art Center, 2003, p. 24.

14. A.D. Coleman, (1972) "I'm Not Really a Photographer," in Douglas Fogle, *The Last Picture Show: Artists Using Photography 1960-1982*, Minneapolis: Walker Art Center, 2003, p. 23.

15. See Nancy Foote, "The Anti-Photographers" (2003), pp. 24-31. Along with Ruscha, Foote compiles a lengthy list, which includes: Eleanor Antin, John Baldessari, Lewis Baltz, Bernd and Hilla Becher, Jan Dibbets, Hamish Fulton, Douglas Heubler, Richard Long, and Robert Smithson.

16. Nancy Foote, "The Anti-Photographers" (2003), p. 23.

17. See Jeff Wall, "Marks of Indifference: Aspects of Photography in, or as, Conceptual Art" (1995), in Douglas Fogle, *The Last Picture Show: Artists Using Photography 1960-1982*, Minneapolis: Walker Art Center, 2003, pp. 39-44.

18. Wall, "Marks of Indifference" (2003), p. 44.

19. Benjamin H.D. Buchloh, "Conceptual Art 1962-1969: From the Aesthetic of Administration to the Critique of Institutions," *October*, Vol. 55 (Winter, 1990), p. 119.

20. Wall, "Marks of Indifference" (2003), p. 43.

21. A.D. Coleman, "My Books End Up in the Trash" in Ruscha, *Leave Any Information* (2002), p. 49.

22. Coplans, "Concerning *Various Small Fires*" (2002), p. 26.

23. Douglas M Davis, "From Common Scenes, Mr Ruscha Evokes Art" in Ruscha, *Leave Any Information* (2002), p. 29.

24. Willoughby Sharp, "'...A Kind of a Huh': An Interview with Ed Ruscha" in Ruscha, *Leave Any Information* (2002), p. 65.

25. Pindell, "Words with Ruscha" in Ruscha, *Leave Any Information* (2002), p. 62.

26. Wall, "Marks of Indifference" (2003), p. 43.

27. Bourdon, "Ruscha as Publisher [or All Booked Up] in Ruscha, *Leave Any Information* (2002), p. 41. For *Real Estate Opportunities* Ruscha becomes realtor or property-owner; for *Some Los Angeles Apartments*, as Jeff Wall notes, he could well be owner, manager or resident (See Wall, "Marks of Indifference" (2003), p. 43). Not forgetting, of course, Ruscha as forensic detective in *Royal Road Test*, or town planner in *Thirtyfour Parking Lots*.

28. Roland Barthes, "The Death of the Author" (1967), in Roland Barthes, *Image, Music, Text*, translated by Stephen Heath, London: Fontana Press, 1977, p. 147. Full quotation reads: "To give a text an Author is to impose a limit on that text, to furnish it with a final signified, to close the writing. Such a conception suits criticism very well, the latter then allotting itself the important task of discovering the Author (or its hypostases: society, history, psyche, liberty) beneath the work: when the Author has been found, the text is 'explained' — victory to the critic."

29. Barthes, "Death of the Author" (1997), p. 142.

30. Wolf, *Ed Ruscha* (2004), p. 112.

31. Jaleh Mansoor, "Ed Ruscha's 'One-Way Street'" *October*, Vol. 111 (Winter, 2005), p. 127.

32. Herman Barendse, "Ed Ruscha: An Interview" in Ruscha, *Leave Any Information* (2002), p. 213.

33. Barendse, "Ed Ruscha: An Interview" in Ruscha, *Leave Any Information* (2002), p. 214.

34. Wall, "Marks of Indifference" (2003), p. 43.

35. Wall, "Marks of Indifference" (2003), p. 43. Similarly, Buchloh chastises Ruscha *et al* for a "critical devotion to the factual conditions of artistic production and reception without aspiring to overcome the mere facticity of these conditions." Buchloh, "Conceptual Art" (1990), p.141.

36. Buchloh, "Conceptual Art" (1990), p. 143.

37. Theodor W. Adorno, *Aesthetic Theory*, (1970), 1997, p. 1.

38. Adorno, *Aesthetic Theory*, (1970), 1997, p. 79.

39. See also Shierry Weber Nicholsen, *Exact Imagination, Late Work: On Adorno's Aesthetics*, (1997), The MIT Press, Cambridge, Massachusetts, 1997, pp. 22-24. To be clear, Adorno's notion of the shudder is a primordial experience and therefore quite distinct from the Romantic sublime, although on one level, it is possible to see similarities between them.

40. Sharp, "'...A Kind of a Huh'" in Ruscha, *Leave Any Information* (2002), p. 65.

41. Wall, "Marks of Indifference" (2003), pp. 43-4. Funnily enough, since the original publication of Wall's essay, idiocy and stupidity have, through the work of artists like Maurizio Cattelan, become key strategies in contemporary art practice.

42. Bernard Brunon, "Interview with Edward Ruscha" in Ruscha, *Leave Any Information* (2002), p. 250.

43. Sianne Ngai, "Merely Interesting" *Critical Inquiry*, Vol. 34, No. 4, Summer 2008, pp.777-817.

44. Ngai, "Merely Interesting" (2008), p. 777.

45. Ngai, "Merely Interesting" (2008), p. 778.

46. Ngai, "Merely Interesting" (2008), pp. 785-6.

47. Ngai, "Merely Interesting" (2008), p. 786 [emphasis in original].

48. Jaleh Mansoor, "Ed Ruscha's 'One-Way Street'" *October*, Vol. 111 (Winter, 2005), p. 134.

49. Mansoor, "Ed Ruscha's 'One-Way Street'" (2005), p. 132.

Ruscha Redux Catalogue[†]

Ginza Kaiwai and Ginza Haccho, 1954
Shohachi Kimura, Yoshikazu Suzuki
Toho Shuppan,
hardcover, accordion-foldout
with slip box

Burning Small Fires, 1968
Bruce Nauman
poster, folded with card cover

Six Hands, 1971*
Joel Fisher
self-published, artist book

Learning from Las Vegas, 1972
Robert Venturi, Denise Scott Brown, Steven Izenour, M.I.T. Press, hardcover,
printed wrappers with glassine

Pomona Houses, 1972* **
Marcia Hafif
Mother Lode Editions,
softcover artist book

Edward Ruscha: Prints and Publications
1962–74, 1975*
Edward Ruscha, Joanna Drew, Reyner Banham, Arts Council of Great
Britain, exhibition catalog, softcover,
accordion-foldout

Broadway, 1983* **
Jan Henderikse
self-published, artist book,
accordion-foldout

Eminent Erections, 1985
David John Russ
Solid Productions,
softcover artist book

L.H. Lives Here, 1987
Maurizio Nannucci
Art Metropole, Ottenhausen Verlag,
softcover artist book

Twentynine Palms, 1991
Jeff Brouws
Hand-Job Press / Gas-N-Go
Publications, softcover artist book

Twentysix Abandoned
Gasoline Stations, 1992
Jeff Brouws
Hand-Job Press / Gas-N-Go
Publications, softcover artist book,
printed wrappers with glassine

Motor Racing Photographs, 1992*
Jesse Alexander
At Speed Press,
softcover artist book,
printed wrappers with glassine

Parade Route, 1993
Robbert Flick
self-published, hardcover artist book,
accordion-foldout

12 Assholes and a Dirty Foot, 1996*
John Waters
chromogenic prints, with curtain

More Los Angeles Apartments, 1998
John O'Brian
VAFS/Collapse Editions,
softcover artist book, printed
wrappers with glassine

Road Test, 1998*
Sylvie Fleury
artwork,
crushed make-up

Zugerstrasse Baarerstrasse
1999/2000, 2000
Jean-Frédéric Schnyder
Edition Patrick Frey,
softcover artist book,
accordion-foldout in slip box

Macintosh Road Test, 2000
Corinne Carlson, Karen Henderson, Marla Hlady
self-published, softcover,
spiral bound

Six Films
[on Sol Lewitt publications], 2001*
Jonathan Monk
Yvon Lambert, exhibition poster

17 Parked Cars In Various Parking Lots
Along Pacific Coast Highway Between
My House and Ed Ruscha's, 2002
Mark Wyse
self-published,
softcover artist book

None of the Buildings
on Sunset Strip, 2002
Jonathan Monk
Revolver,
softcover artist book, wrappers

107th Street Watts, 2003
Edgar Arceneaux
Revolver,
softcover artist book,
accordion-foldout in slip box

The Royal Road to the Unconscious, 2003
Simon Morris
Information as Material,
softcover artist book, spiral bound

Small Fires Burning
(after Ed Ruscha after Bruce Nauman),
2003*
Jonathan Monk
Grazer Kunstverein,
film installation, 16mm film

Small Fires Burning
(after Ed Ruscha after Bruce Nauman),
2003*
Jonathan Monk
Grazer Kunstverein, Yvon Lambert
film poster

Various Fires, 2003
*New Catalogue
(Luke Batten / Jonathan Sadler)*
self-published,
softcover artist book

Every Building on
100 West Hastings, 2003
Stan Douglas
Arsenal Pulp Press,
softcover

26 Gasoline Stations, 2003
Jonathan Lewis
self-published,
flip book

Every Building on
the Sunset Strip, 2003
Jonathan Lewis
self-published, flip book

Fortynine Coach Seats, 2003*
Tom Sowden
self-published,
softcover artist book

Fiftytwo Shopping Trolleys
(in Parking Lots), 2004
Tom Sowden
self-published,
softcover artist book

& Milk (Today is just
a copy of yesterday), 2004
Jonathan Monk
Grazer Kunstverein,
softcover artist book

Thirtysix Fire Stations, 2004
Yann Sérandour
self-published,
softcover artist book, printed
wrappers with glassine

Getting to Know the Neighbors, 2004
Jennifer Dalton
self-published,
accordion-foldout,
book sculpture

Picturing Ed: Jerry McMillan's
Photographs of Ed Ruscha, 2004
Jerry McMillan
Smart Art Press, Craig Krull Gallery,
exhibition catalogue

73 Häuser von Sinemoretz, 2004
Dominik Hruza
self-published,
softcover artist book

29 Gas Stations and
26 Variety Stores, 2005
Toby Mussman
self-published,
softcover artist book

Ten Convenient Stores, 2005
Harlan Erskine
self-published,
softcover artist book

Twentyfour Former
Filling Stations, 2005
Frank Eye
self-published,
softcover artist book

**The History of
Photography Remix, 2005**
Kota Ezawa
Haines Gallery and Murray Guy,
hardcover book

**Every Hallucination on the Sunset
Strip, Volumes I & II, 2005***
Jeremy Blake
digital c-print, two parts

**Three Slideshows After Ed Ruscha
and The Networked Computer, 2006*
Stains/Glitches, Various Small (images
of) Fires and Milk, Every Building on
the Sunset Strip (Internet Re-Creation)+**
Michael Bell-Smith
video 7:07 min, color, silent

Chinese Crackers, 2006*
Jonathan Monk
Lisson Gallery,
16 mm film projection

Real Estate Photographs, 2006
Henry Wessel
Fraenkel Gallery,
softcover

Fifteen Pornography Companies, 2006
Louisa Van Leer
self-published with funding
from a Cal Arts grant,
softcover artist book

Seven Suns, 2006
Jen Denike
The New Center of Contemporary
Art, softcover artist book, printed
wrappers with glassine

**Thirtyfour Parking Lots
on Google Earth, 2006**
Hermann Zschiegner
self-published,
softcover artist book

149 Business Cards, 2006
John Tremblay
Onestar Press,
softcover artist book

**Sechsundzwanzig Autobahn
Flaggen, 2006**
Michalis Pichler
Revolver,
softcover artist book, printed
wrappers with glassine

**Internal Combustion/Twentysix
Gasoline Stations, 2006**
Jan Freuchen
Norsk Kulturrad, exhibition catalogue

Bicycling Sunset Strip, 2006*
Rainer Ganahl
video

**Thirtyfour Parking Lots on Google
Earth, 2006***
Hermann Zschiegner
digital c-prints, 16 x 20"

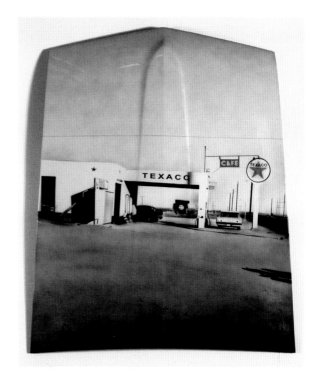

**Thirtyfour Parking Lots,
Forty Years Later, 2007**
Susan Porteous
self-published, softcover artist book

**Occupied Plots,
Abandoned Futures, 2007**
Joachim Koester
Galerie Jan Mot, Brussels, Belgium,
silver-gelatin prints

Vingt-Six Stations Service, 2007
Kai-Olaf Hesse
self-published, softcover artist book,
accordion-foldout with hardcover
slip box

**Several Split Fountains
and a Jack, 2007**
Daniel Mellis
Jack of All Trades Press,
softcover artist book

Hard Light, 2007
Achim Riechers, Rinata Kajumova
self-published,
softcover artist book

62 Gasoline Stations, 2007
Gabriel Lester
self-published,
softcover artist book

Every Mailbox On The Read Road, 2007
Reinhard Voigt
self-published, artist book,
accordion-foldout
in slipcase

**Every Letter in
"The Sunset Strip", 2008**
Derek Sullivan
self-published,
softcover artist book

Persistent Huts, 2008
Derek Sullivan
Printed Matter,
softcover artist book,
accordion-foldout

Foreclosure, 2008
Taro Hirano
Nieves, softcover artist book

**Coloured People in
Black and White, 2008**
Jonathan Monk
Argo Books,
softcover artist book

**Some of the Buildings
on the Sunset Strip, 2008**
Tom Sowden
self-published, softcover artist book,
accordion-foldout

Some Belsunce Apartments, 2008
Anne-Valérie Gasc
self-published,
softcover artist book,
printed wrappers with glassine

Every Instance Removed, 2008
Derek Stroup
self-published,
softcover artist book

**Cutting Book Series:
Traveling into Then & Now, 2008**
Noriko Ambe
book sculpture

**Every Building, Or Site, That a Building
Permit Has Been Issued for a New
Building in Toronto in 2006, 2008***
Daniel Young and Christian Giroux
35mm film, 13 min

**Remake of Ed Ruscha's Thirtyfour
Parking Lots on the internet and using
Google Maps, 2008***
Pascual Sisto
website

Some Las Vegas Strip Clubs, 2008
Julie Cook
self-published,
softcover artist book

**Veintiocho Casillas
de Seguiridad, 2009***
Victoria Bianchetti
self-published,
softcover and hardcover editions

Nutsy's Road Test Version 0.63, 2009
Tom Sachs
artist zine, self-published,
softcover, stapled

**Twentysix Abandoned
Gasoline Stations, 2009**
Eric Tabuchi
Florence Loewy,
boxed set of 26 postcards

**The History of Photography
in Pen & Ink, 2009**
Charles Woodard
A-Jump Books, softcover

Thirtyfour Parking Lots, 2009
Travis Shaffer
self-published,
softcover artist book

**26 Repurposed Gasoline Stations
(with apologies to Ed Ruscha
and Jeff Brouws), 2009***
Peter Calvin
self-published,
softcover artist book

**Various Studios & Homes
Inhabited by Ed Ruscha, 2009**
Chris Svensson
self-published,
softcover artist book

Rew-Shay Hood Project, 2009*
Jonathan Monk
airbrush paint on car hood

Twentysix Gasoline Stations, 2009
Michalis Pichler
Printed Matter,
softcover artist book,
printed wrappers with glassine

**Twentysix Gasoline
Stations Revisited, 2009**
Martin Möll
Kunsthalle, Bern, Switzerland,
26 silver-gelatin prints

Real Estate Opportunities, 2009
Eric Doeringer
self-published, softcover,
printed wrappers with glassine

Some Los Angeles Apartments, 2009
Eric Doeringer
self-published, softcover,
printed wrappers with glassine

**Various Fires and
Four Running Boys, 2009**
Thomas Galler
Edition Fink,
softcover, printed wrappers
with glassine

Various Blank Pages, 2009
Doro Boehme, Eric Baskauskas
self-published,
softcover artist book

Twentythree Bankers Blink, 2009
Jochen Manz
self-published,
softcover artist book

**Twentysix Gasoline Stations, Every
Building on the Sunset Strip, Thirtyfour
Parking Lots, Nine Swimming Pools, A
Few Palm Trees, No Small Fires, 2009**
Joachim Schmid
self-published,
softcover artist book

Sixteen Google Street Views, 2009
Jon Rafman
Golden Age,
softcover artist book

Twentysix Gasoline Stations, 2009*
Anonymous
self-published,
softcover artist book

**Twentysix Gasoline
Stations, 2.0, 2009**
Michael Maranda
Parasitic Ventures Press,
softcover artist book

Various Homages to Ed Ruscha, 2009*
Jeremy Sanders
Glen Horowitz Bookseller,
softcover catalogue

Followed, 2009*
Hermann Zschiegner
self-published,
softcover artist book

**Every coffee I drank in
January 2010, 2010**
Hermann Zschiegner
self-published,
softcover artist book

Nineteen Potted Palms, 2010
Clara Prioux
self-published,
softcover artist book

**Twentysix Abandoned
Jackrabbit Homesteads, 2010**
Kim Stringfellow
self-published,
softcover artist book

**Various Unbaked Cookies
and Milk, 2010**
Marcella Hackbardt
self-published,
softcover artist book

Eleven Mega Churches, 2010
Travis Shaffer
self-published,
softcover artist book

**Real Estate Opportunities:
A 2010 International
Investment Guide, 2010**
Travis Shaffer
self-published,
softcover artist book

39 Sources and One Sink, 2010
Robert Pufleb
self-published,
hardcover artist book

**One Thousand Two Hundred
Twelve Palms, 2010**
Mark Ruwedel
Yale University Art Gallery,
hardcover

One Gasoline Station, 2010
Dejan Habicht
Zavod P.A.R.A.S.I.T.E.,
broadsheet

**Nine Swimming Pools Behind
a Broken Glass, 2010**
Tanja Lažetic
Zavod P.A.R.A.S.I.T.E.,
softcover artist book

**Coloured People in Black
and White (Yellow), 2010**
Tanja Lažetic
Zavod P.A.R.A.S.I.T.E.,
softcover artist book

**Twentysix Gasoline Stations
Only (552 km), 2010***
Tanja Lažetic
Zavod P.A.R.A.S.I.T.E.,
softcover artist book

**Sechundzwanzig Wiener
Tankstellen, 2010**
Stefan Oláh, Sebastian Hackenschmidt
Roma Publications,
softcover

Fiftyone US Military Outposts, 2010
Mishka Henner
self-published,
softcover artist book

125 Swimming Pools, 2010*
Jenny Odell
Jen Bekman 20 X 200,
artwork

**Various (Small) Pieces
of Trash, 2010**
Tadej Pogačar
Zavod P.A.R.A.S.I.T.E.,
softcover artist book

Whiteowned Gasoline Stations, 2010*
Sowon Kwon
Vermont College of Fine Arts,
softcover artist book

Various Fires and MLK, 2010*
Scott McCarney
self-published,
softcover artist book,
printed wrappers with glassine

Dead Gas Stations, 2010
Bill Daniel
The Holster,
softcover artist book,
stapled

Thirty Cellar Doors, 2010*
Audun Mortensen
self-published,
softcover artist book,
stapled

**Twelve Los Angeles Corners
(and Nothing Broken), 2010**
Marc Valesella
self-published,
softcover artist book

144 Empty Parking Lots, 2011*
Jenny Odell
Jen Bekman 20 X 200,
artwork

Real Estate Opportunities, 2011
Wendy Burton
self-published,
softcover artist book

Nine Live Swimming Pools, 2011
Andreas Schmidt
self-published,
softcover artist book

Peanuts, 2011
Dan Colen
Astrup Fearnley Museum
of Modern Art,
softcover artist book,
dust jacket

Some Los Angeles Apartments, 2011*
Sveinn Fannar Jóhannsson
Multinational Enterprises,
softcover artist book

**Twentysix Faith
Filling Stations, 2011***
Daniel S. Guy
self-published,
softcover artist book

**Various Minuteman
Missile Silos, 2011**
Jeff Brouws
self-published,
softcover artist book

Forty Eight Pub Bathrooms, 2011*
Benjamin Cowley
self-published,
softcover artists book

Records (after Ed Ruscha), 2011*
Eric Doeringer
self-published,
softcover artist book

Salad Dressing, 2011*
*Performance Re-enactment Society
and Tom Sowden*
Arnolfini, softcover

**Every Building on Burnet
(burn-it) Road, 2011**
Keith Wilson
self-published, artist book,
accordion-foldout in slipcase

Twentysix Gasoline Cans, 2012*
Joe Putrock
self-published,
softcover artist book,
printed wrappers with glassine

**Twentysix Beer Steins
and a Bear, 2012***
Brian Murphy
self-published,
softcover artist book

**Project that is not featured in
*Various Small Books***

**Project where the artist noted they
had not been referencing Ed Ruscha**

†
**Every title known as of May 31, 2012,
with apologies for anything omitted**

previous page:
Jonathan Monk, Rew-Shay Hood
Project XXII, 2008/09, air brush
paint, 1969 Ford Mustang,
60 x 49 inches.

middle left:
Hermann Zschiegner's *Followed* and
Jeremy Sanders / Glen Horowitz's
Various Homages to Ed Ruscha were
precursors and inspiration points
for *Various Small Books.*

Acknowledgments

JEFF BROUWS

Making books is not an endeavor that is accomplished alone or in a vacuum. Myriad people join forces and make it happen. Such is the case with *Various Small Books*.

I'd like to first thank all the artists who have graciously allowed us to reproduce their work: you've been generous, forthcoming and patient. The friendships we've made with many of you along the way are an unexpected bonus.

Our writers Phil Taylor and Mark Rawlinson have done a magnificent job and we are grateful for their insight and intelligence. Because of their contributions the book has a depth and substance it might not otherwise have.

Our partner and co-conspirator Hermann Zschiegner brought not only his book collection to the party but an unbridled enthusiasm and creative spark to the proceedings that made all the difference. His initial print-on-demand piece entitled *Followed* showed us the way.

Our copy editor, Alexandra "Pindy" McKee, was indespensible in marshaling the various texts through a arduous and complicated process. She was prompt and on-top-of-it.

Many thanks to Roger Conover, Janet Rossi and Abby Streeter Roake at the MIT Press for their good guidance as this book traversed the production process. We're honored to be involved with such an illustrious and talented team.

To my wife, life-partner, and best friend Wendy Burton goes the greatest thanks. While it's one thing to have a vision and a dream about creating this book (as Hermann and I did), the organizational skills required to make it occur require a special skill set. Wendy, with her good cheer and tenacity, routinely made the oftentimes-overwhelming aspects of this enterprise far more manageable.

And of course there's Mr. Ed Ruscha, for whom we owe so much. His artistic genius and collaborative spirit deeply infuses the work found within these pages, as I'm sure many of the artists will attest. We also thank Ed for allowing us to reproduce his work herein. Thanks also to his assistant Mary Dean.

I'd also like to acknowledge the following people for their help, technical assistance and encouragement at various stages of the project: Emily Alderman, Bob Bull, Shary Connella, Avery Danzinger, Matt Johnston, Craig Krull, Brian Matsumoto with Canon USA, Jerry McMillan, Bob Monk, Xavier Ribas, Jeremy Sanders, and Tom Sowden.

WENDY BURTON

I am grateful to the eighty plus artists who so patiently responded to my endless stream of questions and requests, and to those artists who graciously provided us with additional artwork to be reproduced within these pages. We clearly would not have been able to make this book without your artistic contributions and willing participation. Special thanks to Kai-Olaf Hesse, Jonathan Monk, Tom Sowden, Mark Ruwedel, and Henry Wessel for going the extra miles.

We are extraordinarily fortunate to have had the opportunity to work with Phil Taylor on this project. His thoughtful, intelligent texts add layering, depth, and keen insight to the book. Phil, you are a rock star. We are grateful as well to Mark Rawlinson for his excellent essay.

Without Roger Conover's perseverance, *Various Small Books* might have languished for years without being published. We are honored to have him as our publisher. I have wanted to work with him for many years and this project finally afforded me the opportunity to do so. Thanks go as well to Janet Rossi and Abby Streeter Roake at the MIT Press for their guidance and patience.

This project would never have come to be without our delightful and talented colleague Hermann Zschiegner. His obsession for collecting all things Ruscha is admired and appreciated. I thank him as well for his gentle collaboration and indefatigable enthusiasm.

Great thanks and appreciation go to our splendid copy editor, Alexandra McKee. Her calm spirit and excellent work ethic kept us on track, lo these many, many, many months.

I am grateful to my husband Jeff Brouws, who has done the lion's share of work on this volume. He both inspires and teaches me by example, and without his hard work *Various Small Books* would have simply remained a terrific idea.

Lastly, our thanks to Ed Ruscha, whose epic generosity to other artists is legendary — without whom there would be no books inside these covers, and therefore, no book.

HERMANN ZSCHIEGNER

To my close collaborators Wendy Burton and Jeff Brouws: thank you for your friendship and patience throughout this project. Without your hard work there would be no book. I also need to thank the lucky star that brought us all together.

To all the artists featured in this book: your work provides daily inspiration and I am honored to have your books in my collection. A special acknowledgement to Andreas Schmidt, Jonathan Lewis, and Mishka Henner, my friends at the Artists' Books Cooperative, and the brilliant mind who started this movement: Joachim Schmid. I deeply value your work, friendship, and advice.

To my friend and teacher Reinhold Martin for introducing me to Ed's work. Your lectures on Entropy were hugely influential to me.

And finally to my wife Karen: your love, support, and friendship mean the world to me. This book is for you (and Beebs).

Various Small Books

Referencing Various Small Books by Ed Ruscha

edited and compiled by Jeff Brouws, Wendy Burton, and Hermann Zschiegner

with text by Phil Taylor and an essay by Mark Rawlinson

In the 1960s and 1970s, the artist Ed Ruscha created a series of small photo-conceptual artist's books, among them *Twentysix Gasoline Stations, Various Small Fires, Every Building on the Sunset Strip, Thirtyfour Parking Lots, Real Estate Opportunities,* and *A Few Palm Trees.* Featuring mundane subjects photographed prosaically, with idiosyncratically deadpan titles, these "small books" were sought after, collected, and loved by Ruscha's fans and fellow artists. Over the past thirty years, close to 100 other small books that appropriated or paid homage to Ruscha's have appeared throughout the world. This book collects ninety-one of these projects, showcasing the cover and sample layouts from each along with a description of the work. It also includes selections from Ruscha's books and an appendix listing all known Ruscha book tributes.

These small books revisit, imitate, honor, and parody Ruscha in form, content, and title. Some rephotograph his subjects: *Thirtyfour Parking Lots, Forty Years Later.* Some offer a humorous variation: *Various Unbaked Cookies* (which concludes, as did Ruscha's *Various Small Fires,* with a glass of milk), *Twentynine Palms* (twenty-nine photographs of palm-readers' signs). Some say something different: *None of the Buildings on Sunset Strip.* Some reach for a connection with Ruscha himself: *17 Parked Cars in Various Parking Lots Along Pacific Coast Highway Between My House and Ed Ruscha's.*

With his books, Ruscha expanded the artist's field of permissible subjects, approaches, and methods. With *Various Small Books,* various artists pay tribute to Ed Ruscha and extend the legacy of his books.

Jeff Brouws is a photographer whose work is in many private and public collections, including Harvard's Fogg Museum, the Los Angeles County Museum of Art, Princeton University Art Museum, and the Whitney Museum of American Art. His homages to Ruscha include *Twentysix Abandoned Gas Stations.* **Wendy Burton** is a photographer whose work is in such collections as the San Francisco Museum of Art, the Santa Barbara Museum of Art, and the University of Louisville Photographic Resource. Her homage to Ruscha is *Real Estate Opportunities.* **Hermann Zschiegner** is a principal in the award-winning New York–based design agency TWO-N, a member of the ABC Artists' Book Cooperative, and the author of *Thirtyfour Parking Lots on Google Earth.*